Put any picture you want on any state book cover. Makes a great gift. Go to www.america24-7.com/customcover

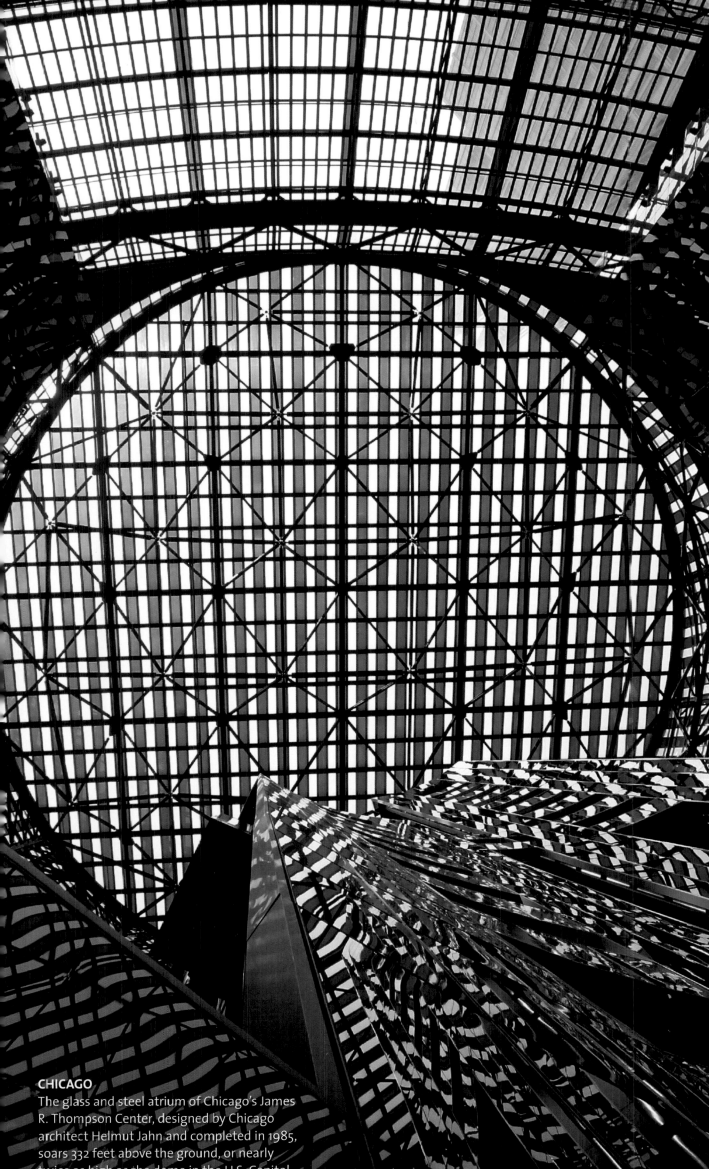

CHICAGO
The glass and steel atrium of Chicago's James R. Thompson Center, designed by Chicago architect Helmut Jahn and completed in 1985, soars 332 feet above the ground, or nearly twice as high as the dome in the U.S. Capitol.
Photo by Antoine F. Terry, AFT

Illinois 24/7 is the sequel to *The New York Times* bestseller *America 24/7* shot by tens of thousands of digital photographers across America over the course of a single week. We would like to thank the following sponsors, the wonderful people of Illinois, and the talented photojournalists who made this book possible.

LONDON, NEW YORK, MUNICH, MELBOURNE, and DELHI

Created by Rick Smolan and David Elliot Cohen

24/7 Media, LLC
PO Box 1189
Sausalito, CA 94966-1189
www.america24-7.com

First Edition, 2004
04 05 06 07 08 10 9 8 7 6 5 4 3 2 1

Published in the United States by
DK Publishing, Inc.
375 Hudson Street
New York, NY 10014

DK Publishing, Inc. offers special discounts for bulk purchases for sales promo-
tions or premiums. Specific, large-quantity needs can be met with special edi-
tions, personalized covers, excerpts of existing guides, and corporate imprints.
For more information, contact:

Special Markets Department
DK Publishing, Inc.
375 Hudson Street
New York, NY 10014
Fax: 212-689-5254

Cataloging-in-Publication data is available
from the Library of Congress
ISBN 0-7566-0053-7

Printed in the UK by Butler & Tanner Limited

First printing, October 2004

CHAPIN
Bobby Hoffman, 33, plants corn on the 2,000-
acre Becker farm, which has been in his wife
Kristin's family for 100 years. It's a good year
for corn—more than 33 bushels per acre.
Illinois claims the highest number of family
farms in the country.
*Photo by Steve Warmowski,
Jacksonville Journal-Courier*

ILLINOIS 24/7

24 Hours. 7 Days.
Extraordinary Images of
One Week in Illinois.

Created by Rick Smolan and David Elliot Cohen

DK Publishing

About the America 24/7 Project

A hundred years hence, historians may pose questions such as: What was America like at the beginning of the third millennium? How did life change after 9/11 and the ensuing war on terrorism? How was America affected by its corporate scandals and the high-tech boom and bust? Could Americans still express themselves freely?

To address these questions, we created *America 24/7*, the largest collaborative photography event in history. We invited Americans to tell their stories with digital pictures. We asked them to shoot a visual memoir of their lives, families, and communities.

During one week in May 2003, more than 25,000 professionals and amateurs shot more than a million pictures. These images, sent to us via the Internet, compose a panoramic yet highly intimate view of Americans—in celebration and sadness; in action and contemplation; at work, home, and school. The best of these photographs, more than 6,000, are collected in 51 volumes that make up the *America 24/7* series: the landmark national volume *America 24/7*, published to critical acclaim in 2003, and the 50 state books published in 2004.

Our decision to make *America 24/7* an all-digital project was prompted by the fact that in 2003 digital camera sales overtook film camera sales. This technological evolution allowed us to extend the project to a huge pool of photographers. We were thrilled by the response to our challenge and moved by the insight offered into American life. Sometimes, the amateurs outshot the pros—even the Pulitzer Prize winners.

The exuberant democracy of images visible throughout these books is a revelation. The message that emerges is that now, more than ever, America is a supersized idea. A dreamspace, where individuals and families from around the world are free to govern themselves, worship, read, and speak as they wish. Within its wide margins, the polyglot American nation manages to encompass an inexplicably complex yet workable whole. The pictures in this book are dedicated to that idea.

—*Rick Smolan and David Elliot Cohen*

American nightlight: More than a quarter
of a billion people trace a nation with incandes-
cence in this composite satellite photograph.
Photo by Craig Mayhew & Robert Simmon, NASA
Goddard Flight Center/Visions of Tomorrow

The Illinois Way

By Bernard Schoenburg

Corn and soybeans. The Sears Tower. Maple "sirup" at a place called Funks Grove. Cities named Marseilles and Cairo—pronounced the Illinois way: mar-sails and kay-ro. The Magnificent Mile of stores on Michigan Avenue. And Lake Michigan itself, which might as well be a sea, as it draws its own eastern horizon. Ilinois is many places, many images, urban and rural. It is the vague, all-purpose notion of "downstate" and the sprawling, imprecise universe called Chicagoland.

There are 12.5 million faces of Illinois. They twang in the south, where Kentucky is just across the Ohio River and the Ozarks are just across the Mississippi. They invite you to Metropolis to see the statue of Superman. They speak of great books and nanotechnology in a university town called Champaign—pronounced just like the bubbly stuff, but spelled differently, of course. They gamble on riverboats, boats that never leave their docks. High school students in western Illinois go absent on the first day of deer hunting season. In Chicago, on the other hand, you can't legally own a handgun.

Ah, Chicago. Where they play the blues and trade pork belly futures. Where Al Capone thrived and defined the city to the world—until Michael Jordan soared like a god for the once-great Bulls and rewrote the mythology. Where Mayor Richard J. Daley, the man Mike Royko called "the Boss," fine-tuned the Chicago Machine and got Picasso to make that thing that now adds character to downtown. Is it a bird? Is it a lady? Who cares? We got culture.

"I am somebody!" While Jesse Jackson affirmed life itself for Chicagoans at his weekly meetings of Operation PUSH in a one-time synagogue on the

CHICAGO
In 1922, Chicago newspaperman Ben Hecht described Lake Michigan fog moving "like a great cat through the air, slowly devouring the city." Here, the action is caught from the 95th floor of the John Hancock Center.
Photo by Jon Lowenstein, Aurora

South Side, Richard M. Daley, son of the Boss, carried on the family tradition, with a gentler touch.

And where did young Daley stop on his way to City Hall? Two hundred miles south, in Springfield, of course, where he served in the ornate Senate chamber under the silver-gray dome with its century-old stained-glass replica of the state seal 230 feet above the rotunda floor hawking "state sovereignty." Outside, there's a statue of that tousled-haired orator from Pekin, Everett M. Dirksen, who led U.S. Senate Republicans but did it the Illinois way: He worked both sides of the aisle. A little donkey and a little elephant share his pedestal on the Statehouse lawn.

Yes, we are not Wisconsin. Let them have their cheese and earnest policy debates. We get the job done. Just like the coal miners who, though harshly reduced in numbers, still emerge, faces blackened, from the tunnels under our central and southern regions. Like the Hispanic immigrants who man the meatpacking plant in Beardstown. Like the soy processors in Decatur. And the carmakers who incorporate Japanese methods in a place called Normal.

Ours is the state where Abraham Lincoln lost an election to a senator named Stephen Douglas. But hey, we gave Lincoln the flint and the forum that would help him move to the White House and hold together the nation. And we are now, proudly, the Land of Lincoln. Our license plates tell you so.

Look over parts of the Illinois River, or the Mississippi, or near Starved Rock State Park. Eagles fly there—majestic, dominant, beautiful. They too help define us.

Evanston native Bernard Schoenburg *is a longtime political writer and columnist at* The State Journal-Register, *a Copley newspaper in Springfield, Illinois.*

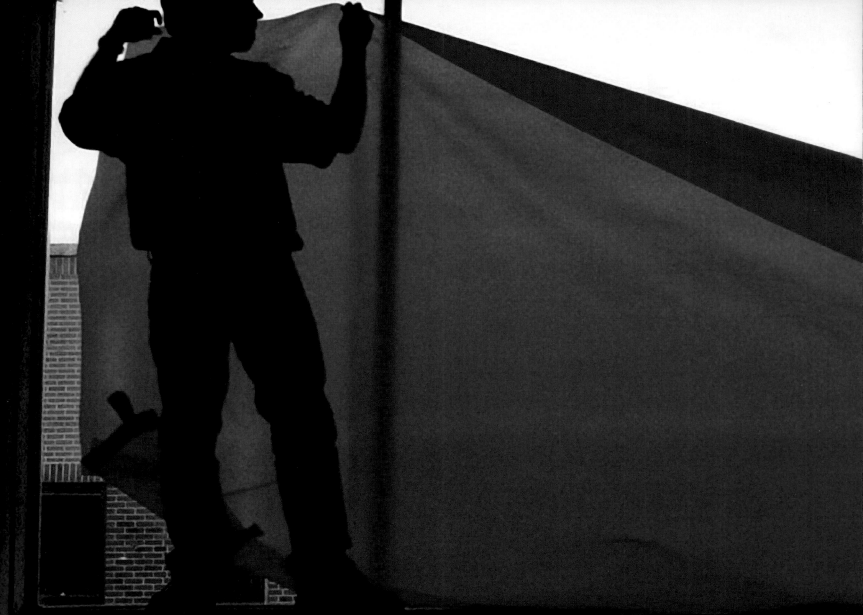

OTTAWA
Jamie Klock jumped into action when the plastic sheeting to block out light fell down during the premiere of *Prairie Tides* at the Christ Community Church. The film tells the tale of the nearby Illinois & Michigan Canal, a 97-mile waterway built in 1848 to connect the Great Lakes to the Mississippi.
Photo by Tom Sistak

CHICAGO

Chicago is home to more than 500 outdoor murals. Because of the city's corrosive winters, the material used for public murals has gradually shifted in the past 20 years from paint to mosaic tiles. This Division Street mural by Chicago artist Dzine represents the Graf Movement, which began in the 70s and legitimized graffiti as fine art.
Photo by Jon Lowenstein, Aurora

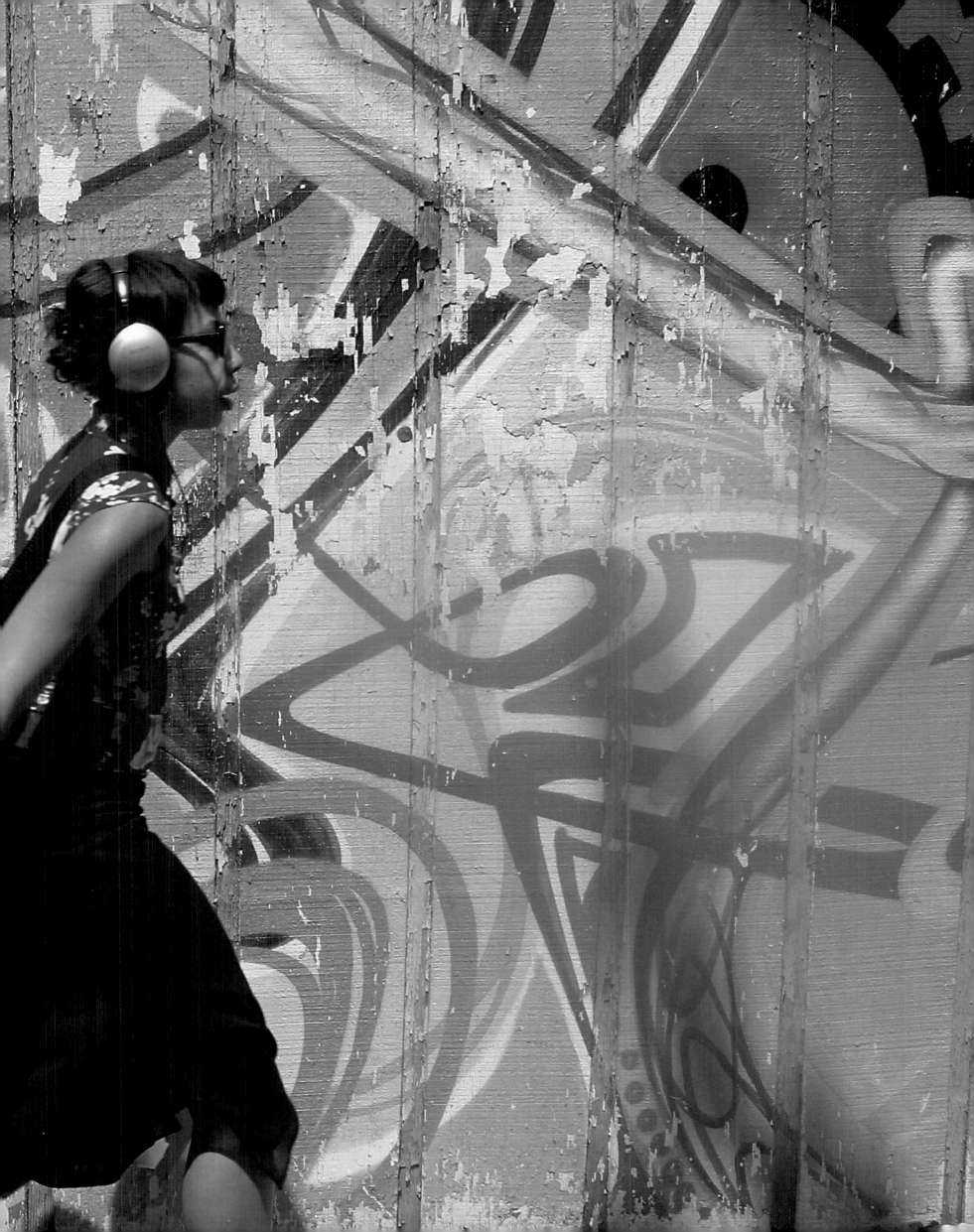

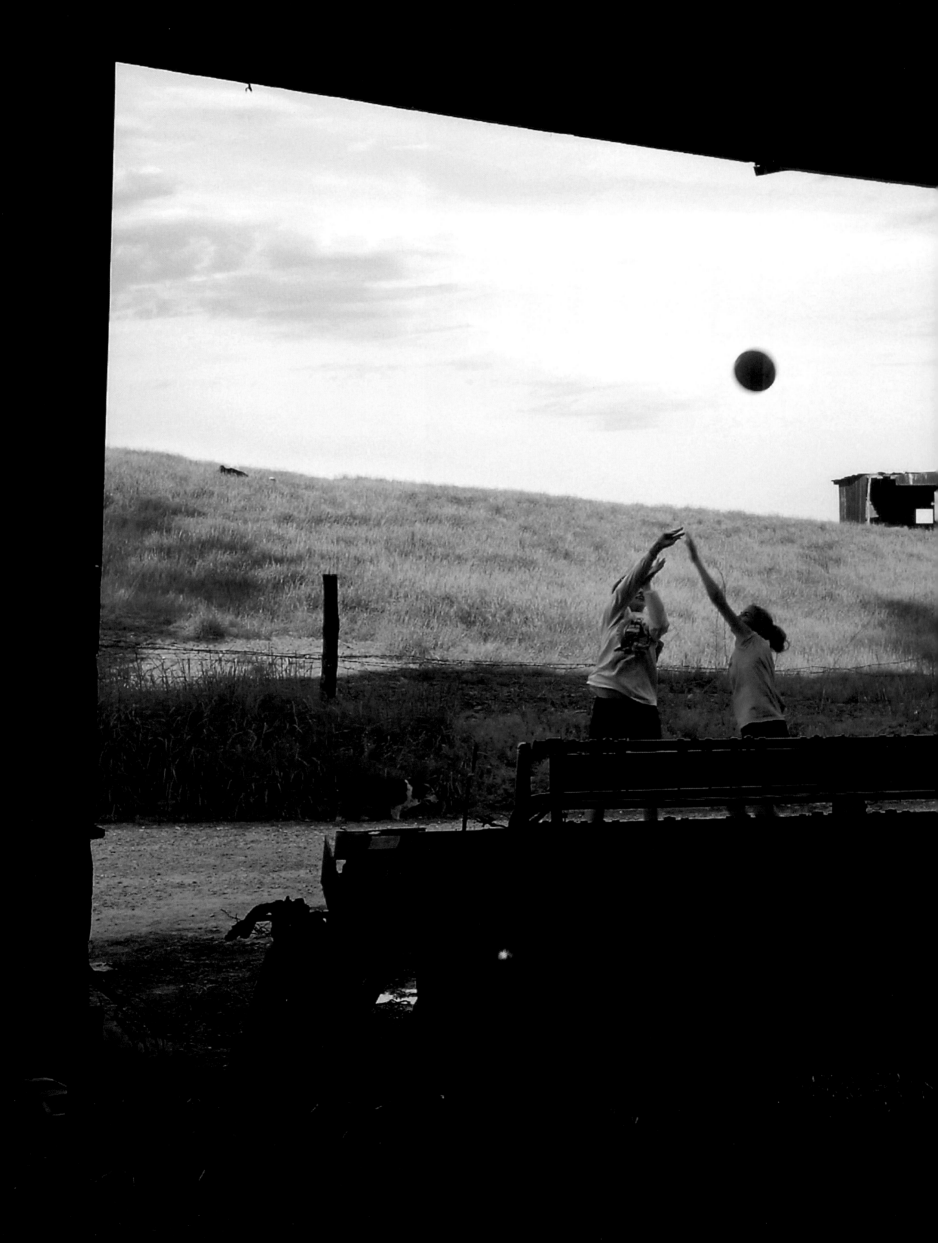

ROODHOUSE

Kate and Anna Mansfield shoot hoops behind the machine shed on their family's 120-acre farm. The Mansfields' 57 head of cattle, raised for milk and beef, are hormone free. Like a lot of small farmers in Illinois, parents Steve and Cindy moonlight—he works at the local school for the blind; she tutors at the elementary school.
Photo by Steve Warmowski,
Jacksonville Journal-Courier

CHICAGO
Ana Maria Barella collapses in her apartment, which overlooks Chicago's Rush Street area, after a night out dancing. Ana Maria, a writer and consultant, moved here from Gurnee, a northern Chicago suburb, a few years ago to start a new life.
Photo by Michael Hettwer

BYRON
It's 8:12 p.m. Do you know where your electricity comes from? The Byron Generating Station is one of seven nuclear power plants in Illinois, the most of any state. There are 11 working reactors, which supply 51.6 percent of the electricity to Illinois.
Photo by Alex Garcia

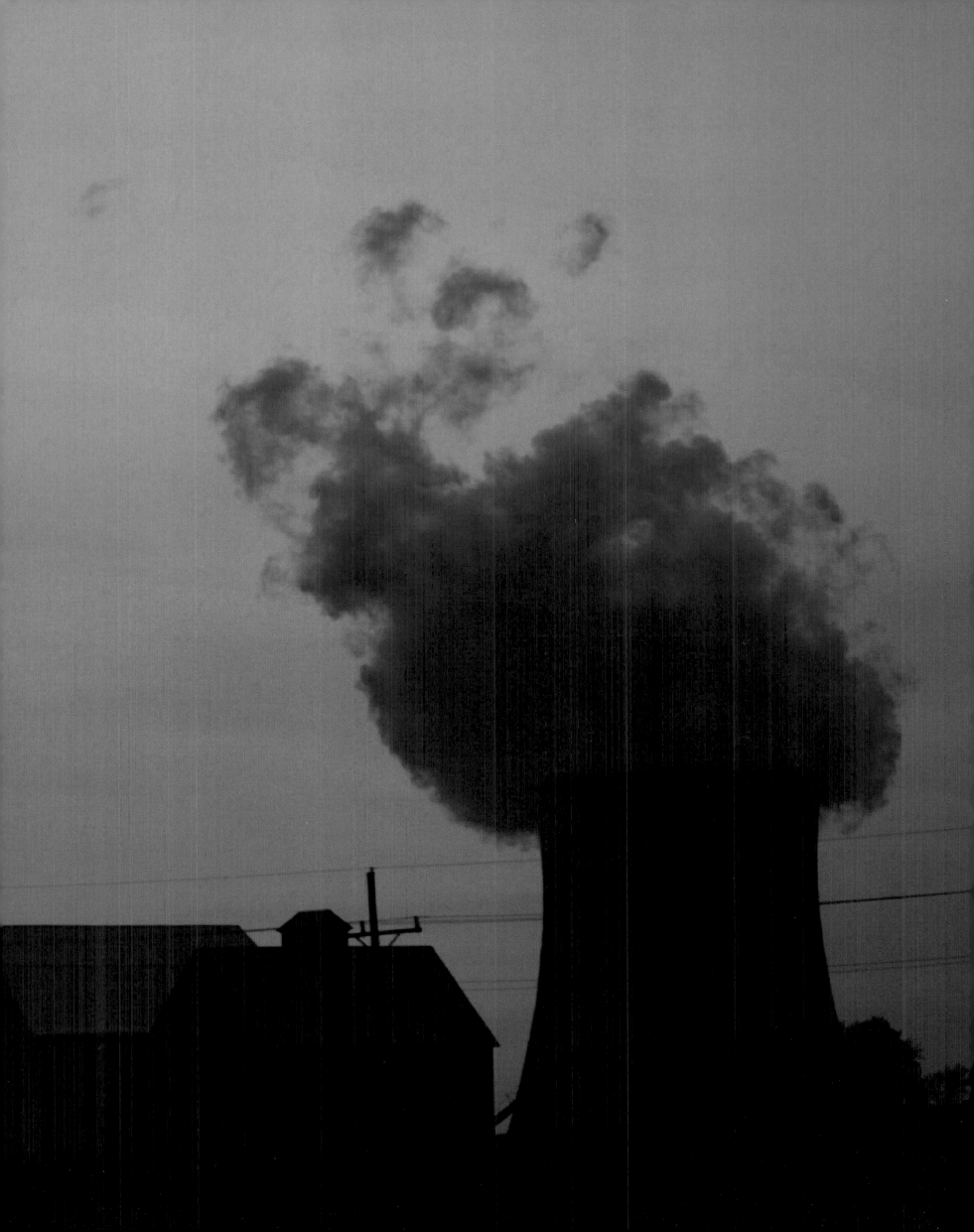

RICHMOND
Napping peacefully is no small
feat in the Lebrecht household.
James Lebrecht is father to 11 children,
including Anna, 2, and Mick, 5 months.
Photo by Juli Leonard

Hearth & Home

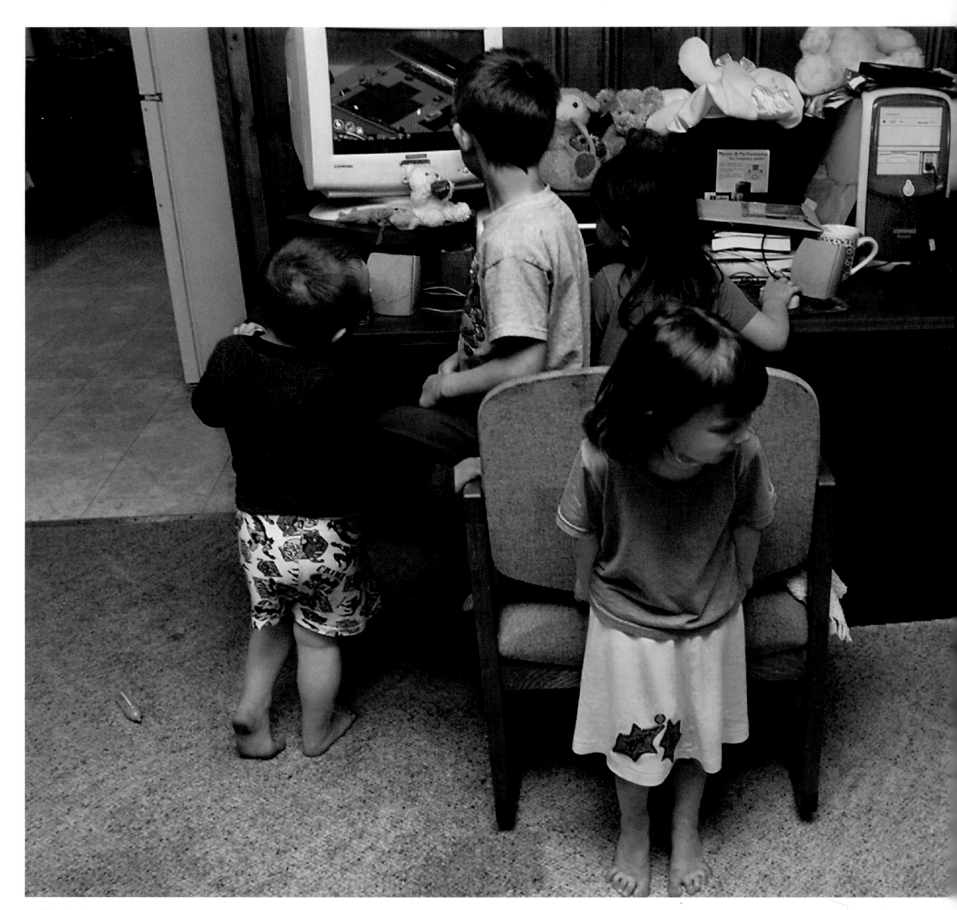

RICHMOND

Having 11 children teaches mother Elizabeth Lebrecht (seen here with Luke, 3; Ben, 7; Sarah, 5; Bekah, 4; and Mick, 5 months) to be a world-class scheduler. Up at 2 a.m. for chores and homeschooling, everyone pitches in to feed and change babies as well as prepare meals. Bedtime for the children is 6 p.m.

Photos by Juli Leonard

RICHMOND
With 10 siblings, it's not surprising that Timmy
Lebrecht can find only one shoe.

NAPERVILLE
Sweet spring: Kedzie Becker, 7, waits for the school bus outside her house. Besides leaping for leaves, Kedzie's into gymnastics, swimming, and soccer.
Photo by Stuart Thurlkill

WILLOW SPRINGS
Sneak preview: Laura Husar Garcia holds an
early ultrasound image of her tiny baby girl
over her not-so-tiny belly. Grace Mayari Husar
Garcia was born a month later.
Photo by Alex Garcia

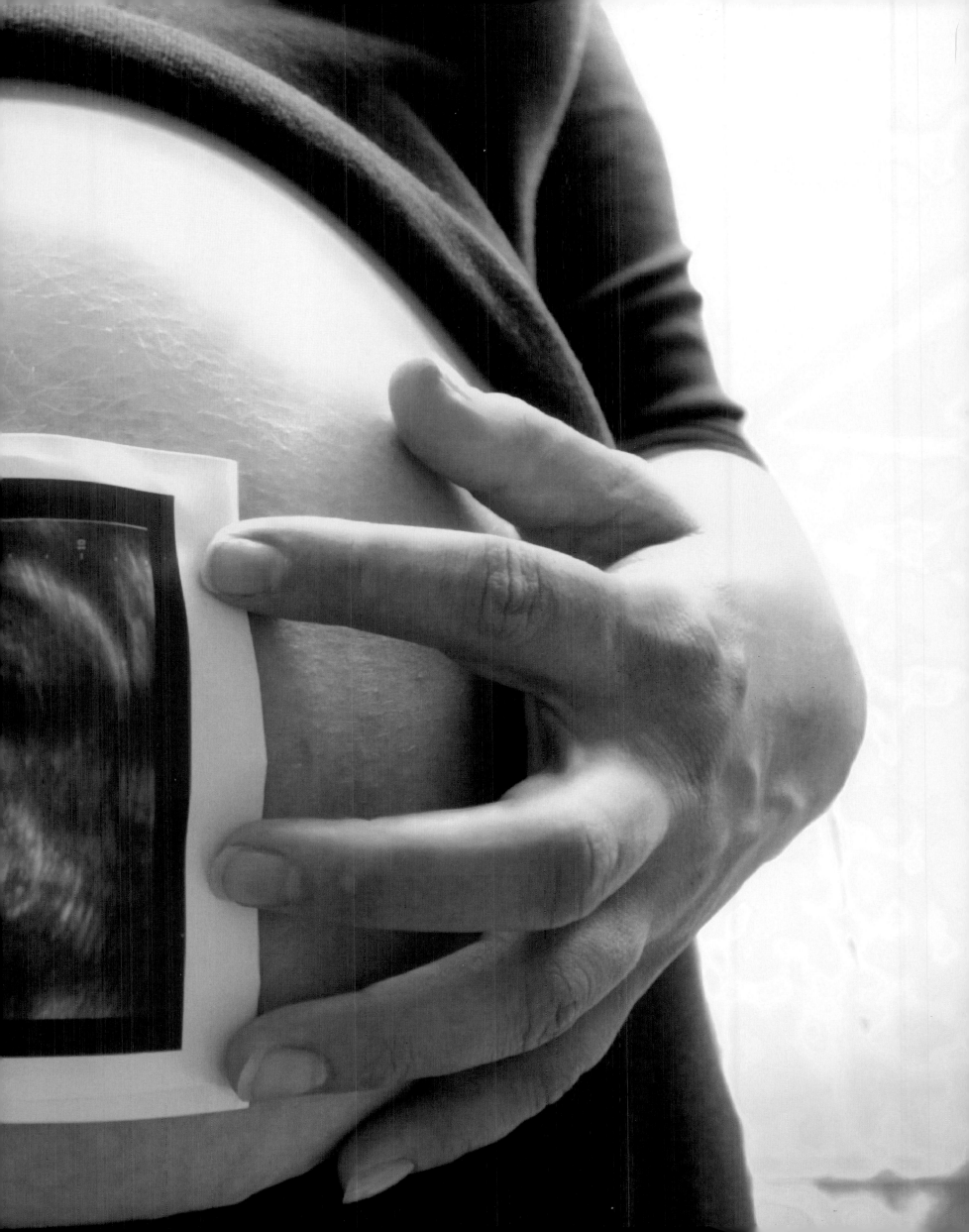

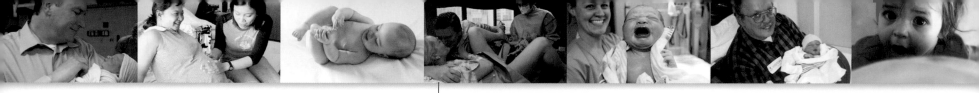

CHICAGO

Labor of love: Gretchen and Brian Baker welcome 15-second-old Lily into the world at Prentice Women's Hospital in Chicago. Fashionably late to arrive, Lily's birth was induced. To accommodate medical necessity or busy schedules, 20 percent of deliveries in American hospitals are induced.
Photo by Michael Hettwer

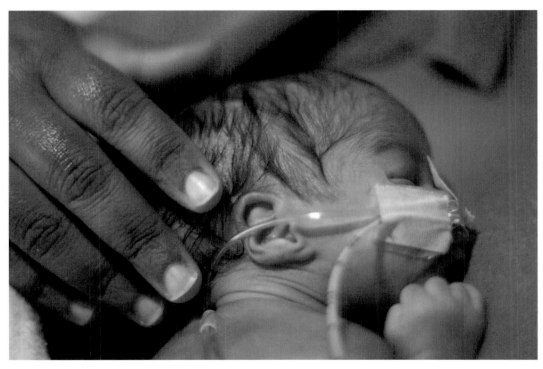

CHICAGO
Kahlani Peterson was born three months prema-
ture and weighed less than two pounds. For 10
weeks, she remained in the Special Care Nursery
at Rush-Presbyterian-St. Luke's Medical Center.
Mother Nicole visited her daily to do what's called
"kangaroo care," laying the tiny child against her
naked chest in order to bond.
Photo by Troy T. Heinzeroth

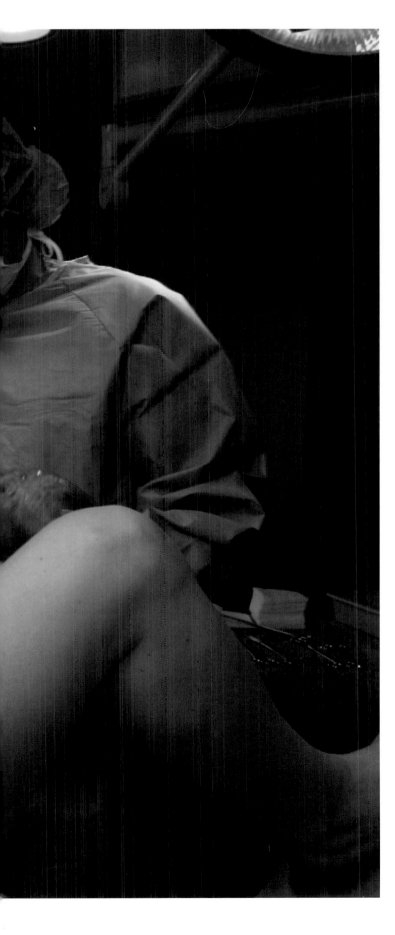

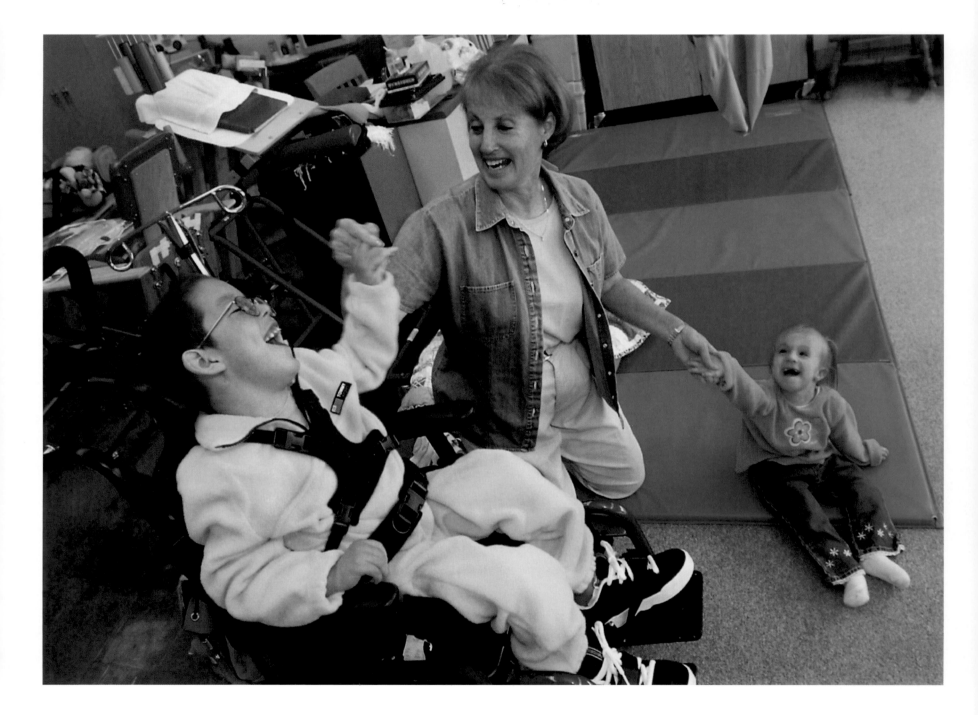

MOLINE

The joy is in the small victories. Mary Boehm, adaptive physical education teacher, takes Desmond Terronez, 6, and Camryn Hoskins, 3, through their favorite warm-up exercise, "up and down." Twice a week, she works with them in her specialized gym class for S.K.I.P. (Special Kids in Preschool), a program focusing on the needs of 40 special kids aged 3 to 6.

Photo by Todd Mizener

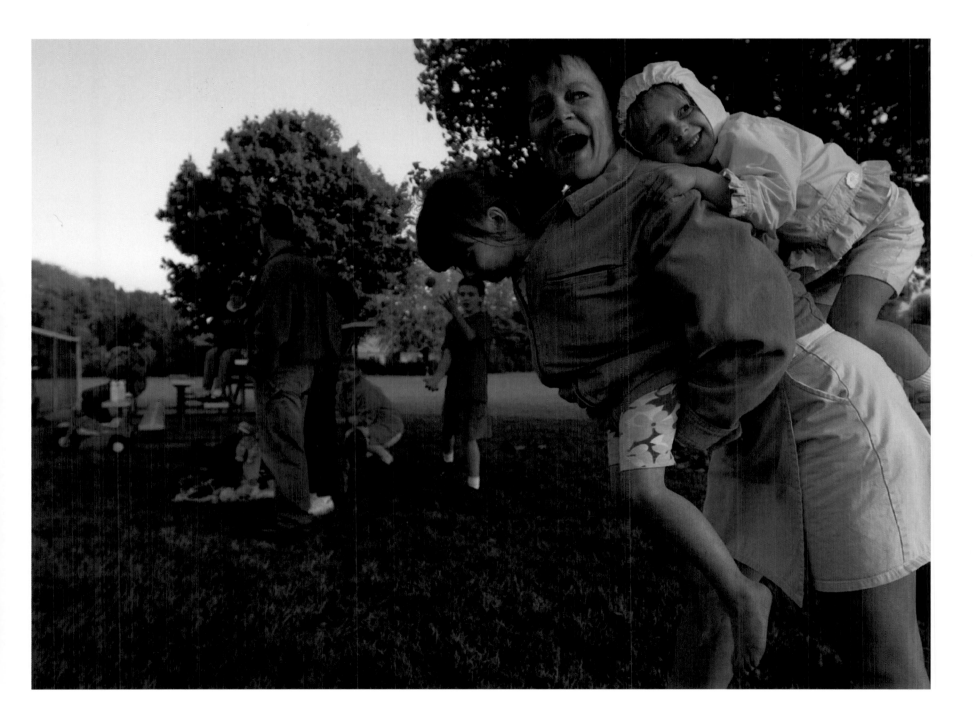

NAPERVILLE

Front and back row seats: Victoria Kinder balances daughter Josephine, 3, and friend Kendall Maida, 4, during a T-ball game at a neighborhood park. Josephine's sister is playing in the game, which is divided up not by innings but by snack breaks.
Photo by Stuart Thurlkill

CHICAGO

Matt, 5, and Ben, 3, are the adopted Chinese sons of Garey Schmidt, 45, a single dad and health care benefits manager for whom fatherhood has been a revelation. "The boys are dependent on me for everything," Schmidt says. "The love and emotion they have, it's overwhelming." In 2002, Americans adopted nearly 5,000 children from the People's Republic of China.
Photo by Tim Klein

WOODSTOCK

Bird bath: Katie Wittman and her parakeet Ollie are rarely separated. From the town square to school soccer games, they're a well-known pair.
Photo by Holly Digney

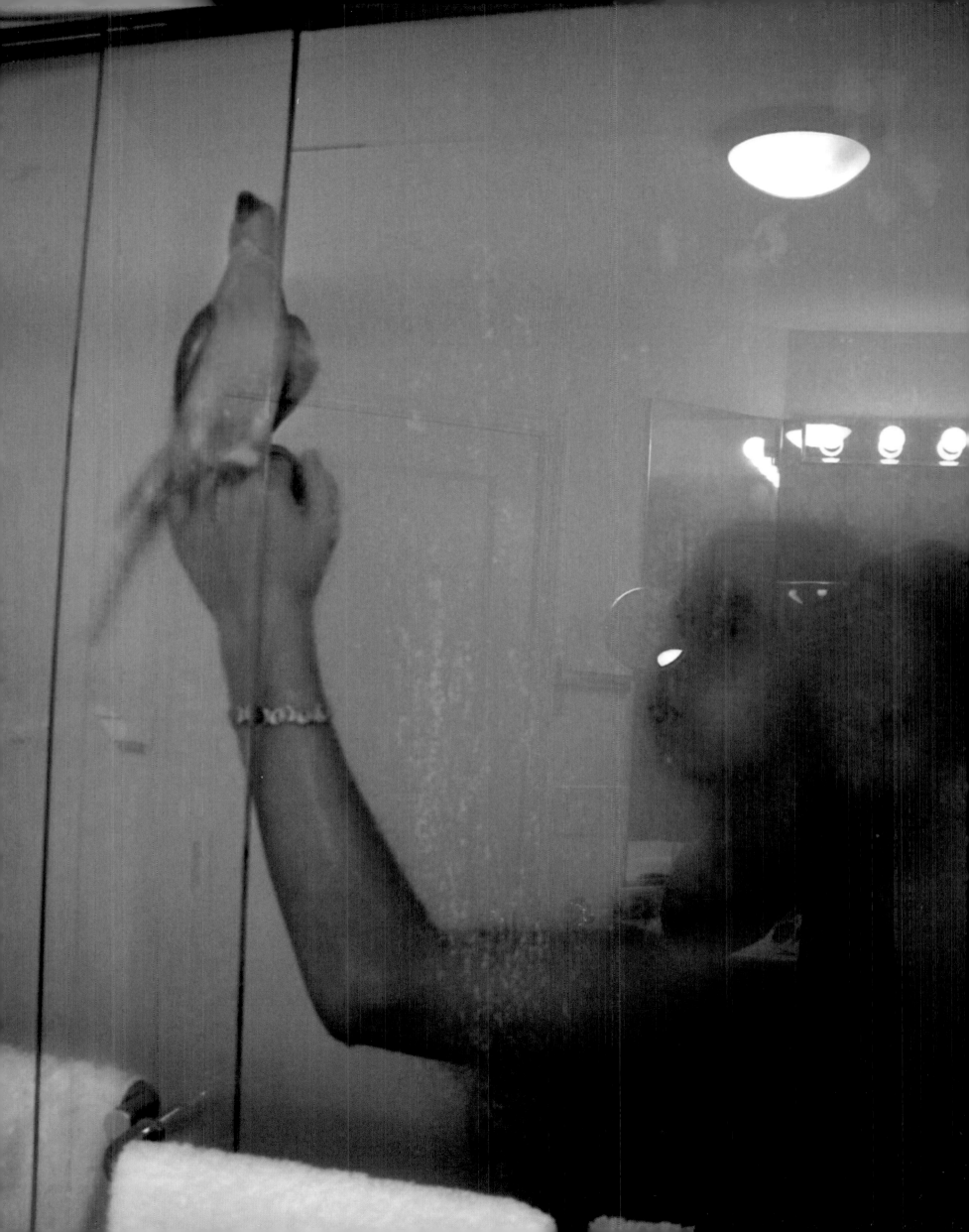

AURORA

Three years ago, personal problems prevented 19-year-old Christopher McGhee's mother from taking care of her son, who has cerebral palsy. Enter his uncle Zechariah, a gospel choir director in Cologne, Germany. In Aurora for a concert, Zechariah saw he was needed and stepped in. He works three jobs to support Christopher, who is thriving at the Hope D. Wall School.
Photos by Stuart Thurlkill

LAKE IN THE HILLS

Jenni hopes her ankles and feet will be strong enough for her to get onto pointe by Christmas. She attends ballet classes twice a week and jazz classes once a week. For members of the Dance Company, class attendance is mandatory. If Jenni misses more than 10 percent of her classes, she could face expulsion.

LAKE IN THE HILLS

Through thick and thin: Jenni (left) tries her best to balance dance classes, rehearsals, and performances, which consume at least four hours each week, along with school, baby-sitting, family, and friends. Attending slumber parties and school dances—or just hanging out with pals like Nicole Sather (right)—is becoming more difficult for the blossoming ballerina.

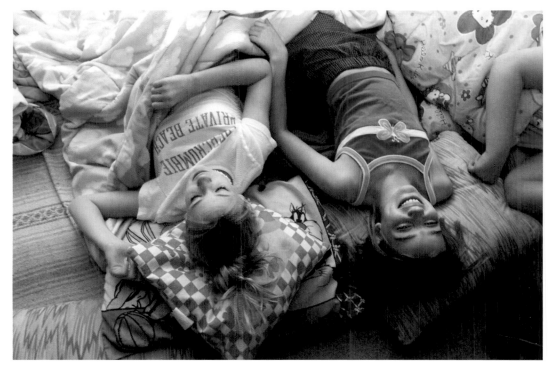

CHICAGO

A top tourist attraction, American Girl Place is a three-story retail experience. American Girl's pricey dolls come in a gamut of complexions and hair colors. On the premises: a doll hair salon, a doll theater, and a dress shop that sells girls' clothes to match the dolls'. At the café, Caroline Cronin and Madeline Sheridan, both 6, take tea with their mini-me's.

Photo by Michael Hettwer

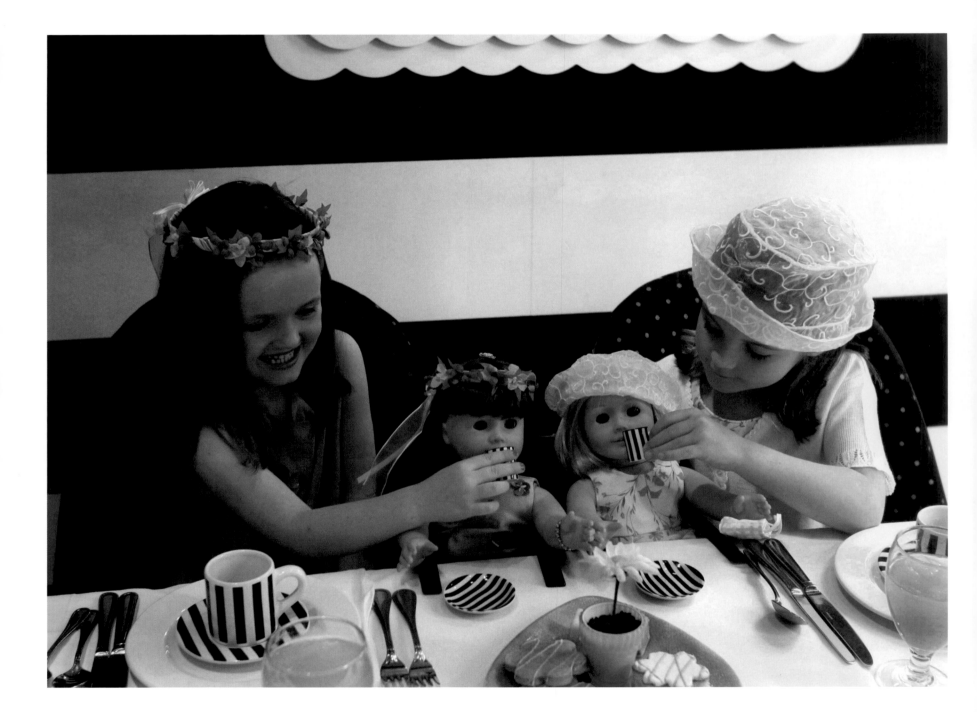

CHICAGO
Filling up at the Fullerton Restaurant in Logan Square is a Saturday morning tradition for Alberto Ortiz and daughter Susana.
Photo by Denise Keim

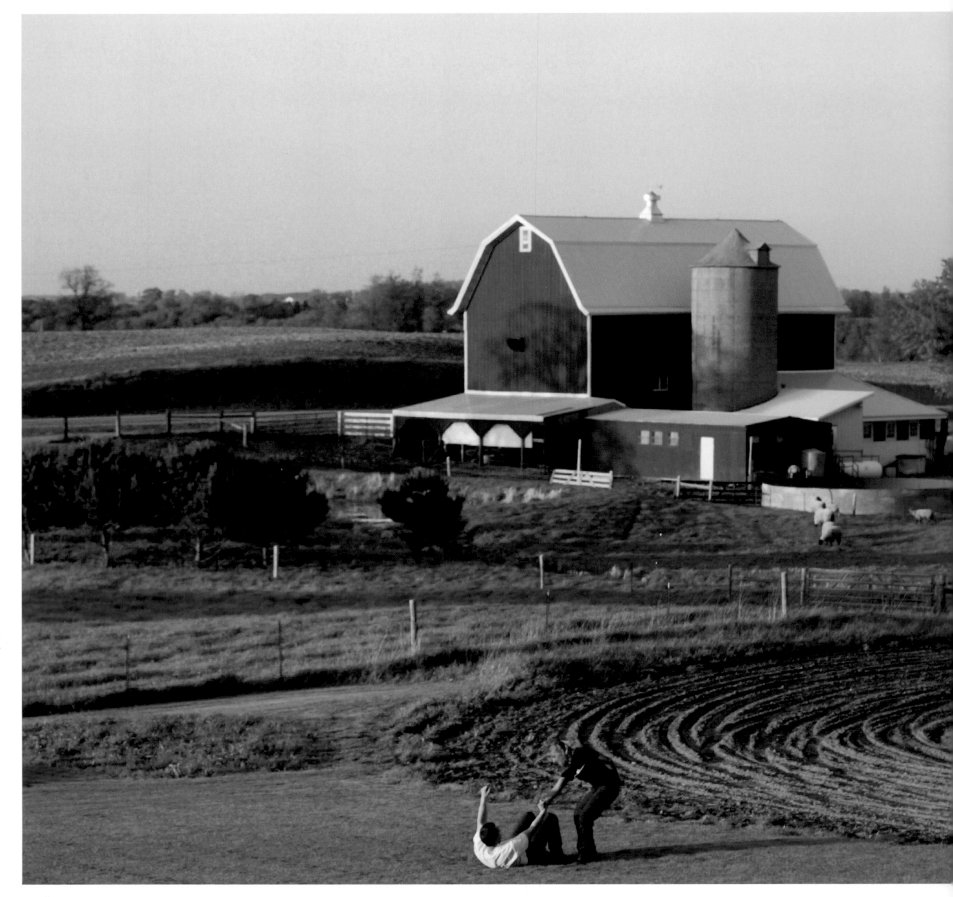

HARVARD
Taking a break at the Dietz family farm, Laura Dietz, 18, and her boyfriend, Kirk Meyer, 16, are both students in the Future Farmers of America program at Harvard High School, the last such farm operations training program in the country. They have their own flock of sheep (30 head), which they sell as breeding stock and show at local fairs.
Photo by Greg Hess

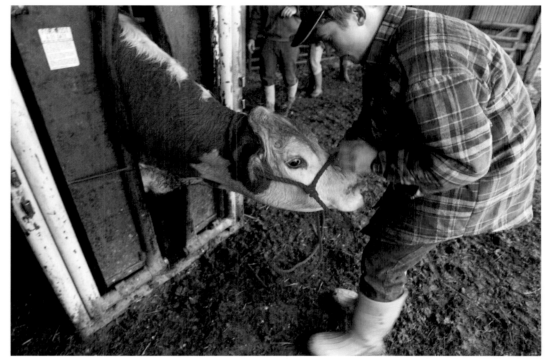

MARENGO

Hey, where's the hay? Two-year-old polled Hereford Garnet sticks her head through the slit in the back of her old-fashioned feeder expecting a bale of hay. Instead, she finds Dan Clarke, 18, waiting with the halter for an afternoon walk.
Photo by Greg Hess

JACKSONVILLE

Retired corn farmer Garland Petefish, 85, leans on a wood pry, which he uses to turn the logs he cuts into lumber in his 100-year-old refurbished sawmill. Twenty years ago, he bought the saw-mill, moved it to his property, and began selling sassafras, cottonwood, and maple logs to hobby-ists and carpenters. "It fills in the time," he says.
Photo by Steve Warmowski, Jacksonville Journal-Courier

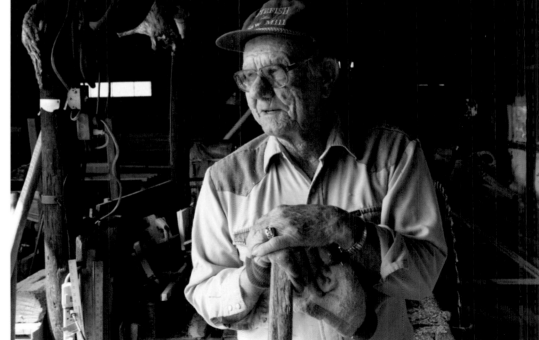

HINSDALE

Kelly Gabriel, 11, says Salt Creek is one of her favorite places. A mile from her Hinsdale home, the creek powers Graue Mill, the only operating waterwheel gristmill in Illinois. The mill is one of three authenticated, pre–Civil War, Underground Railroad stations in the state.

Photo by Cesar Gabriel

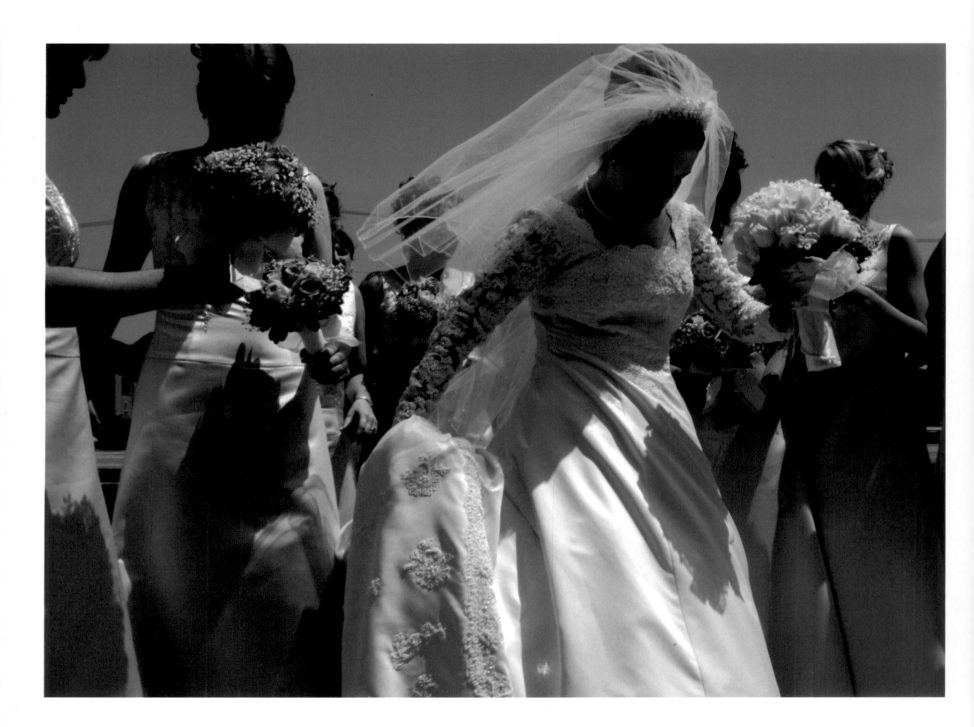

NILES

Two hundred guests attended Judy and Michael Jozwiak's wedding at Our Lady of Ransom Church in Niles. One-tenth of them were in the wedding party. That breaks down to nine bridesmaids, eight groomsmen, one flower girl, one best man, and one ring bearer.

Photos by Denise Keim

CHICAGO

On the way to their reception, Stephanie and Michael Stern stopped in front of historic Wrigley Field for a wedding-party photo, a popular ritual for ardent Cubs fans. It was Stephanie's idea: "The wedding was all about me," she said. "I thought I should do something for him."

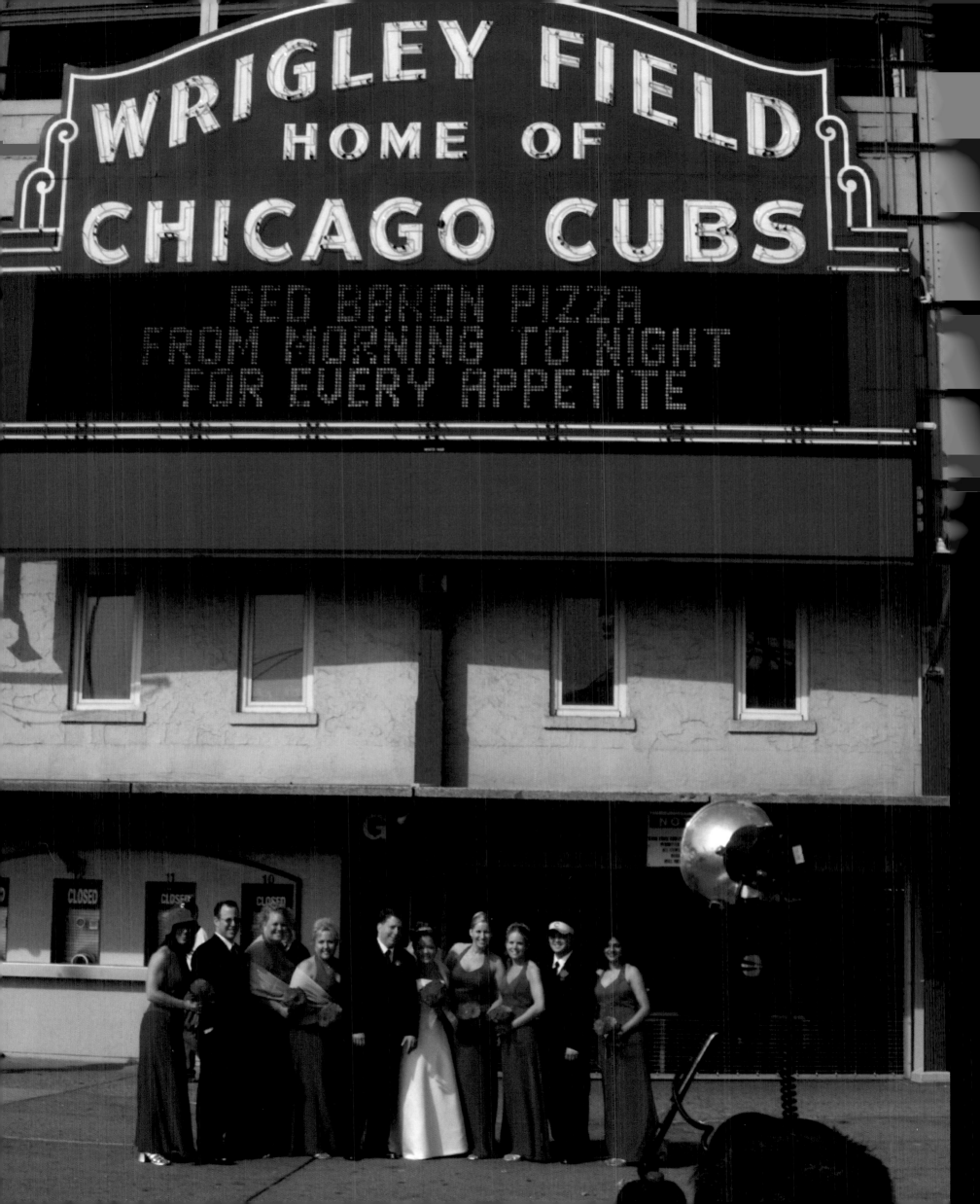

WHEATON

Budding entomologist Timothy Hudson, 3, admires his new pet caterpillar.
Photos by Michael Hudson

WHEATON

Best buddies: Joshua Maxwell and David Hudson met in Sunday school and learned they shared a common back fence. The two kindergartners have been close friends ever since.

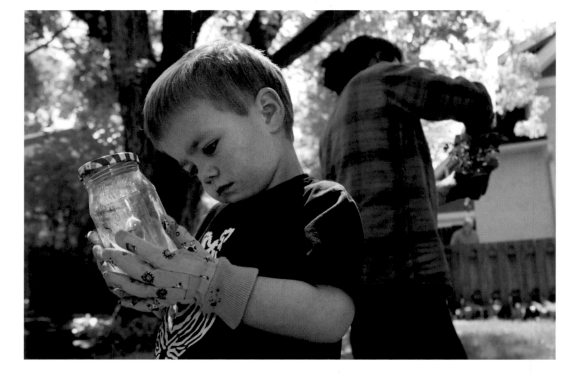

CHICAGO

Alexuis Johnson, 6, plays outside the troubled Cabrini-Green housing complex where she lives...for now. Plans are in the works to demolish Cabrini-Green and other city housing projects like it. Chicago negotiated with private residential developers throughout the city to allot a percentage of units built for low-income families. Some families, however, fear they may get lost in the shuffle.

Photo by Alex Garcia

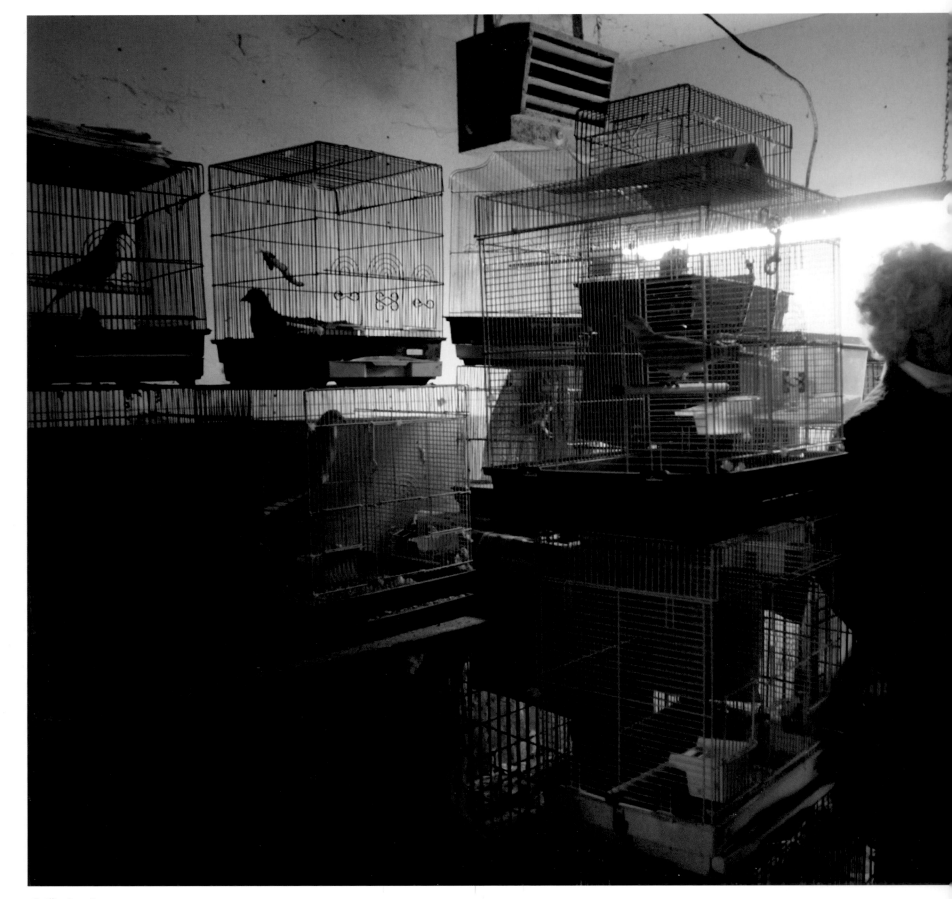

RURAL PEORIA COUNTY
Marge Bjorklund, 75, is licensed by the state of Illinois to care for orphaned and injured wildlife—including owls, squirrels, goats, and opossums—at her home. Her charges are set free or used for educational purposes in local schools. Abandoned by its previous owner, this red-tail hawk named Sarah was rescued from starvation and brought to Bjorklund's menagerie 10 years ago.
Photos by Fred Zwicky

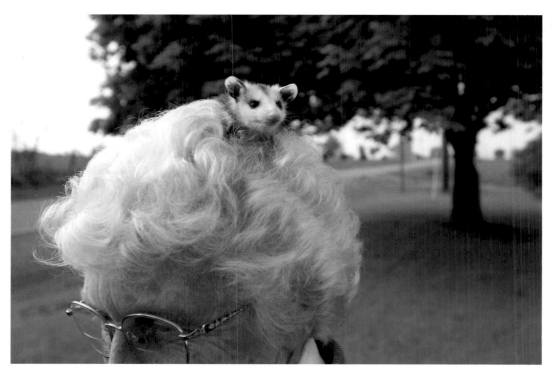

RURAL PEORIA COUNTY
Pogo, a five-ounce baby opossum, spends the day nesting in Bjorklund's hair, a substitute for his mother's fur. Bjorklund nursed him back to health with an eyedropper after Pogo's mom was run over by a car.

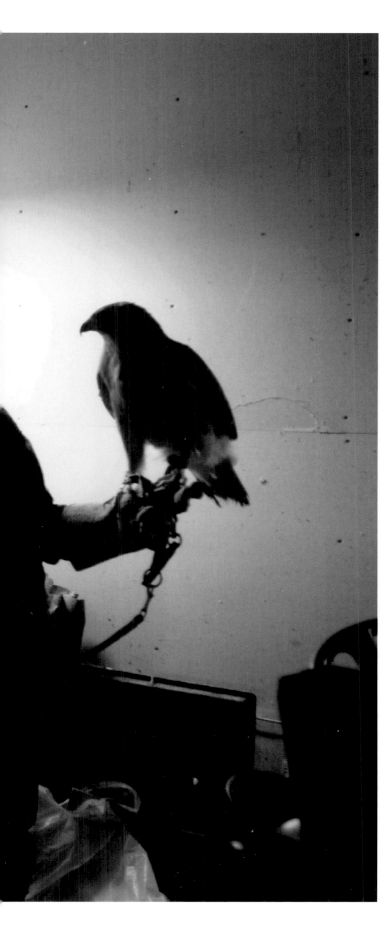

RICHMOND

Burning the midday oil: 11-year-old Timmy Lebrecht continues his homeschooling studies in math while his siblings help around the house. Illinois leads the country in families who homeschool their kids.

Photo by Juli Leonard

SPRINGFIELD

James Heffernan (left) and his five siblings use a converted bedroom for their studies. James's mother says she decided to homeschool after learning of a family whose homeschooled children attended Harvard and Princeton. Heffernan extracurriculars include swimming and wrestling. The children can choose to attend public high school. So far, none has.

Photo by T.J. Salsman, The State Journal-Register

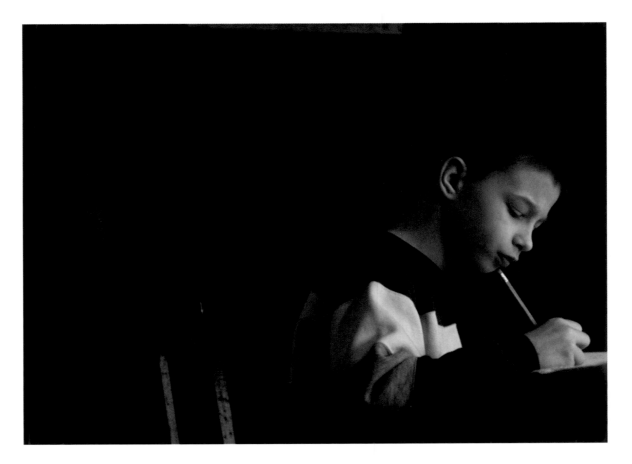

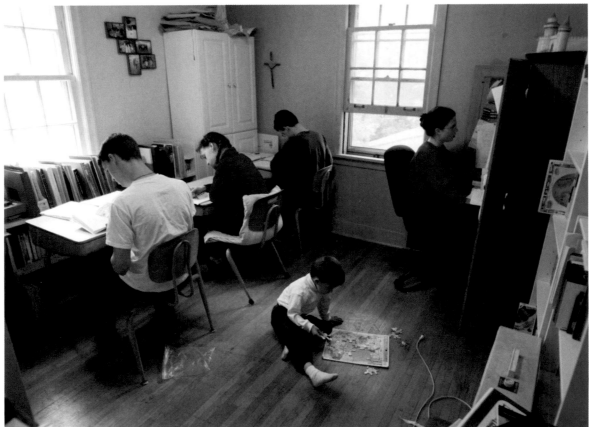

MOKENA

I Am the Walrus: When he's not clowning for daughter Rebecca, 4, Joe LiVigni, a drummer in his younger days, can actually show her the right way to hold drumsticks.

Photo by Jean Lachat

OTTAWA

"Character first, ability second" is the concept behind the Suzuki Method taught to violin students like Cassidy Pfilbsen, 8. Developed by Dr. Shinichi Suzuki in 1942, the program focuses on nurturing the love of music and teaching young children to learn an instrument the same way they learn a language: by listening, absorbing, and copying.

Photo by Tom Sistak

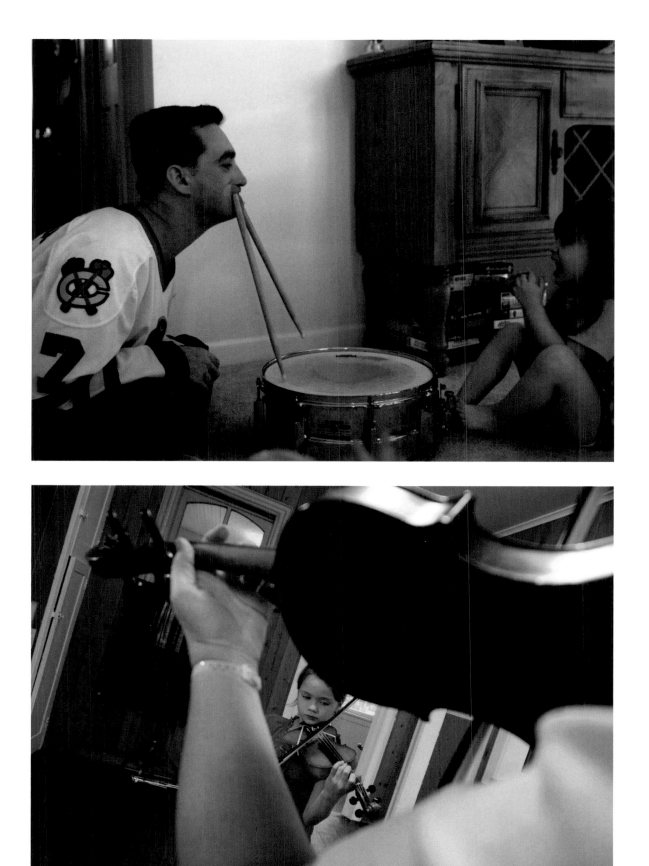

CHICAGO
At first, Our Lady of Tepeyac High School senior Sandra Perez wanted a $500 prom dress from Water Tower Place, but the practical 17-year-old found this more affordable coral number at JCPenney.
Photo by Tim Klein

URBANA
Senior Amanda Prillaman shakes it up at the Champaign Central High School prom at the Lincoln Square Mall in Urbana. The big event, entitled "Red Carpet Affair," was set up like a movie premiere. As attendees entered, they had their picture taken by parents posing as paparazzi.
Photo by Scott Strazzante, Chicago Tribune

CHAMPAIGN

Champaign Central High School All-American
runner Jeremy Kruidenier, 18, gets help from mom
with his grandfather's shirt studs as he dresses
for the prom. Fraternal twin Ryan is next in line.
Photo by Scott Strazzante, Chicago Tribune

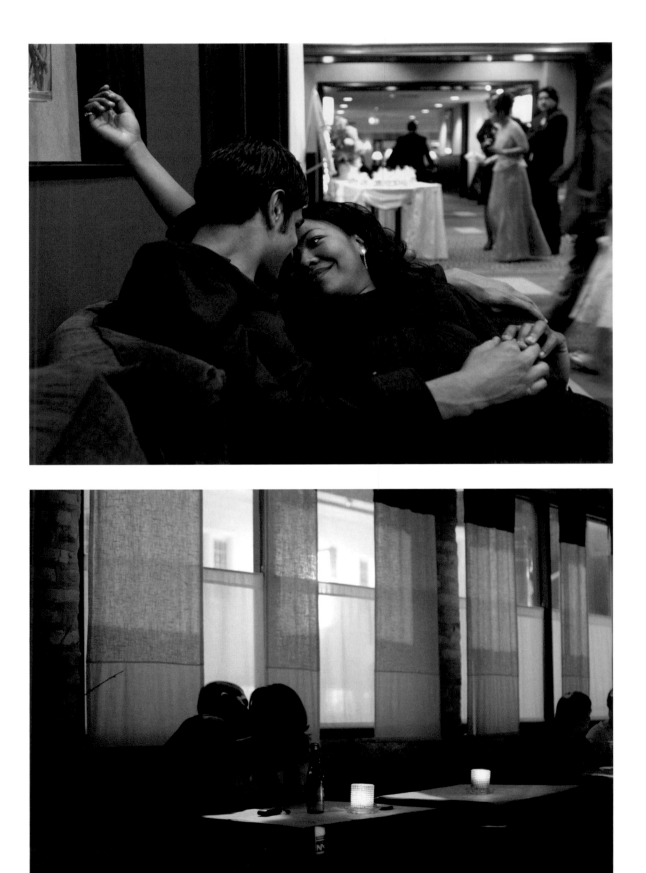

CHICAGO
Melissa McCall is delighted for her friend Maria Roces, whose wedding she's attending; but she's even happier to steal a quiet moment with her boyfriend of three months, William Cabrera.
Photo by Reed Hoffmann, Freelance

CHICAGO
An intimate moment in a Logan Square tapas bar.
Photo by Tim Klein

NAPERVILLE

First kiss: Mutual friends fixed up Bonnie Hudgens and Thomas Fletcher on a blind date. After dinner at La Sorella Restaurant in downtown Naperville, Thomas turned and kissed her impulsively. According to Bonnie, both were pleasantly surprised.
Photo by Stuart Thurlkill

CHICAGO

During a friend's housewarming party in Logan Square, Martin Schnatterbeck and Kate Lee-Chin discuss the latest step in their nascent relationship—flying to Puerto Rico together to attend a wedding.
Photo by Tim Klein

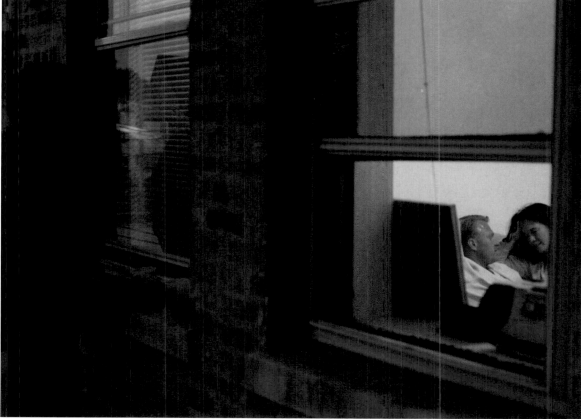

The year 2003 marked a turning point in the history of photography: It was the first year that digital cameras outsold film cameras. To celebrate this unprecedented sea change, the *America 24/7* project invited amateur photographers—along with students and professionals—to shoot and, via the Internet, submit digital images. Think of it as audience participation. Their visions of community are interspersed with the professional frames throughout this book. On the following four pages, however, we present a gallery produced exclusively by amateur photographers.

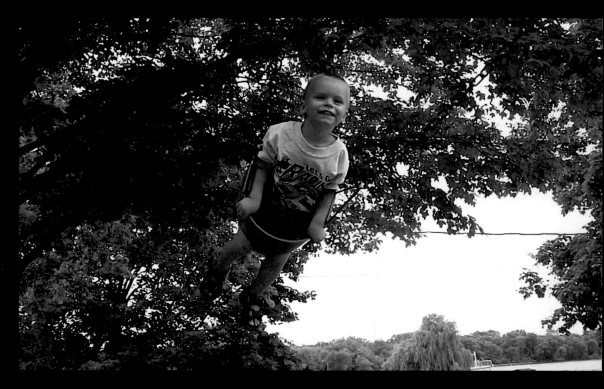

ST. CHARLES Will Hough, 3, flies through the air with the greatest of ease in Potawattomie Park.
Photo by Bill Hough

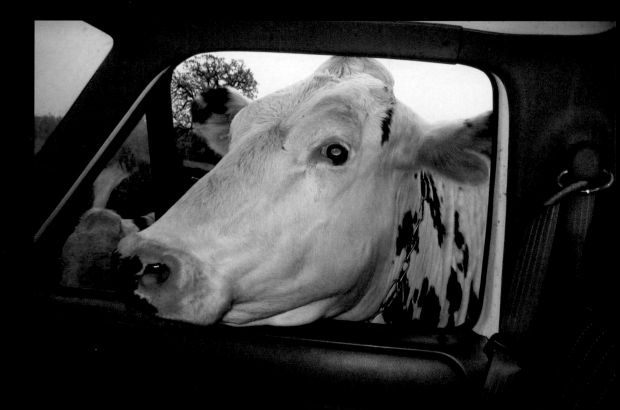

HEBRON Got room? Marsha, one of 60 milking cows on the Nichols's dairy farm, is "nosey and bossy," says the Holstein's owner—and amateur photographer—Kimber Nichols. *Photo by Kimber Nichols*

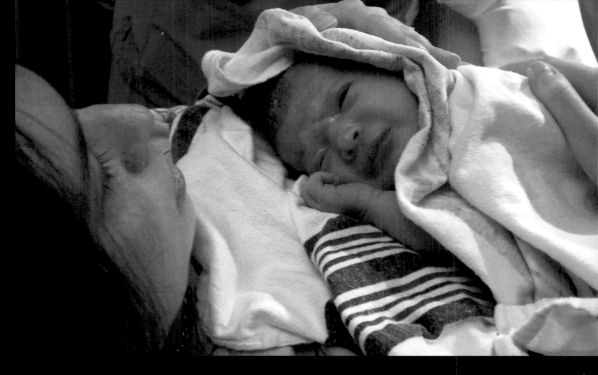

HIGHLAND PARK Joel Sattler struck papa pay dirt with his photo of wife Karen holding 10-minute-old Allison, who had just opened her eyes for the first time. Now he uses this picture as the screensaver on his computer. *Photo by Joel Sattler*

NAPERVILLE In your face: Erik Gleim, 5, learns the ins and outs of the positive/negative principle at the 3D Me exhibit at the DuPage Children's Museum. *Photo by Lynda Gleim*

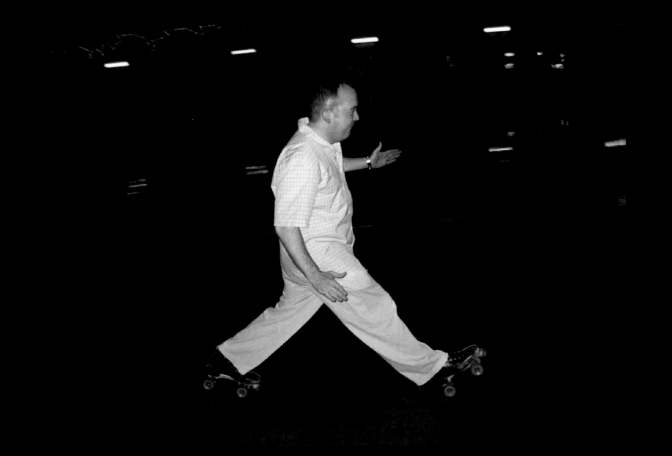

SCHAUMBURG Roboskate: Medical student Mark Mitchell demonstrates his scissors move at Orbit Skate as he rocks to the Styx hit "Mr. Roboto." *Photo by Scott Kolbe*

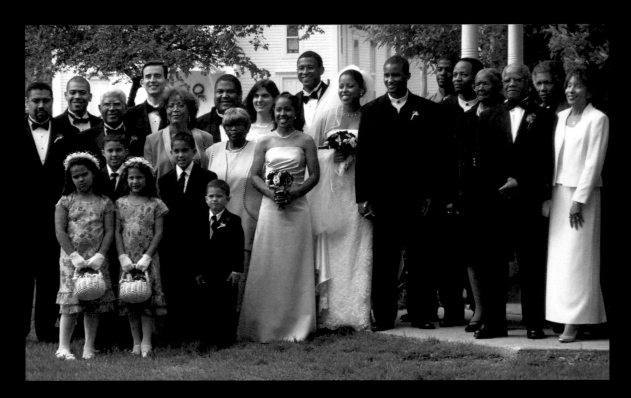

YORKVILLE Claudine Rigaud, a law student, and Marcel Dulaney, a social worker, exchanged vows at Yorkville's Chapel on the Green, the oldest church in Kendall County circa 1855. After the ceremony, the party limo'ed over to Aurora for a reception at Walter Payton's Roundhouse. *Photo by Jon Peterson*

JOLIET Beau, a 3-year-old Pomeranian-poodle mix, knows he'll soon be rewarded with a treat. The dog's owner, Jake Levandowski, has taken more than 1,700 digital portraits of the photogenic pooch.
Photo by Jake JK Levandowski

CHICAGO My Blue Heaven: After attending an all-day printing conference, color specialist Ken Kirschbaum of Naperville unwinds at Spike's Rat Bar, aka "the world's greatest saloon."
Photo by Charles Koehler

MOLINE

Michael Morse of Muscatine, Iowa, vacuums the 5th hole at River Valley Golf, the largest 18-hole championship miniature golf course in the Quad Cities (Moline and Rock Island, Illinois, and Davenport and Bettendorf, Iowa). True to form, Michael keeps his head down.

Photo by Todd Mizener

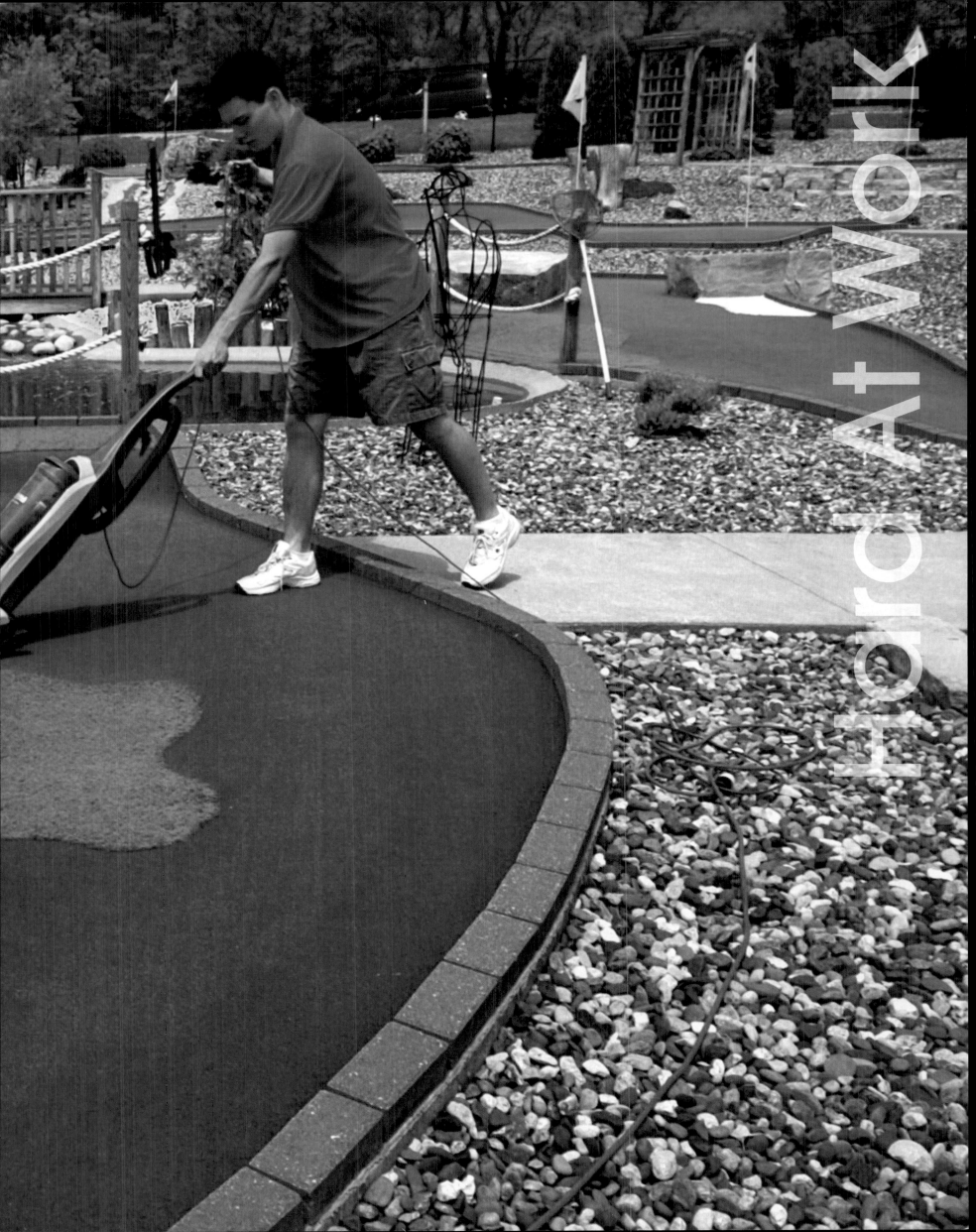

CHICAGO
On a Tuesday afternoon, building engineer Artis Caston busies himself tightening sign fittings atop the Travelodge Downtown Chicago on Harrison Street between Michigan and Wabash. Caston, 46, has been taking care of the 250-room hotel, formerly the Harrison, for about 20 years.
Photo by Robert A. Davis, Chicago Sun-Times

CRYSTAL LAKE

Megan Thoma, 19, waitresses 40 hours a week at Hooters, assistant manages a Shell gas station, and is a nursing student at McHenry County College. "People think Hooter Girls have a glamorous life, but we don't. A lot of the girls are single moms or widows from rough backgrounds." Thoma hopes to become a registered nurse or surgical assistant.

Photo by Juli Leonard

With his pure sable no. 3 brush, Jason
Kaplar "smokes out" eye shadow on Rachel
Elmore during a demo n the makeup department
of Barneys New York on Rush Street. Kaplar and
Elmore are makeup artists who visit the country's
department stores for NARS Cosmetics.
Photo by Denise Keim

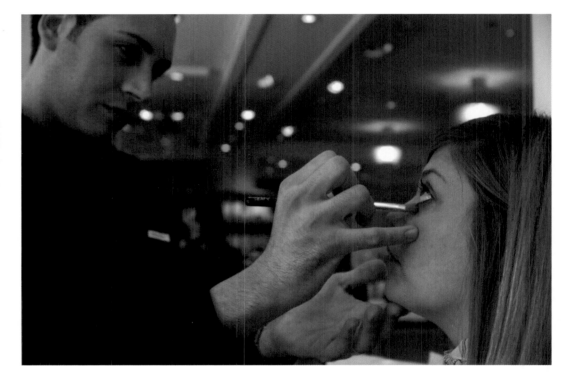

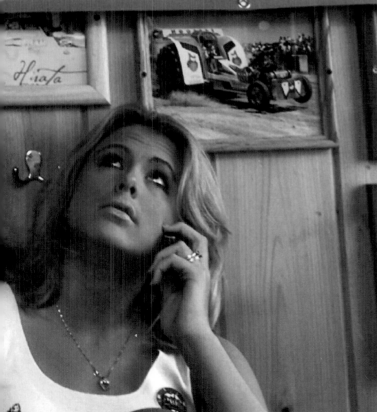

CHICAGO
John Saidla, pulling a finished clock off the assembly line, is one of 40 employees in the clock shop of Chicago Lighthouse Industries (CLI). A program within the Chicago Lighthouse for People Who Are Blind or Visually Impaired, CLI is the sole supplier of clocks to the U.S. government and the State of Illinois.
Photo by Troy T. Heinzeroth

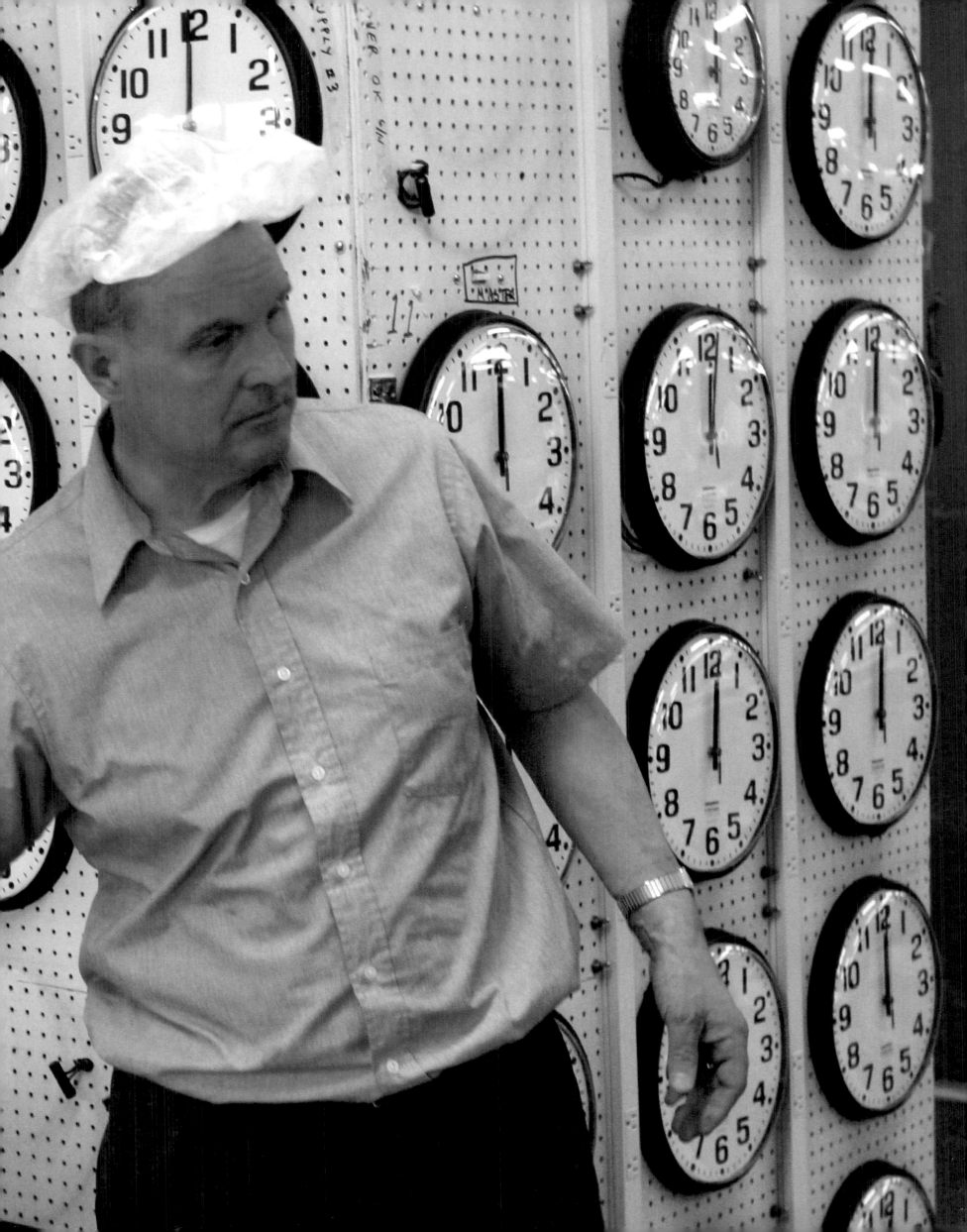

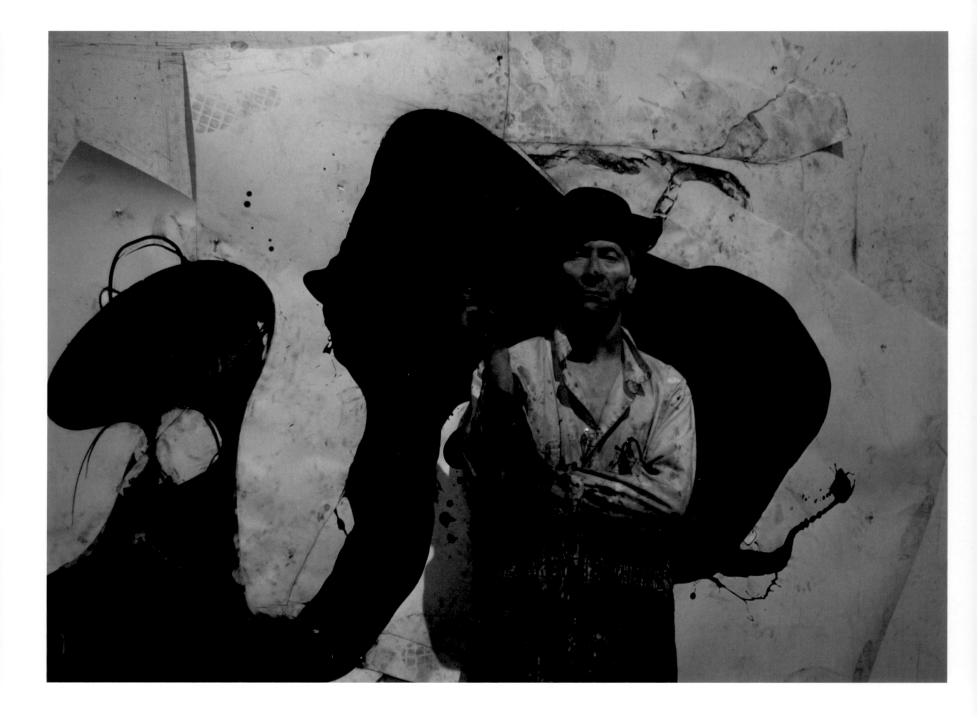

CHICAGO

World-renowned artist Wesley Kimler sometimes works for 72 hours straight. His process involves painting sheets of paper, cutting them up, and assembling them on the wall into sensuous, amoeba-like figures. Kimler's latest commission is for four paintings to grace the lobby of Chicago's 83-story Aon Center (formerly the Amoco Building), the fourth tallest building in America.
Photo by Michael Hettwer

CHICAGO

Cartographer Gerald E. Keefe makes maps the old-fashioned way, by hand. But not for long. Like most companies, Nystrom, the largest supplier of maps to schools in America, introduced computers to improve productivity, which reduced the mapmaking process from six months to one. The oversized maps that Keefe produces have not been converted yet, but he's not worried. He's retiring next year.
Photo by Robert A. Davis, Chicago Sun-Times

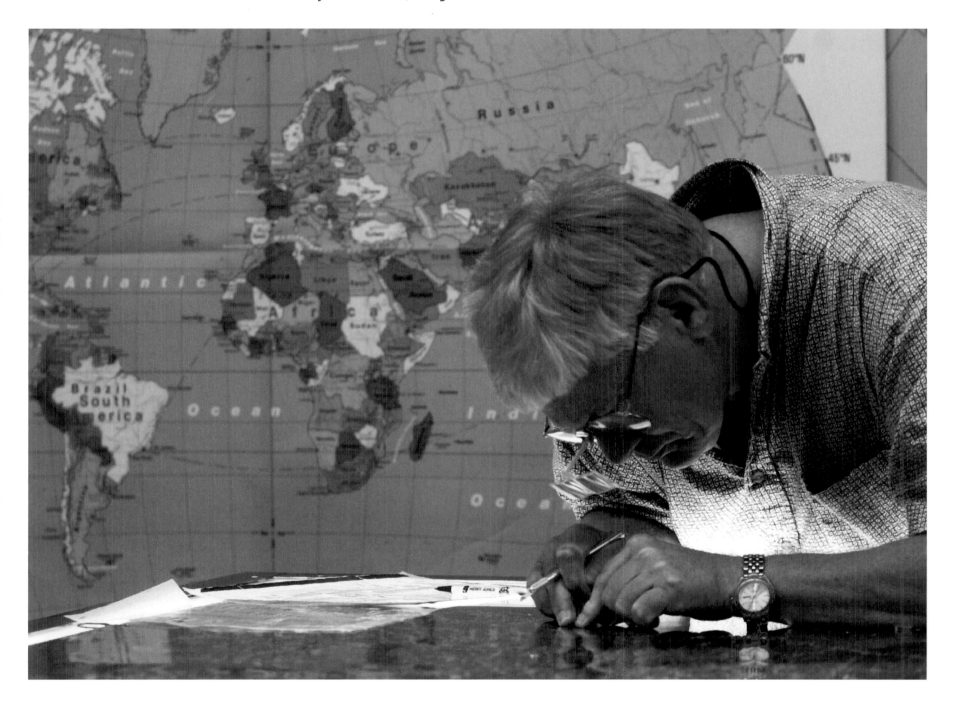

Rafael Gonzales, 54, has tailored men's clothing for 34 years—15 in his native Michoacan, Mexico, and 19 in Texas, California, and Illinois. As for retirement, Gonzales says, "I'm not sure when that will happen. I don't think people here retire."
Photo by Troy T. Heinzeroth

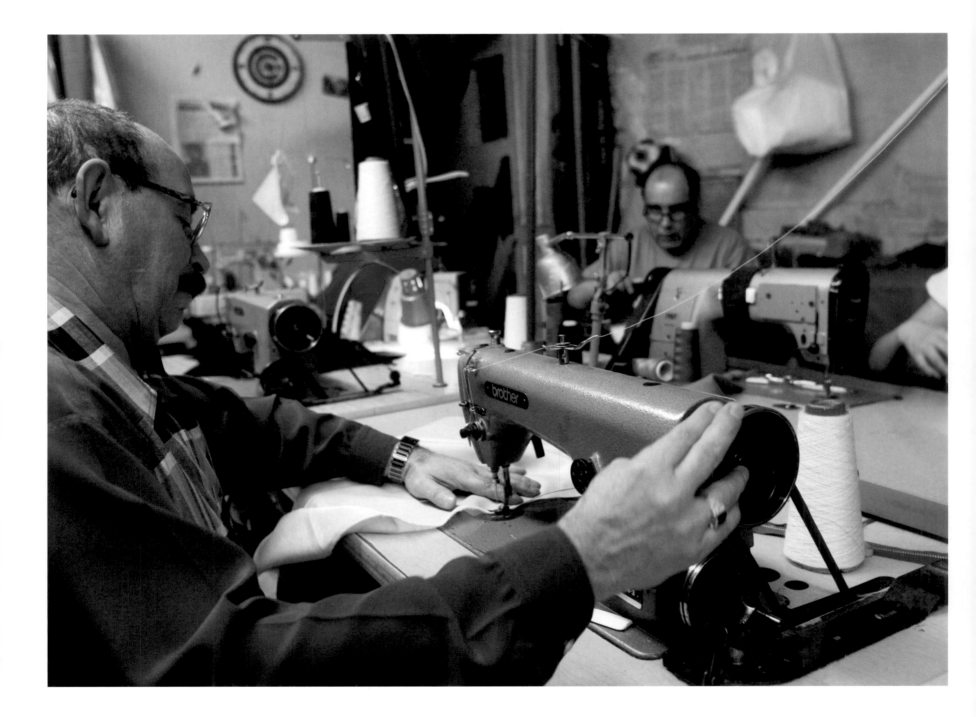

MOLINE

The service manager in the John Deere Collectors Center repairs a 4020 from 1969, the most popular tractor ever built. The center features a 1950s-style garage and specializes in restoring pre-1960, 2-cylinder tractors. Started in 1837 as a plough maker, John Deere became the world's largest manufacturer of agricultural equipment.
Photo by Todd Mizener

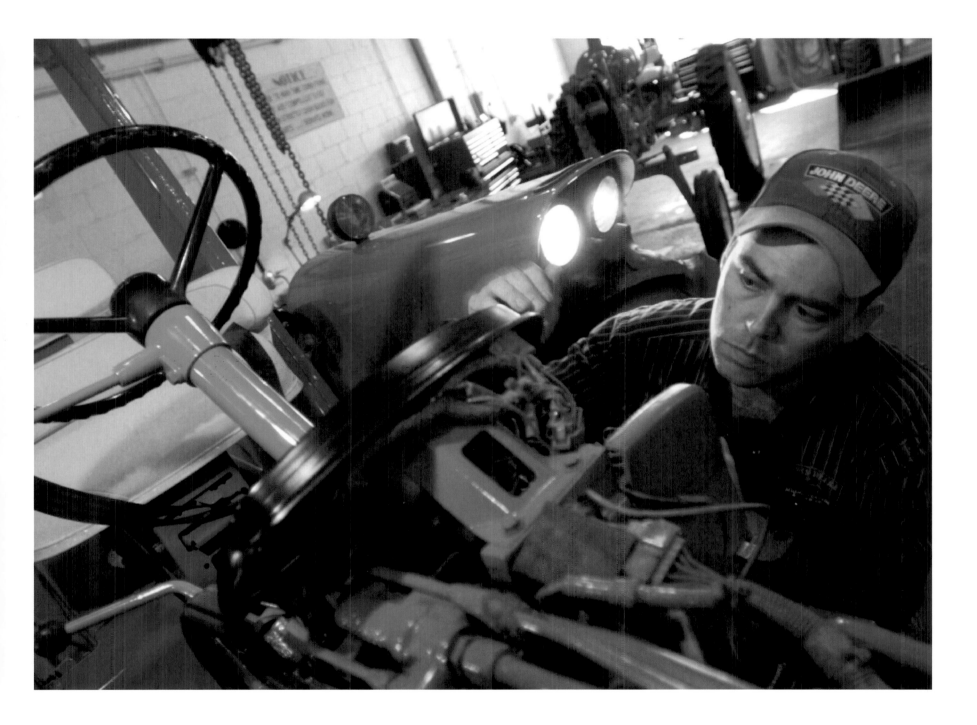

RYLAN RYLAND
HOME HOME

Styrofoam
WEATHERMATE
BRAND
HOUSEWRAP

RYLAND ND
HOMES ES

LOCKPORT
Although Illinois has some of the richest farmland
in America, it is fifth in the nation for land lost to
urban and suburban sprawl. Harlow Cagwin, who
lived on his 118-acre cattle farm 35 miles southwest
of Chicago for nearly 80 years, sold this land to
developers. It is now Willow Walk, a burgeoning
subdivision of single-family homes.
Photo by Scott Strazzante, Chicago Tribune

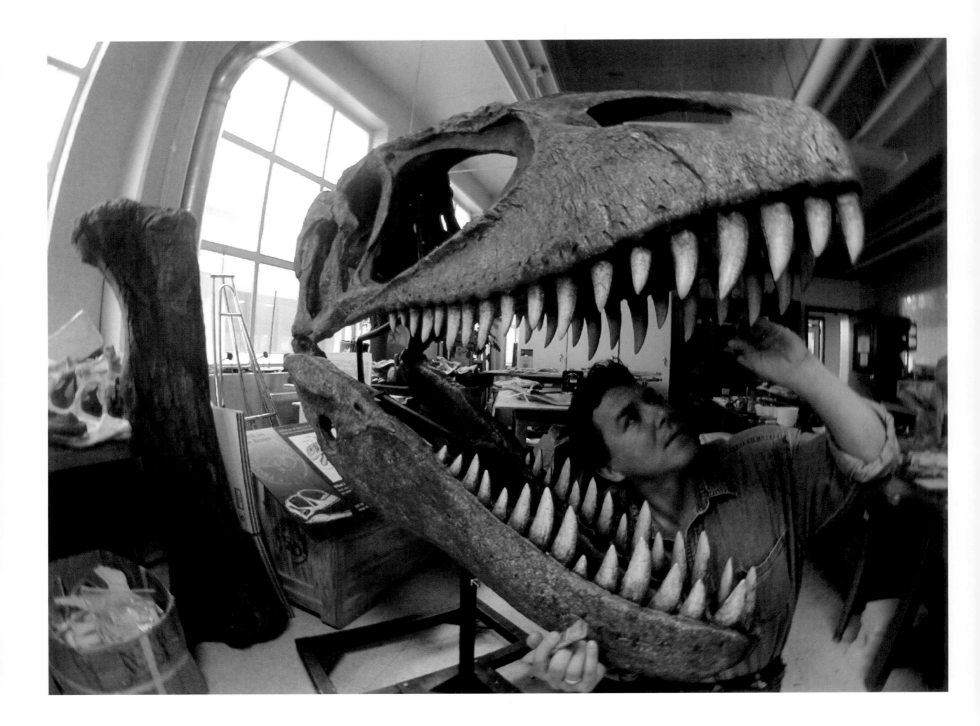

CHICAGO
Dino-floss: In his lab, Dr. Paul Sereno, University of Chicago professor and top dinosaur hunter, cleans the teeth of a 90-million-year-old *Charcharodontosaurus* (shark-toothed lizard). He found the 5′4″ skull of this jumbo version of *Tyrannosaurus rex* in the Sahara in 1995.
Photo by Michael Hettwer

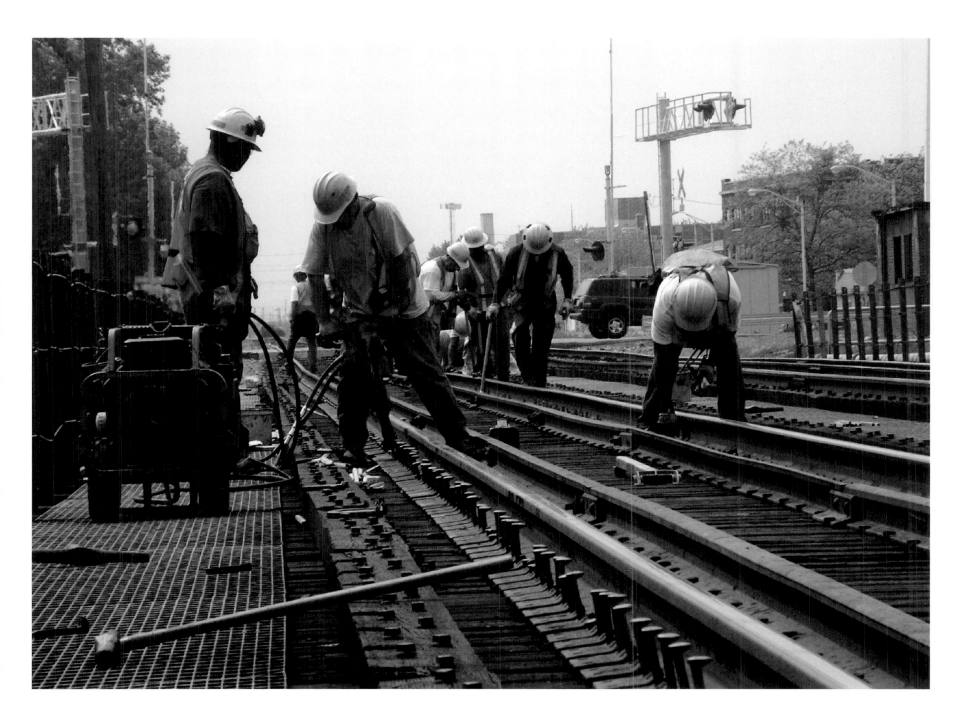

RIVER FOREST

For a smoother ride, a Union Pacific Commuter Operations crew levels the tracks on a bridge spanning the Des Plaines River. After realigning the rails, which are used by the Metra regional commuter system, the crew plugs old spike holes in the railroad ties with wood dowels.

Photo by Adam Ford

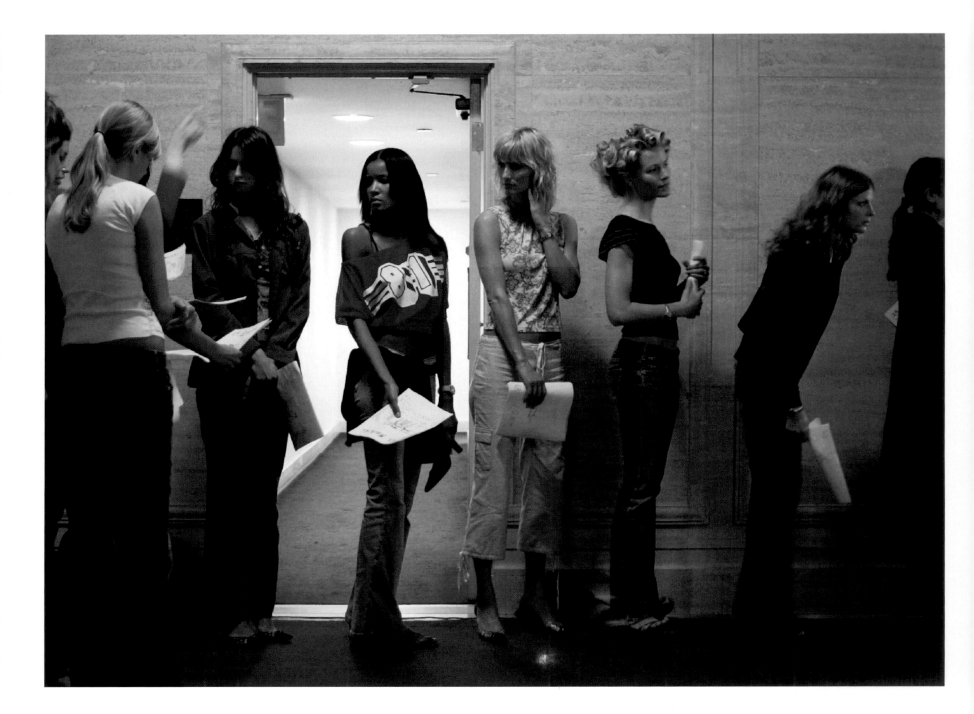

CHICAGO

At the Lyric Opera House, runway models receive their assignments for an Oscar de la Renta fashion show later that evening. Competition for this event was fierce—only one out of every 35 applicants was selected.

Photos by Tim Klein

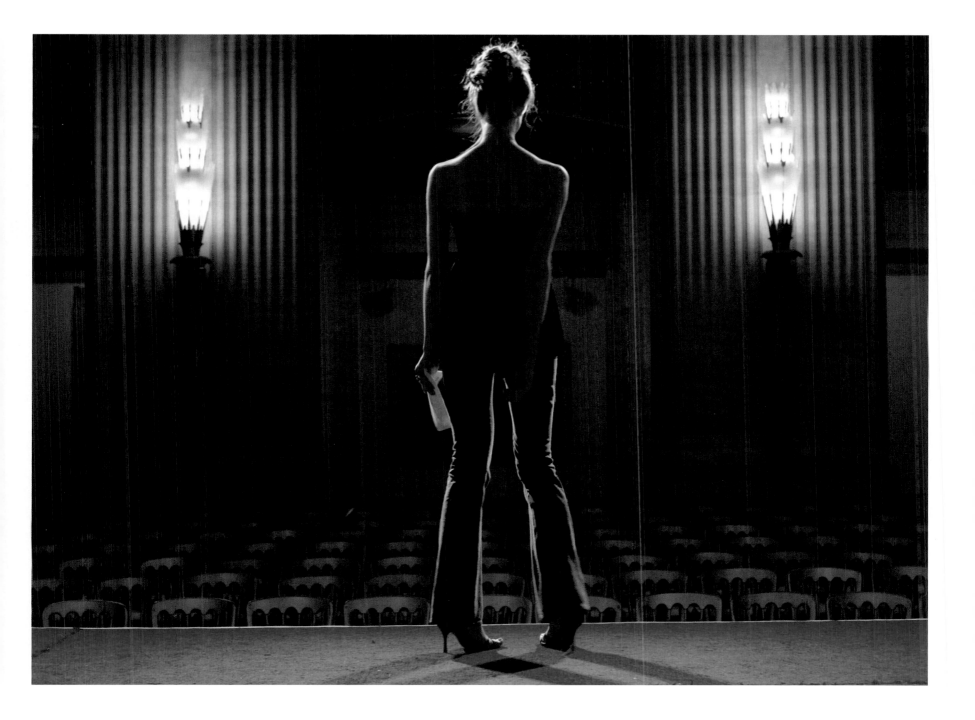

CHICAGO
Model Amy Suhay takes center stage during the final rehearsal for the evening's fashion show, which stars Oscar de la Renta's couture collection.

LEMONT

Leadman Michael Blaske, 22, ties up a barge carrying steel on the Chicago Sanitary and Ship Canal, which flows from the city of Lockport. A fifth-generation river man, Blaske spends his 12-hour workday checking the engine room, training deckhands, and "laying wires" that are used to secure barges together for their trip downriver.
Photo by Robert A. Davis, Chicago Sun-Times

PEORIA

George Manias, 72, has been shining shoes and steaming hats in downtown Peoria since 1946. Across the street from Caterpillar headquarters and the county courthouse, his shop, with its scattered *Playboys* among the reading material, is like a gentlemen's club. But business is down. "People wear cheap shoes," the Peoria native says. "They're not even made of leather...they're throwaway shoes."
Photo by Fred Zwicky

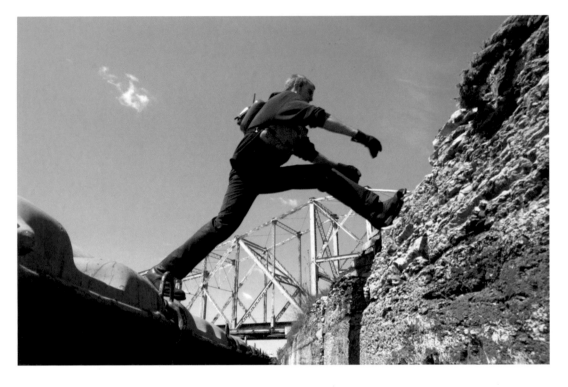

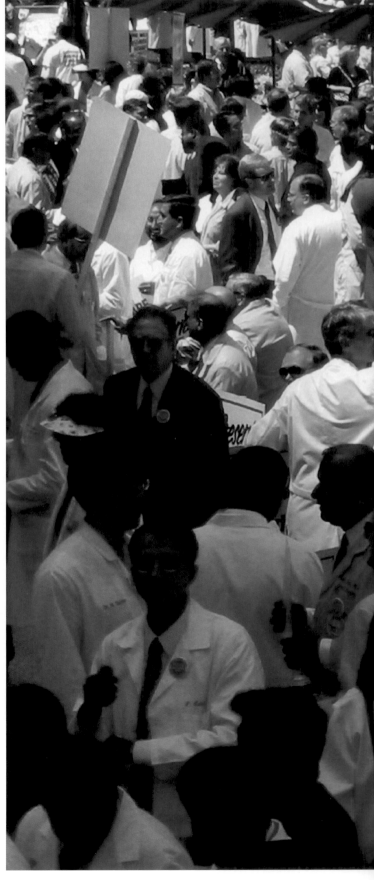

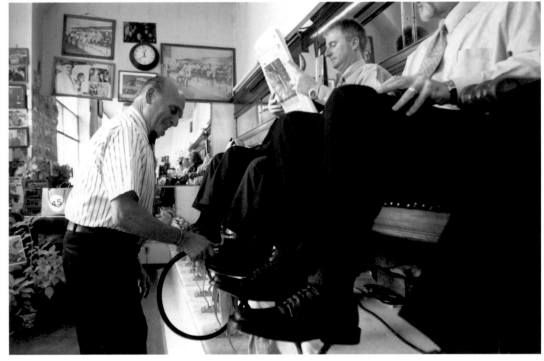

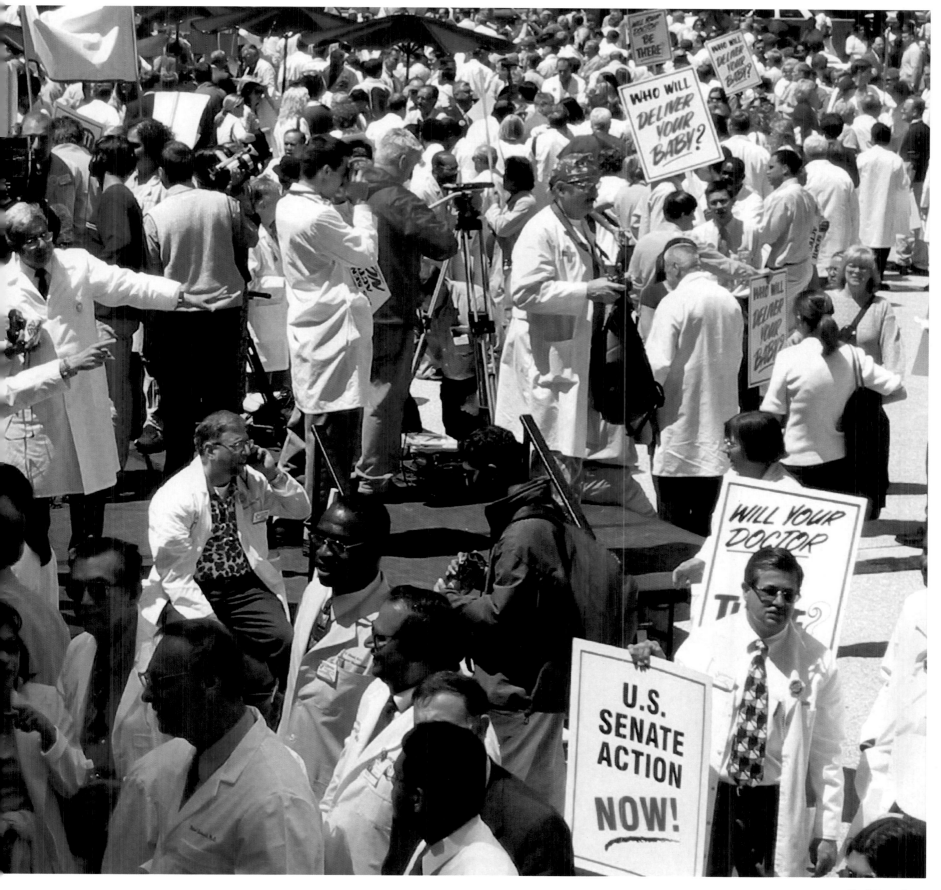

CHICAGO

Four thousand physicians and staff rally in Daley Plaza for federal medical liability reform. Illinois is one of 18 states identified by the AMA to be in crisis. Skyrocketing premiums force physicians to limit services, retire early, or move to states with regulated premiums. The Health and Human Services Department estimates that liability lawsuits add $100 billion to health care costs each year.

Photo by Brett D. Hawthorne

JACKSONVILLE

At Jones Meat & Locker, livestock walk in and neatly wrapped steaks and bacon walk out. On the "kill floor," Jeremy Stewart delivers a bacteria-killing hot rinse. Sixty years ago, small meat processing plants flourished across Illinois, but consolidation and tougher federal hygiene standards imposed in 1967 forced most to close. The Jones family now purveys only locally produced meat.

Photo by Steve Warmowski,
Jacksonville Journal-Courier

CHICAGO

The potato and cheese pierogi at Kasia's Deli is the shop's most popular version of the traditional Polish comfort food, followed by the meat-filled pierogi. Chicago's Polish population is outnumbered only by Warsaw's. Kasia's purveys about a half-million retail and wholesale pierogi every week.

Photo by Denise Keim

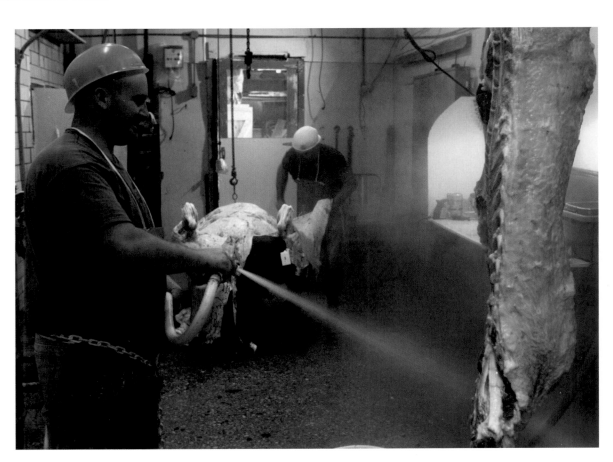

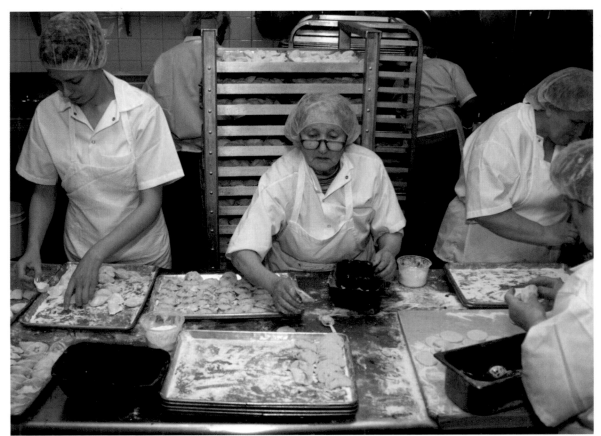

HARVARD

Kirk Meyer, 16, collects eggs on the Dietz family farm. The eggs are sold to local restaurants, as well as anyone who stops by the self-service, honor-system fridge in front of the barn. The price? $1 for 12 large white, $1.25 for 12 large brown.

Photo by Greg Hess

EAST ST. LOUIS

In East St. Louis, where the median household income is $21,324, a bargain is prized. From a State Street vacant lot, Buck Wild peddles "rough fish" such as buffalo fish—a type of carp—and catfish. Passersby can buy a six-pounder for a mere $5.

Photo by Teak Phillips

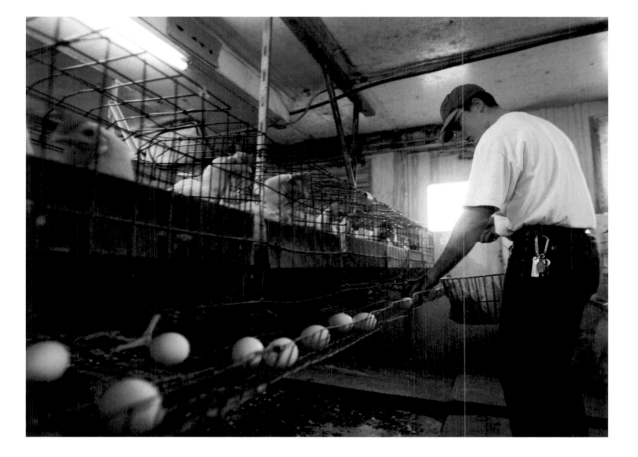

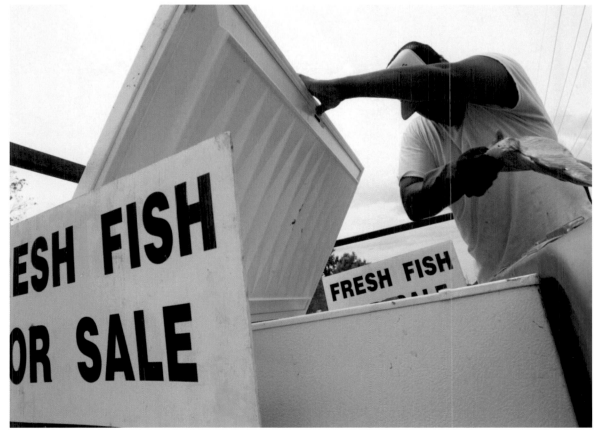

LEMONT

Each week, Illinois Marine Towing barges distribute about 210,000 tons of bulk commodities—such as salt, grain, and gasoline—along the Chicago Sanitary and Ship Canal between Chicago and Lemont, 25 miles southwest of the city. Barge pilot Dale Thomas keeps his eyes peeled for objects in the narrow waterway.
Photo by Robert A. Davis, Chicago Sun-Times

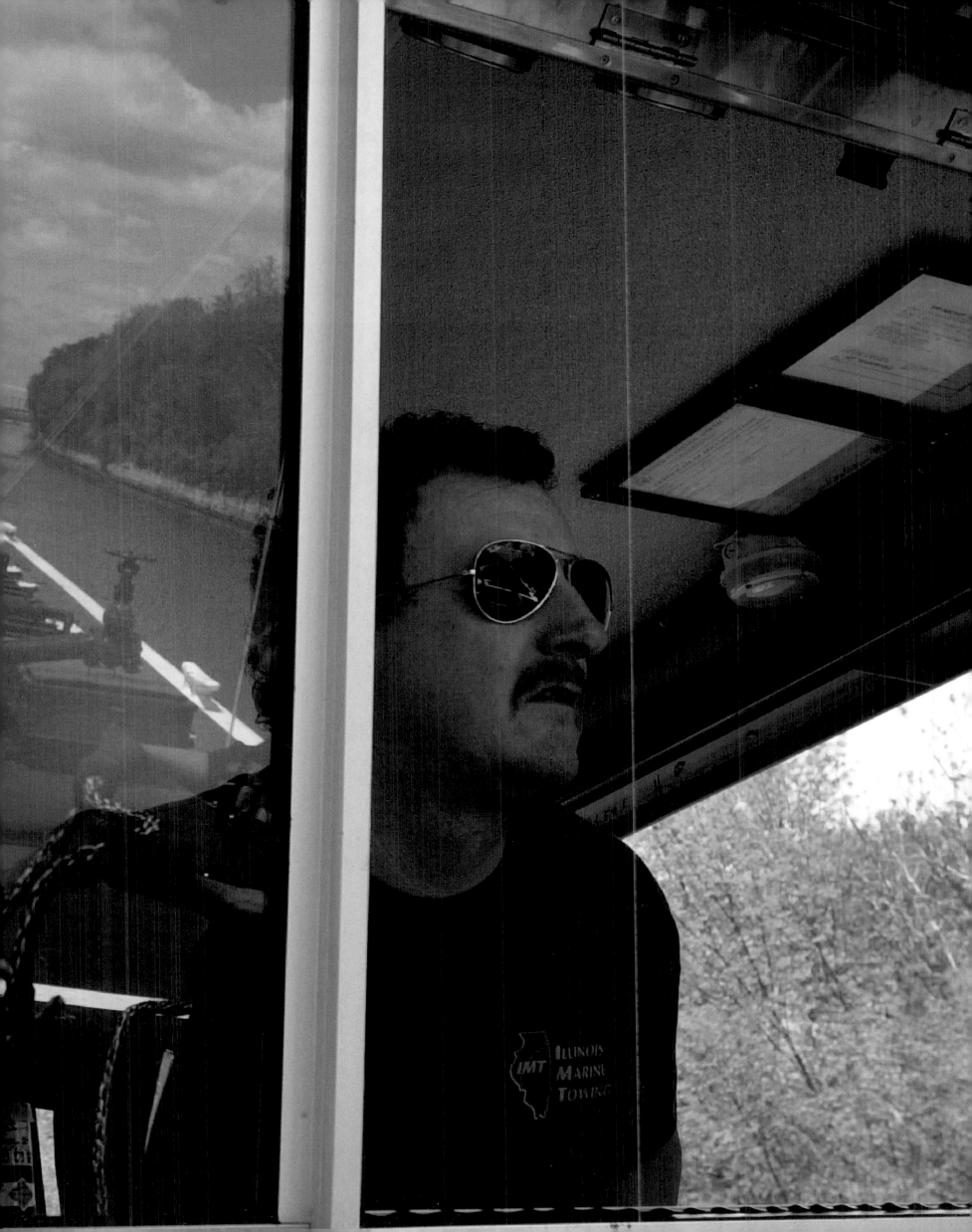

CHICAGO
Founded in 1879, the A. Finkl & Sons steel mill thrived when others failed by focusing on high-quality steel used in products such as fighter plane parts. One hundred percent of the privately owned company's steel is manufactured in Chicago. Illinois currently ranks third in the nation in steel production.
Photos by Michael Hettwer

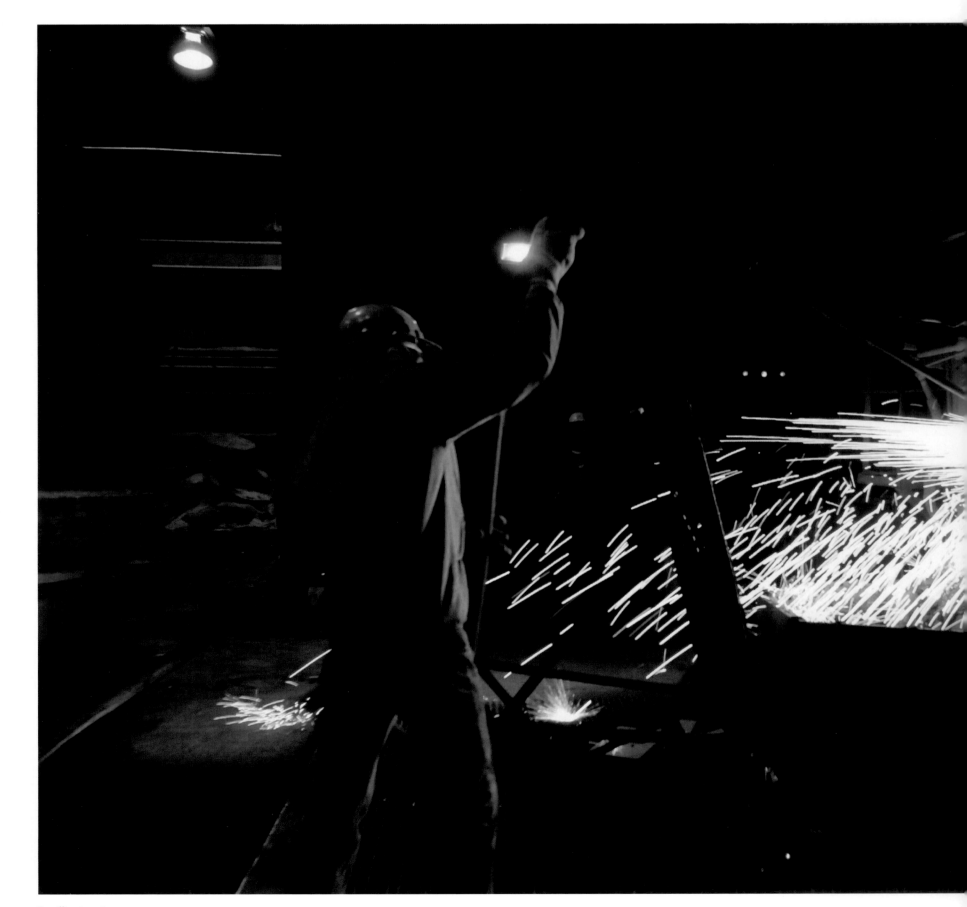

CHICAGO

After purification, the steel is brought to a gas furnace and heated to a temperature of 2,200 degrees Fahrenheit. After being removed from the furnace, the steel will be squeezed by a 6,000-pound press to strengthen it for customers such as Boeing.

CHICAGO

Workers pour 70 tons of molten steel into a ladle for transport to a vacuum that rids it of impurities. The Finkl mill produces more than 100,000 tons of steel each year. To help offset the carbon dioxide produced at the mill, the company planted more than two million trees in Illinois and Wisconsin forests.

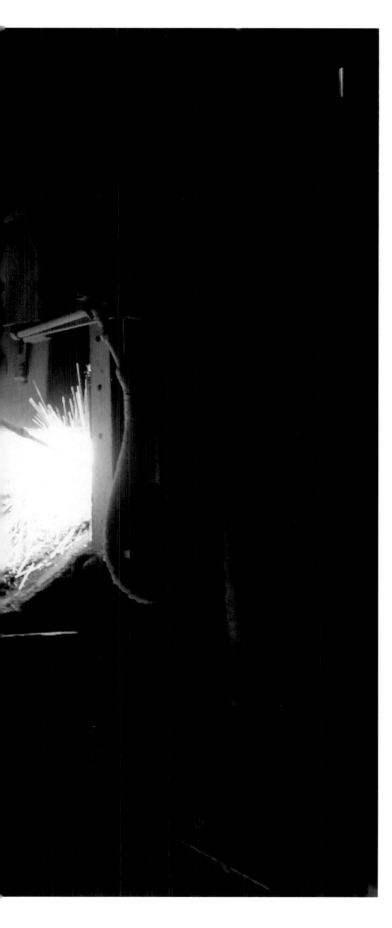

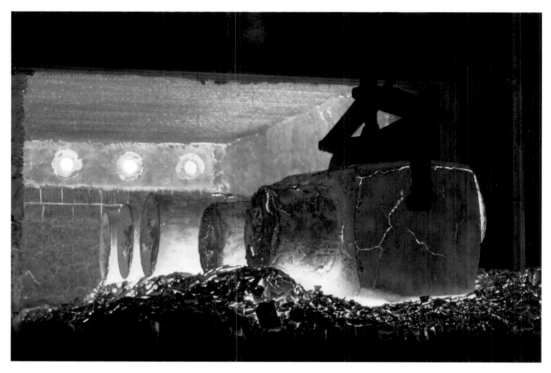

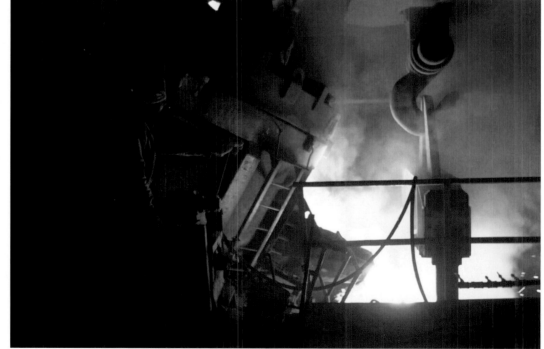

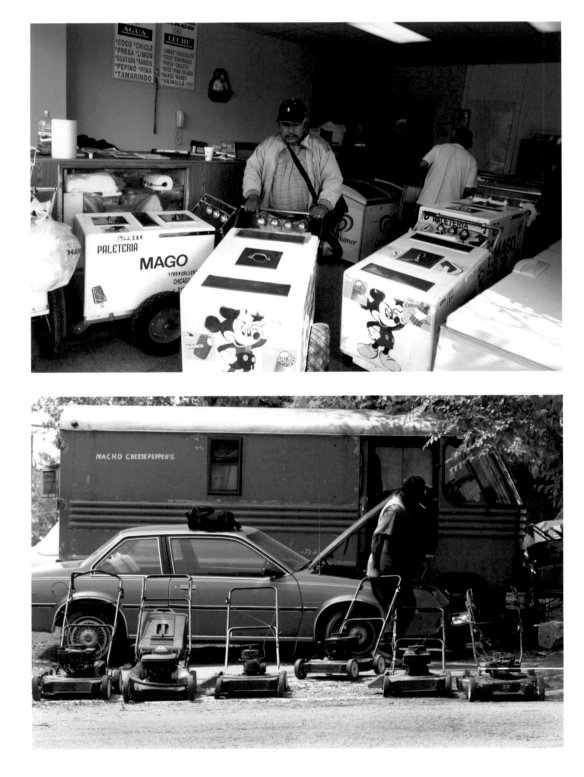

CHICAGO

From April to October, Ricardo Garcia, a 53-year-old ice cream vendor, pushes his cart filled with Paleteria Mago's homemade *paletas* (ice cream popsicles) around Pilsen. He covers about five miles a day.

Photo by Troy T. Heinzeroth

CHICAGO

Oscar Anderson makes a living fixing cars, lawn mowers, and televisions. His dream is to make enough money "to open me a big old shop one day." Anderson, who lives in the brown delivery truck, knows what it's like to be broken and then fixed. He's survived four heart attacks.

Photo by Teak Phillips

ROCK ISLAND

Chris Bode, funeral director at the Wheelan Funeral Home, tidies up the chapel for an afternoon viewing. "In other parts of the country, viewings are going out of favor, but not so much in the Midwest. It has to do with our traditional values," notes Bode, who studied at the Worsham College of Mortuary Science in Wheeling, Illinois.
Photo by Todd Mizener

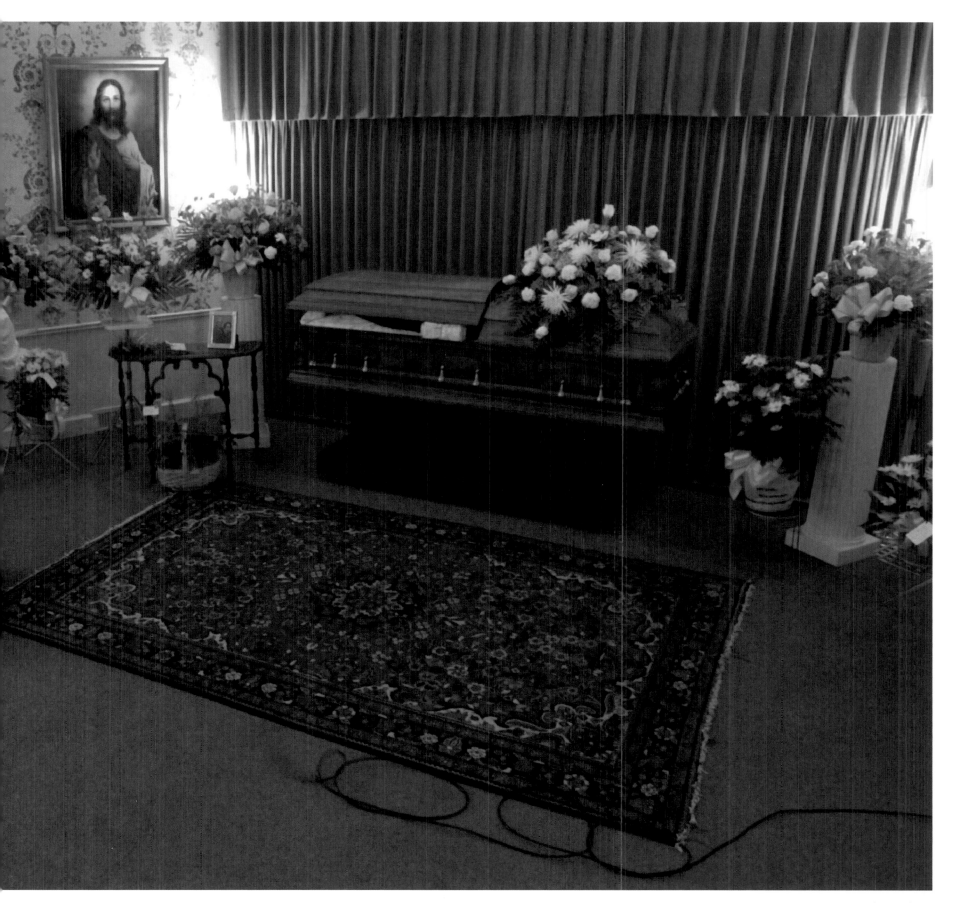

CHICAGO
An unexpected burst of spring weather brings
out the free spirit in Matt Schmidt, age 5.
Photo by Tim Klein

Illinois At Play

CHICAGO
Chris Otis gives golf lessons to folks like retired fireman Tom Driscoll seven days a week, 12 hours a day, April through October. Chicagoans aren't alone in their passion for playing the sticks: Americans spend a staggering 24 billion a year on golf.
Photo by Denise Keim

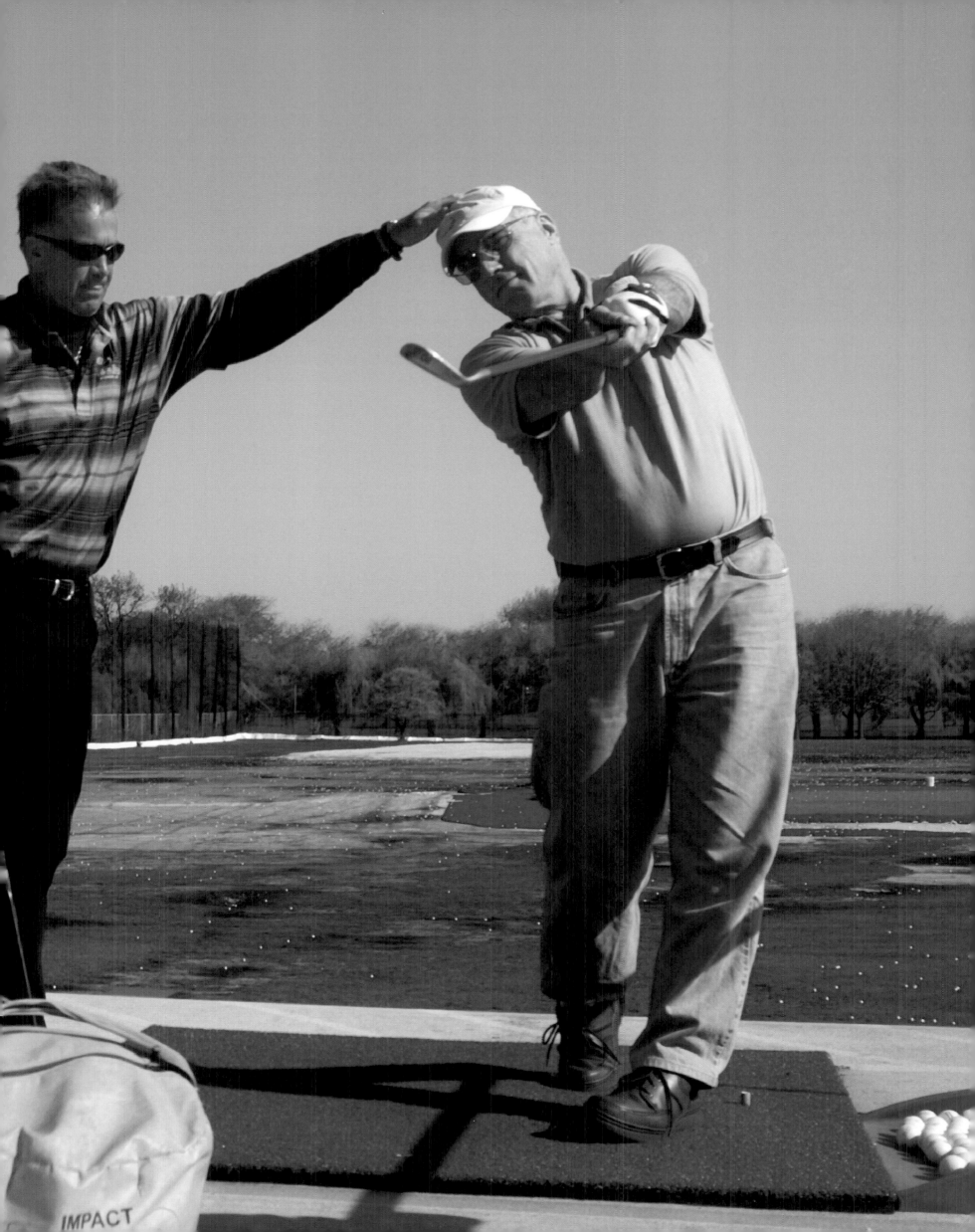

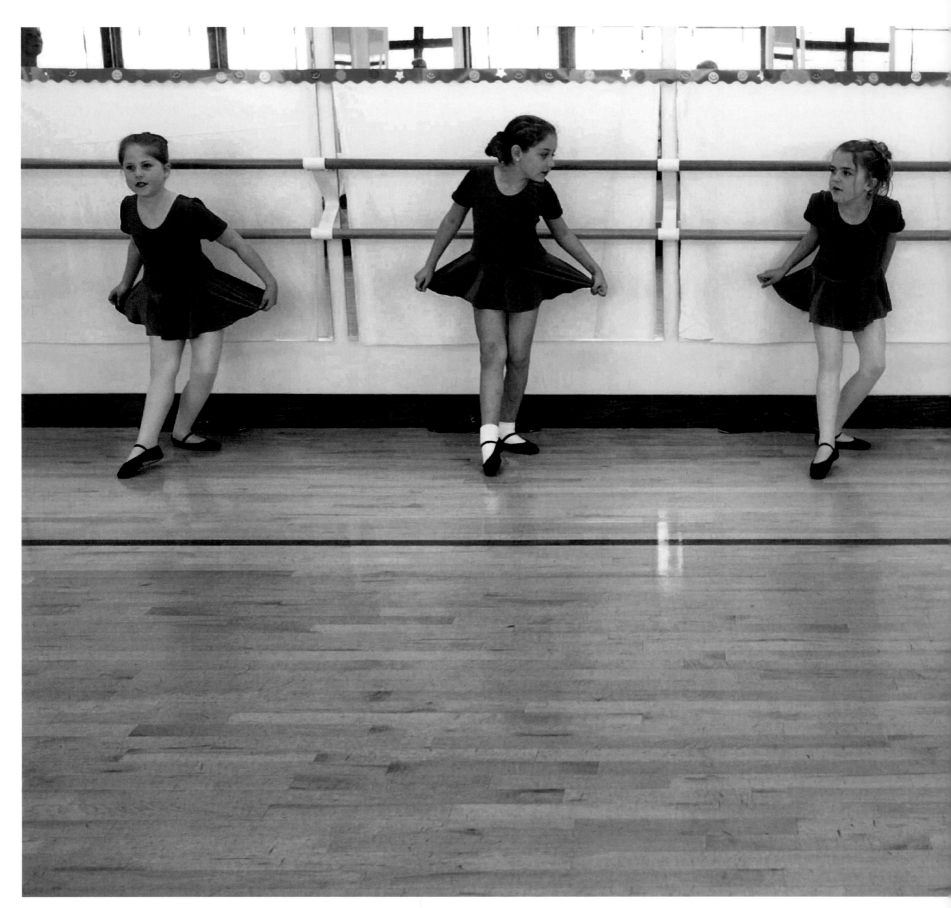

ALGONQUIN

Tiny dancers: Alexandra Kacena, Nicolette Mendicino, Maris Smith, and Alison Griffin practice curtsying at the Ballet Box, where they've all been taking classes for several years. The girls, all 8 years old, are in rehearsal for their upcoming recital called "The Circus."

Photos by Greg Hess

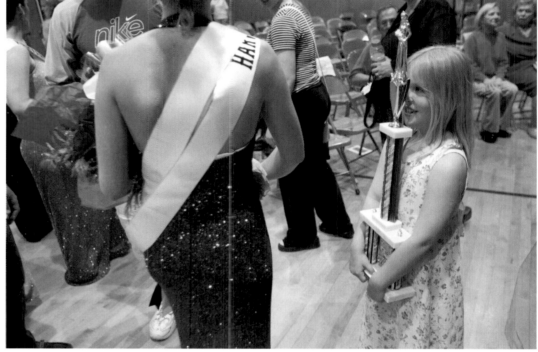

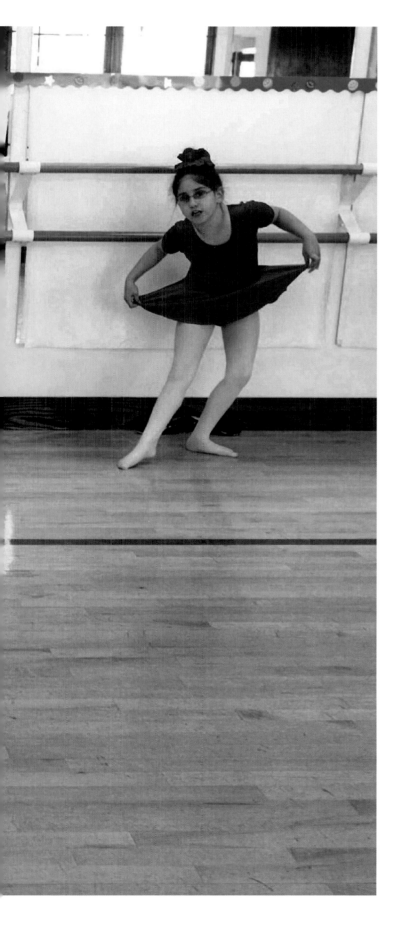

HARVARD

Grace Iftner, 8, holds a trophy for older sister Clarisse, 18, who was chosen Milk Day Queen for the Harvard Milk Days Pageant. Started in 1942 as a tribute to dairy farmers, the three-day event includes a beauty contest, talent show, and tractor pull.

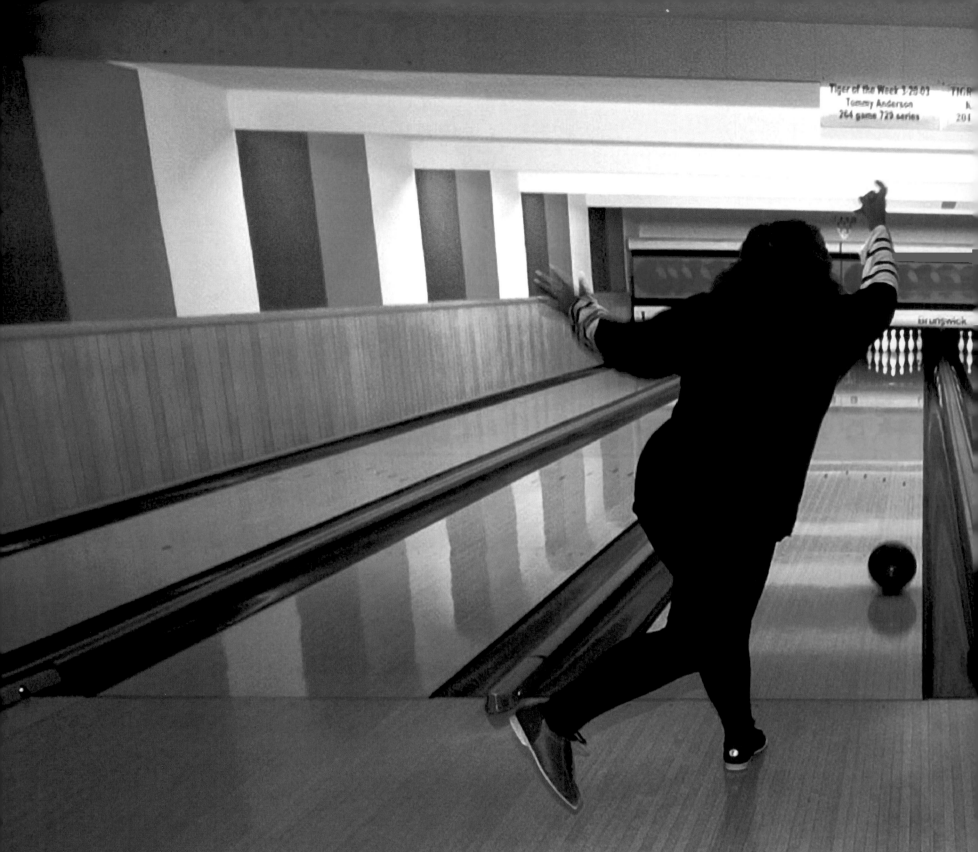

Tiger of the Week 3-20-03
Tommy Anderson
264 game 729 series

OTTAWA
Six lanes, no waiting: While it's quiet at
the moment, Caretto's Bar and Bowling
is hopping during league season (August
through May). Deb English, 1994 Bowler of
the Year, is fond of the 50-year-old lanes,
where scores are still kept manually.
Photo by Tom Sistak

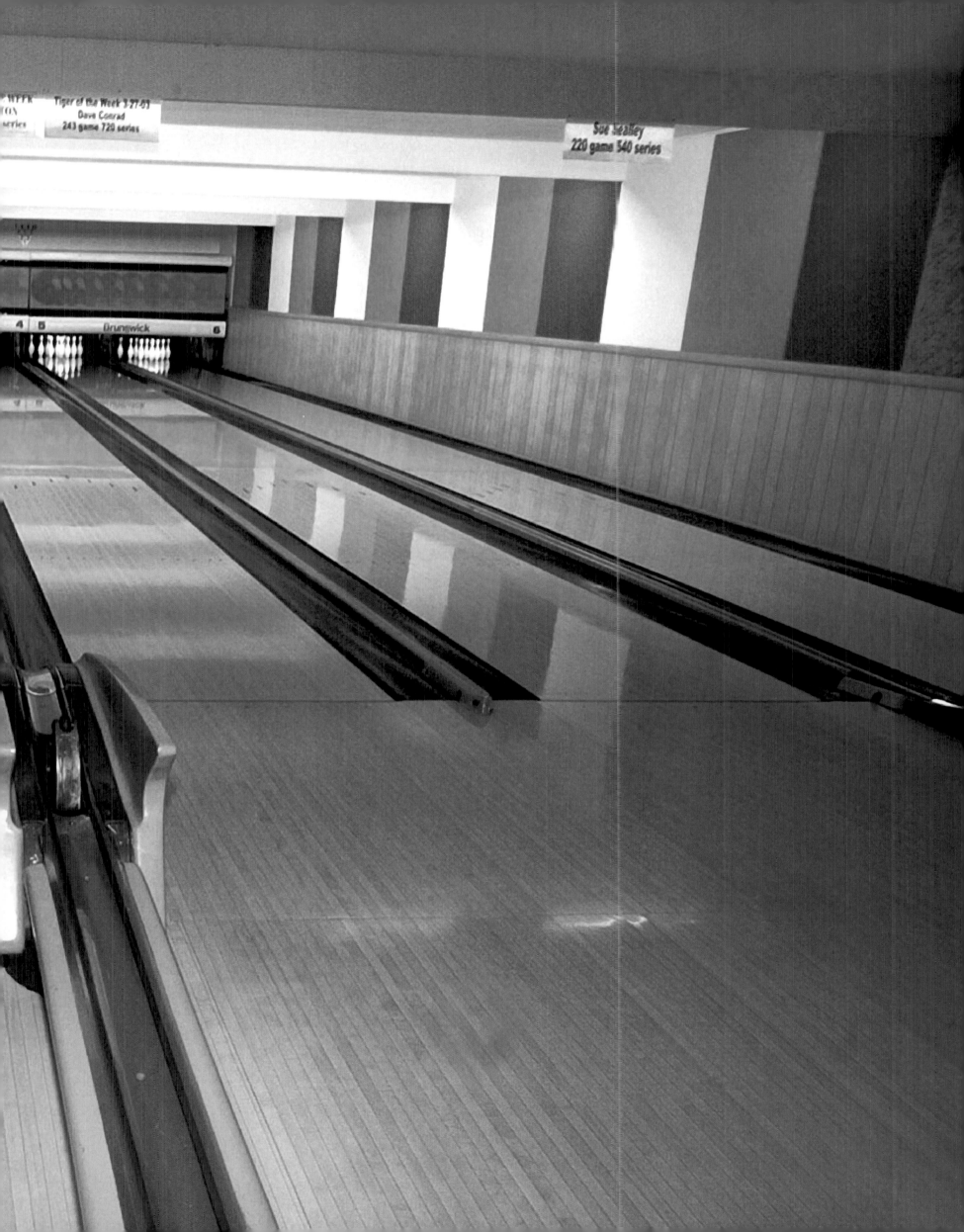

CHICAGO
Drawbridges along the Chicago River salute as a flotilla of sailboats, freed from winter storage, head out to marinas in Lake Michigan. More than 60,000 pleasure craft, roughly half of them sailboats, participate in the annual migration.
Photo by David M. Solzman

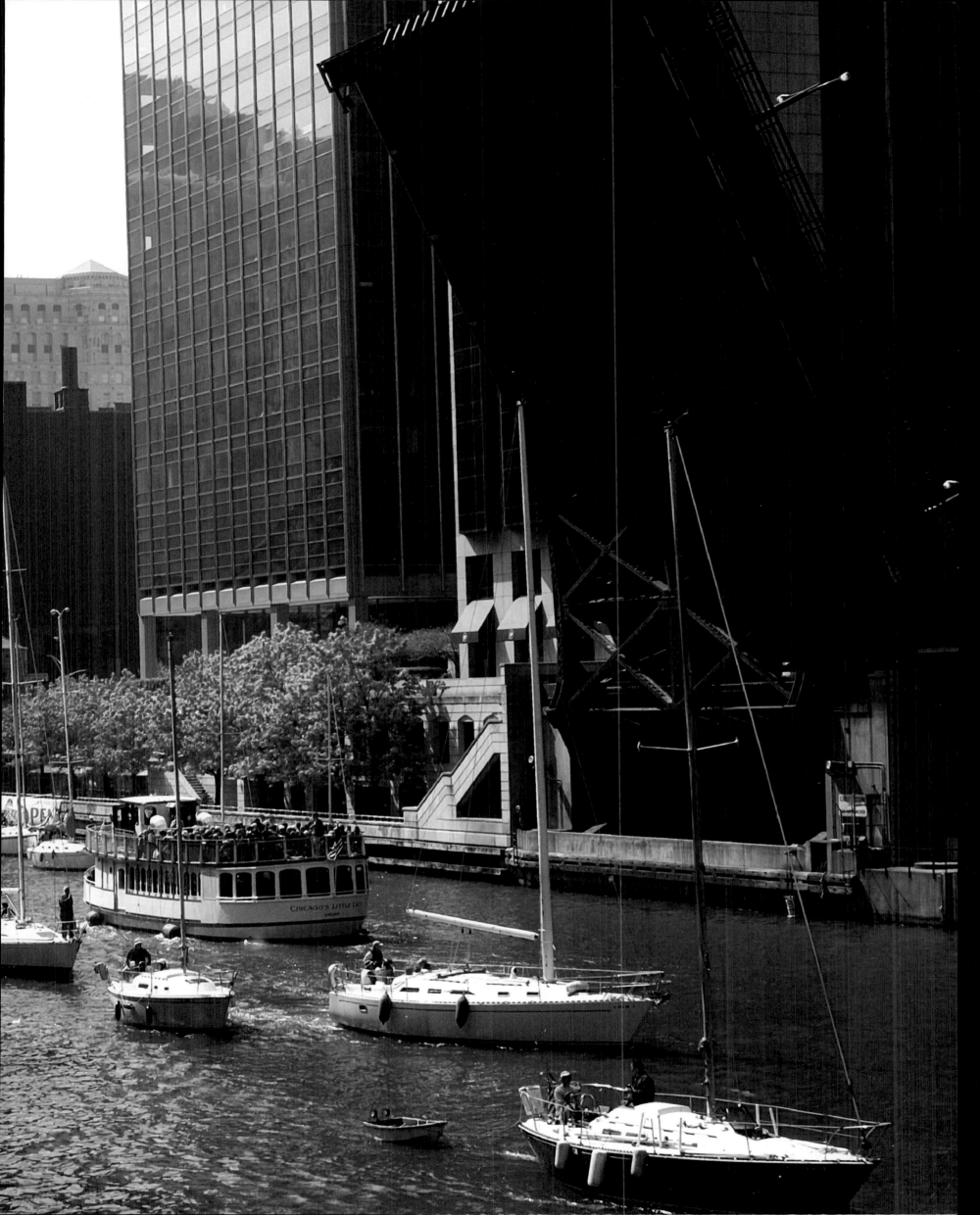

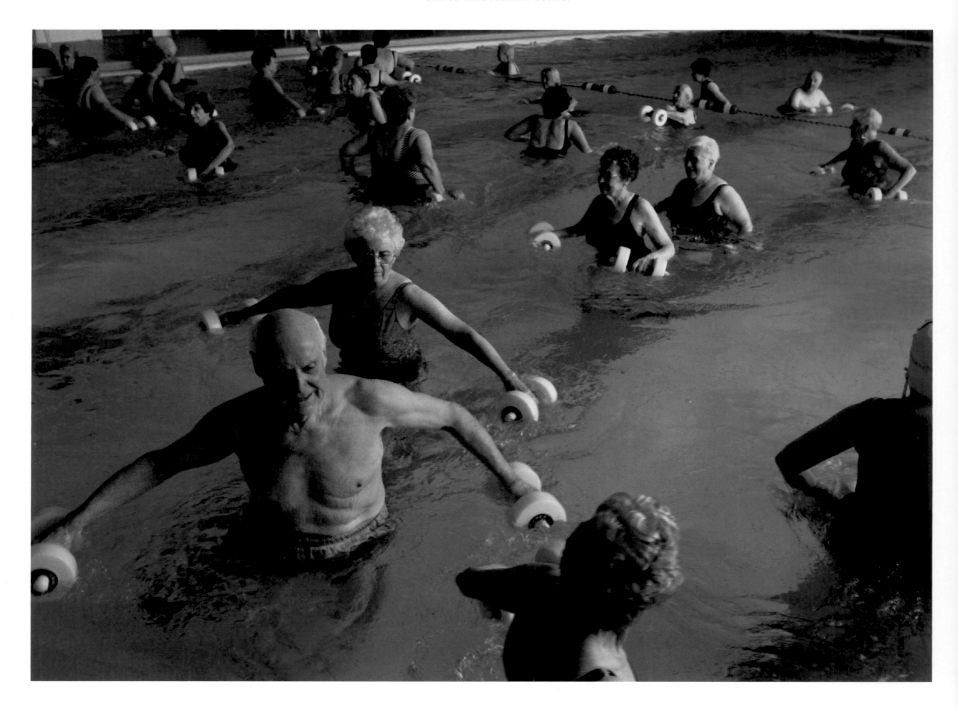

JACKSONVILLE

Every Monday, Wednesday, and Friday at the Sherwood Eddy Memorial YMCA, 83-year-old Anita Hardin (with her back to the lane line, holding one water barbell) teaches a water aerobics class. Not bad for someone who first took the class 20 years ago when she didn't know how to swim. Eventually, she became an instructor and built a loyal following.

Photos by Steve Warmowski,
Jacksonville Journal-Courier

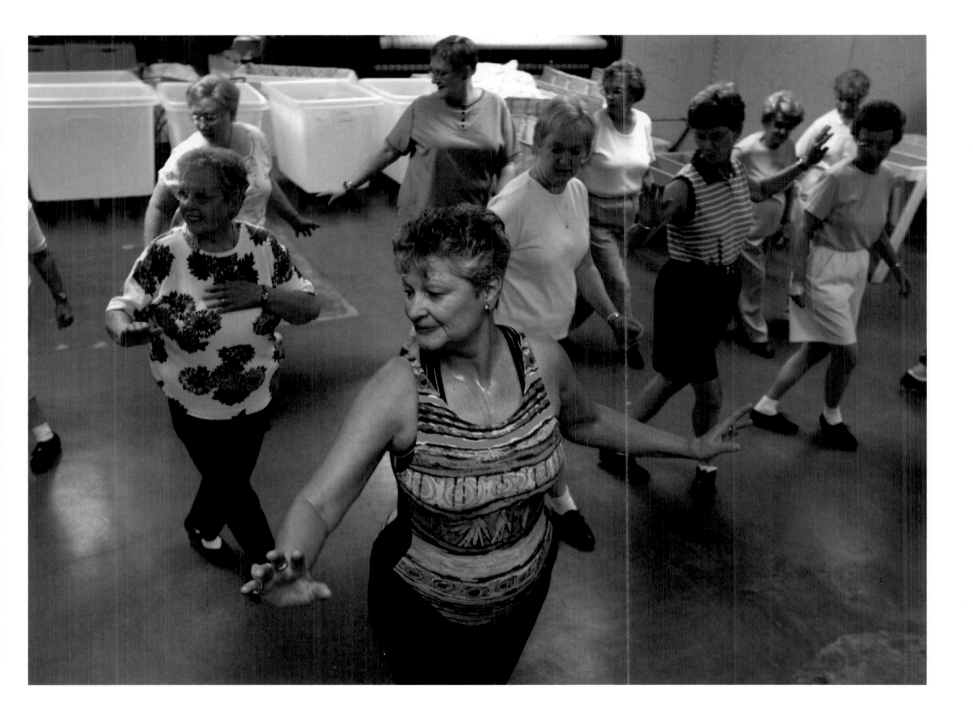

JACKSONVILLE

Rockette science: The Passavant Tappers keep in tip-tap shape by practicing every Wednesday. Comprised of 15 Passavant Area Hospital auxiliary volunteers, the group performs at nursing homes and for fundraisers. All but five are over 70, and all are female. "We'd love to have men," says Sandy Crowe, the group's leader. "But they haven't come around."

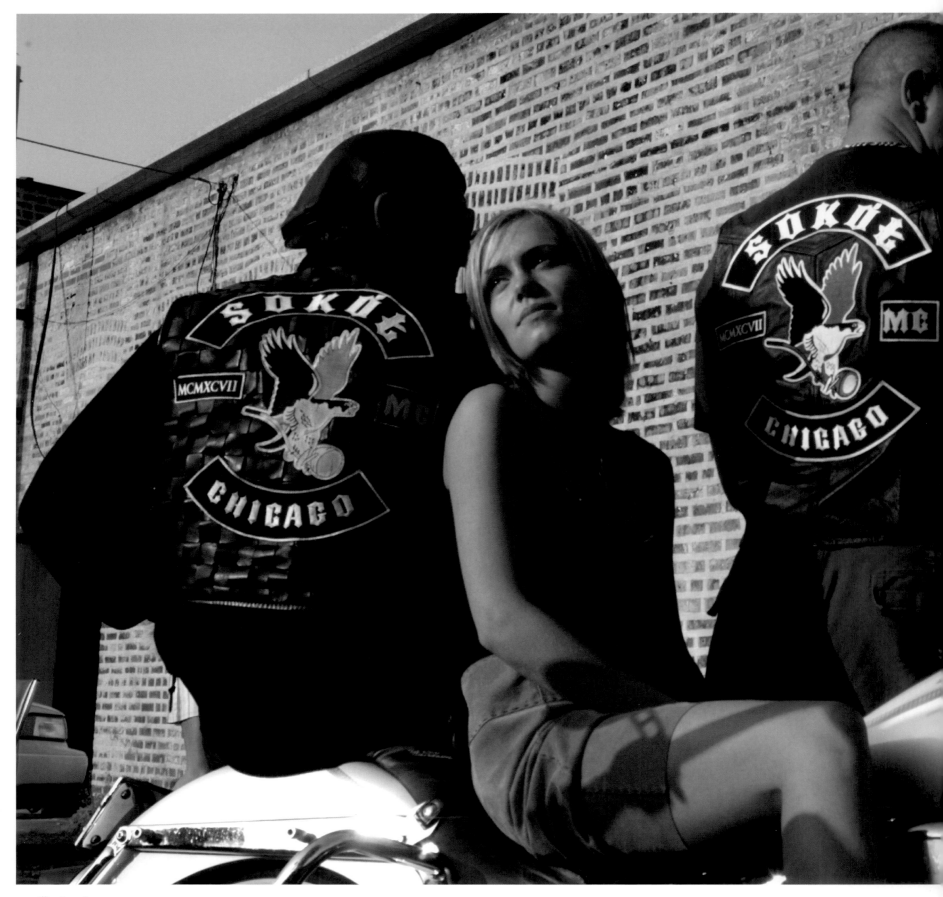

CHICAGO
Outside their clubhouse on North Cicero Street, Sokol Club members Eric Wojtaszek, Edyta Rak, and Wesley Plazinski show off their colors. In communist Poland, motorcycles were the only affordable way to get around, so in Chicago there's a lively Polish motorcycle scene. "A lot of our people have mototcycles in their hearts," says Maggie Huk, the coed club's founder and president.
Photos by Denise Keim

CHICAGO

If Bobby Vinton is the Polish Prince, then Jarek Spuchalski could be the Polish King. The Elvis impersonator, formerly an opera singer in Poland who immigrated 14 years ago, rocked the Sokol Club with 20 classic tunes. How good is he? "When I sing as Elvis, people think I'm lip-synching," says Spuchalski.

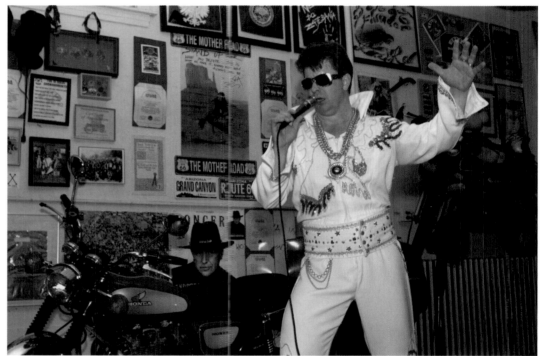

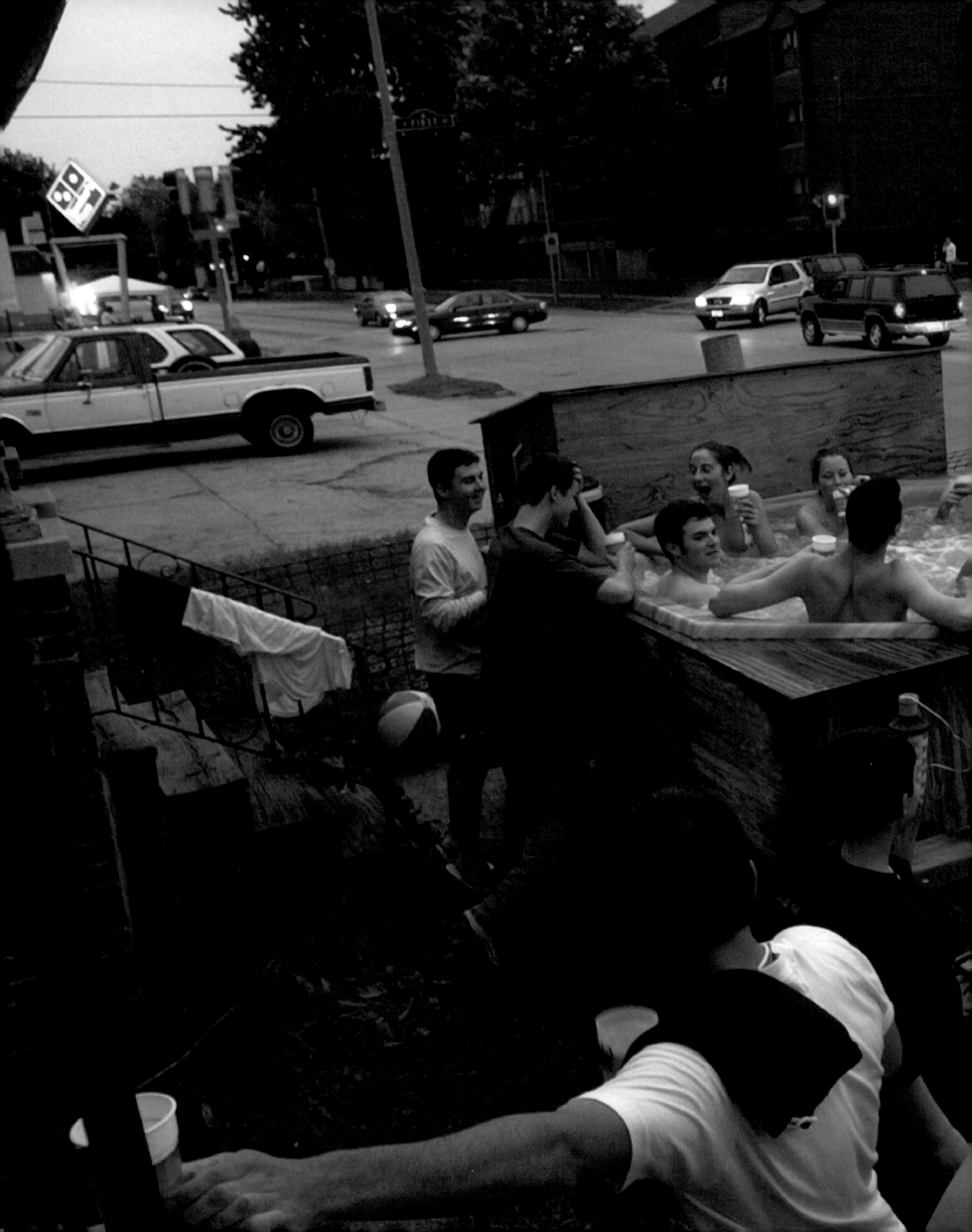

CHAMPAIGN
You're soaking in it! To honor their graduation from the University of Illinois at Urbana-Champaign earlier that day, a group of brand-new degree holders gather at a house party complete with a rented whirlpool on wheels.
Photo by Scott Strazzante, Chicago Tribune

CHICAGO

Most of the students on a field trip to the Art Institute of Chicago learn about the pointillist technique in painting via close inspection of Parisian painter Georges Seurat's masterpiece, *A Sunday Afternoon on the Island of La Grande Jatte* (1884–1886).

Photo by Tim Klein

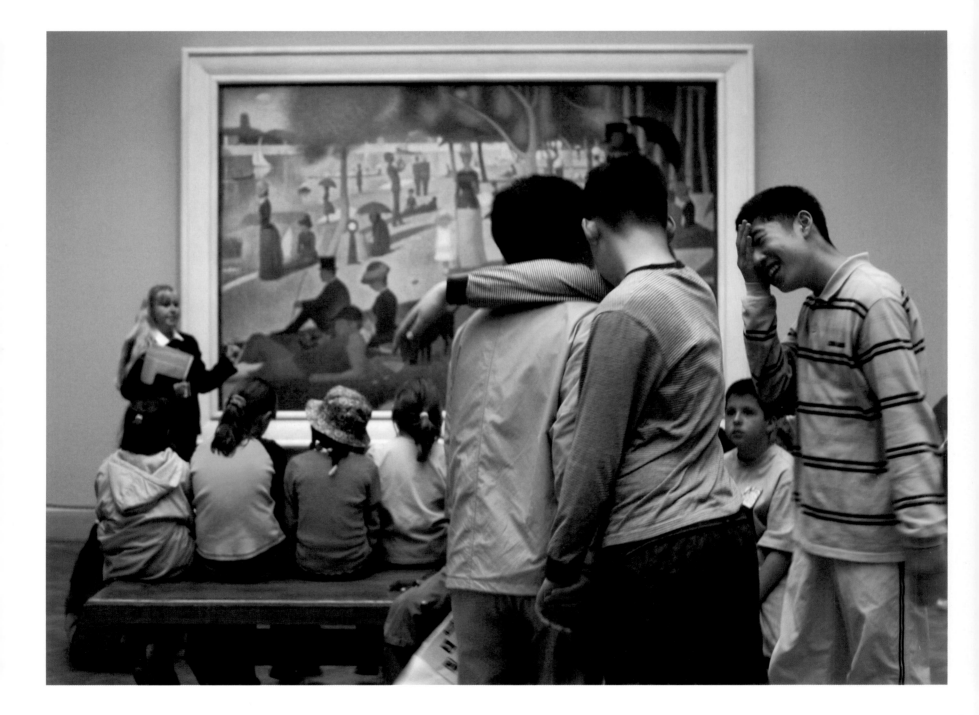

LAKE FOREST

Up since 5 a.m., Lake Forest College students and volunteers assist biology professor Caleb Gordon (pointing) track songbirds' migratory stopover patterns in the Shaw Woods. They use mist nets to catch, then measure and tag orioles, flycatchers, and warblers.

Photo by Joel N. Lerner

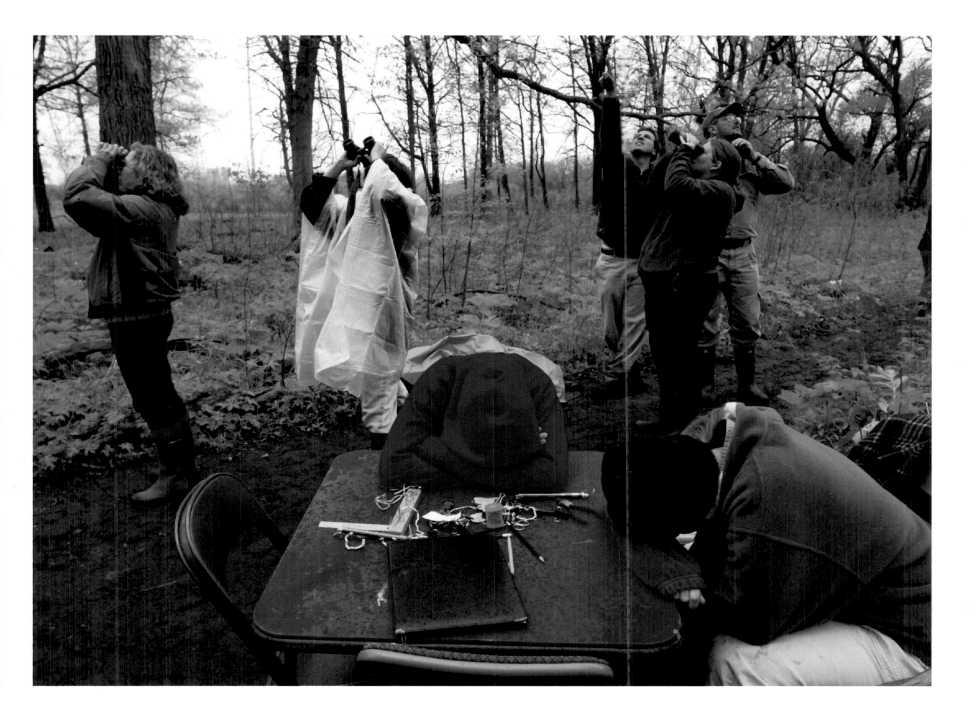

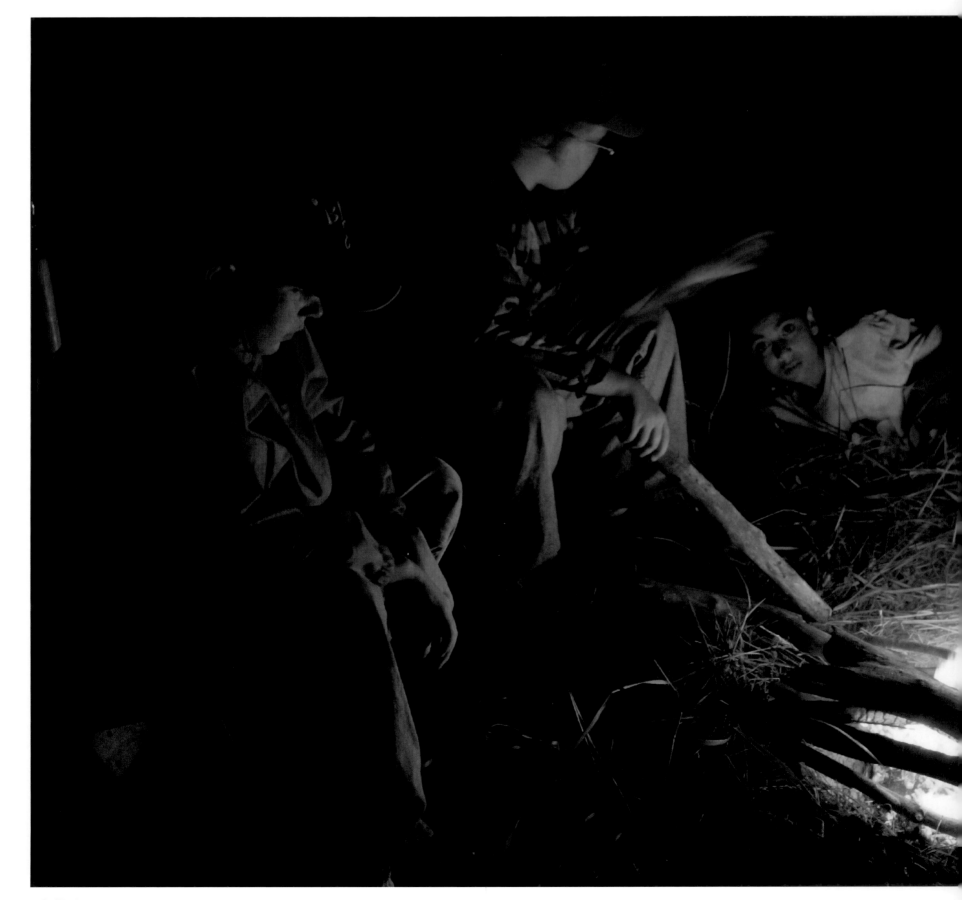

JACKSONVILLE
During a Troop 107 camporee on Lake Jacksonville, Kendell Pocklington, 12, explains his strategy for keeping the patrol fire burning. Eleven-year-olds Garrett Metz and Matt Simon listen—sort of.
Photos by Steve Warmowski,
Jacksonville Journal-Courier

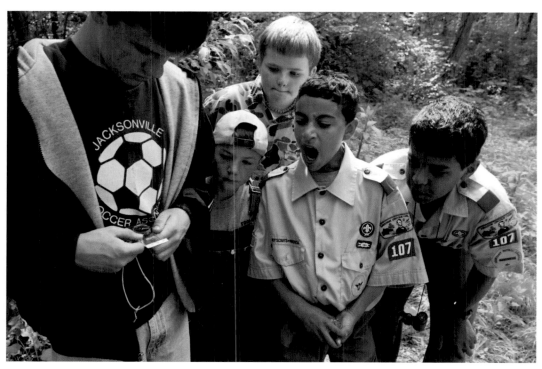

JACKSONVILLE
Billy Hollendonner, 16, teaches Dallas Lashmet, 13 (far right), and 11-year-olds Patrick Hubbert, Michael Stanley, and sleepyhead Matt Simon to orient themselves using a compass.

OTTAWA
Curveball: The Ottawa Phillies Little League
team hustles through batting practice as
storm clouds move in.
Photo by Tom Sistak

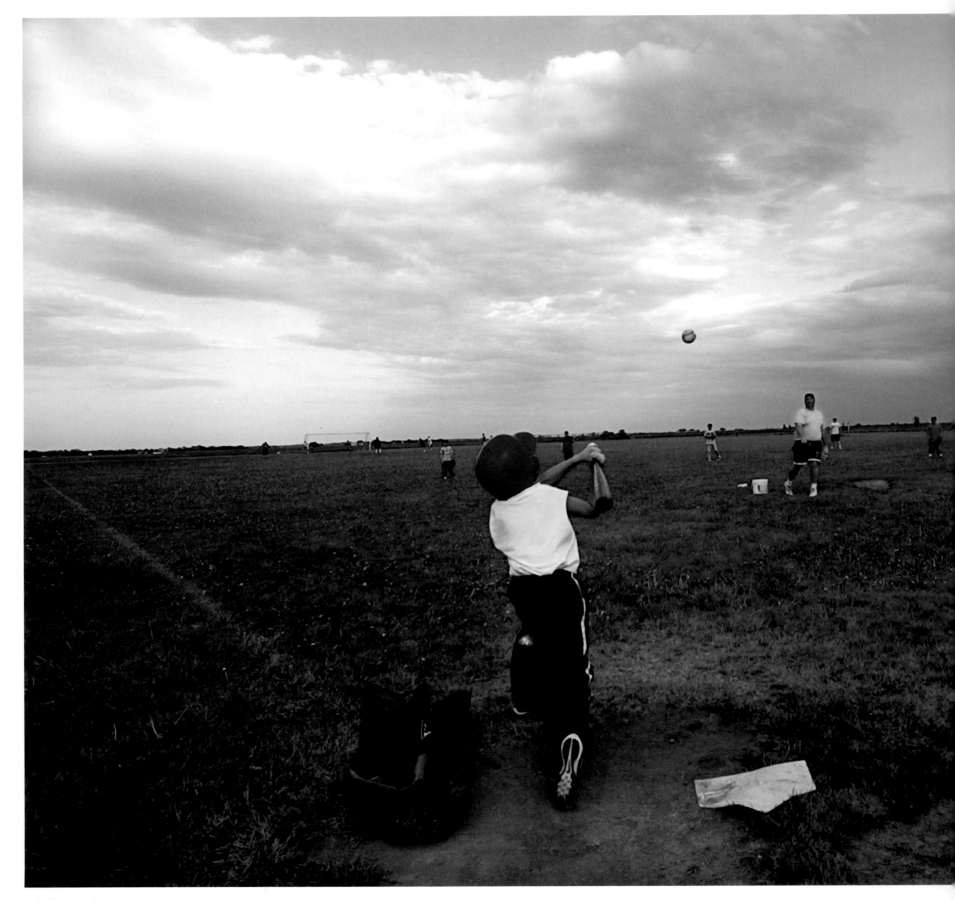

SPRINGFIELD

Striking out feels like the end of the world. Now slugger Roman Ballenger must wait for the eight batters that stand between him and a shot at redemption.

Photo by T.J. Salsman, The State Journal-Register

MOLINE

She's got game: Amber Bausch, 5, is all business at first base during a T-ball contest against Trophy World in Riverside Park. The die-hard White Sox fan is an infielder and catcher for Dutchway Dry Cleaners.

Photo by Todd Mizener

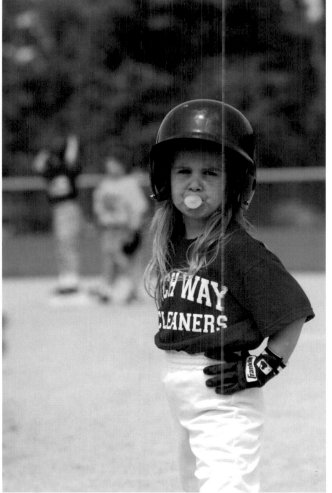

RICHMOND

Exercising their imaginations, as well as their muscles, Alex Britt and Doug Hurst, both 12, venture outdoors on a raft of their own construction. As dusk falls, only the promise of supper can pull them back indoors.
Photo by Greg Hess

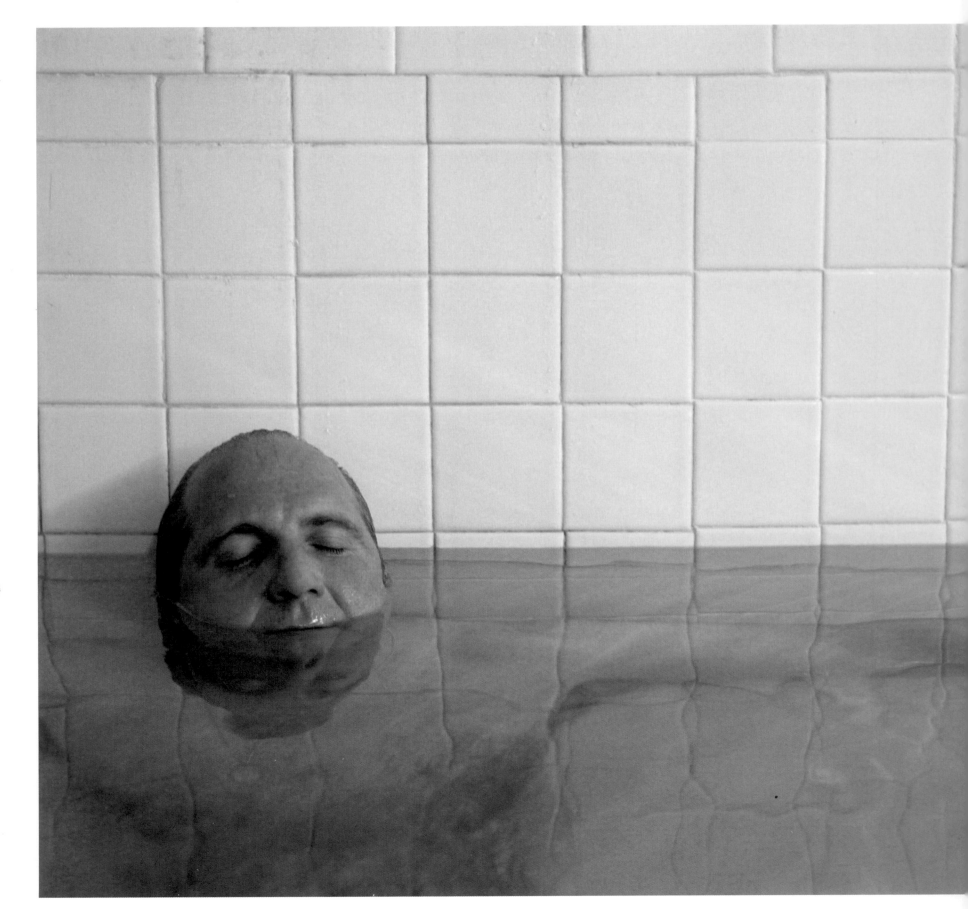

CHICAGO
Division Street Russian Bath regular Matthew Hopkins balances the blistering 150-degree heat of the steam baths with a dip in the 60-degree cooling tub. In 1906, when the Russian Bath opened, there were 50 bathhouses in Chicago. Today, it's the only one left.
Photo by Tim Klein

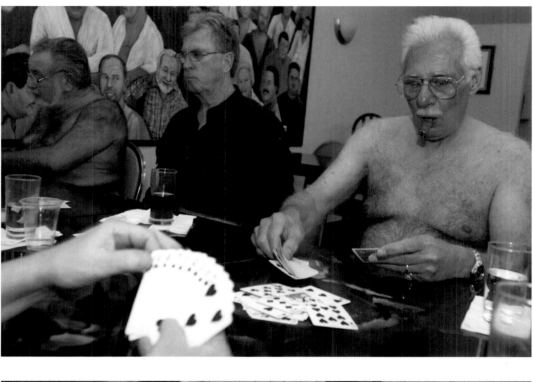

CHICAGO

No, Al Green of Morton Grove didn't lose his shirt playing gin rummy. His attire (or lack thereof) is entirely appropriate in the lounge at the Division Street Russian Bath.

Photos by Robert A. Davis, Chicago Sun-Times

CHICAGO

Dousing themselves with ice-cold water after taking a *schvitz* are Larry Smiley, 65, John Hurwith, 51, and Al Green, 64. The friends, who have a standing (or sitting) date for Wednesdays, have been coming to the baths for decades.

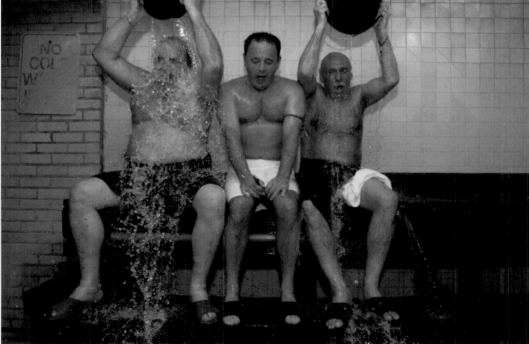

CHICAGO
Sometimes it's oak leaves, sometimes it's maple leaves. Sometimes it's seaweed. Regardless, "the broom" is an invigorating tradition that originated in the centuries-old Russian bath culture. Here in the Division Street Russian Bath, Al Green applies a seaweed broom to the back of John Hurwith as Larry Smiley patiently waits his turn.
Photo by Robert A. Davis, Chicago Sun-Times

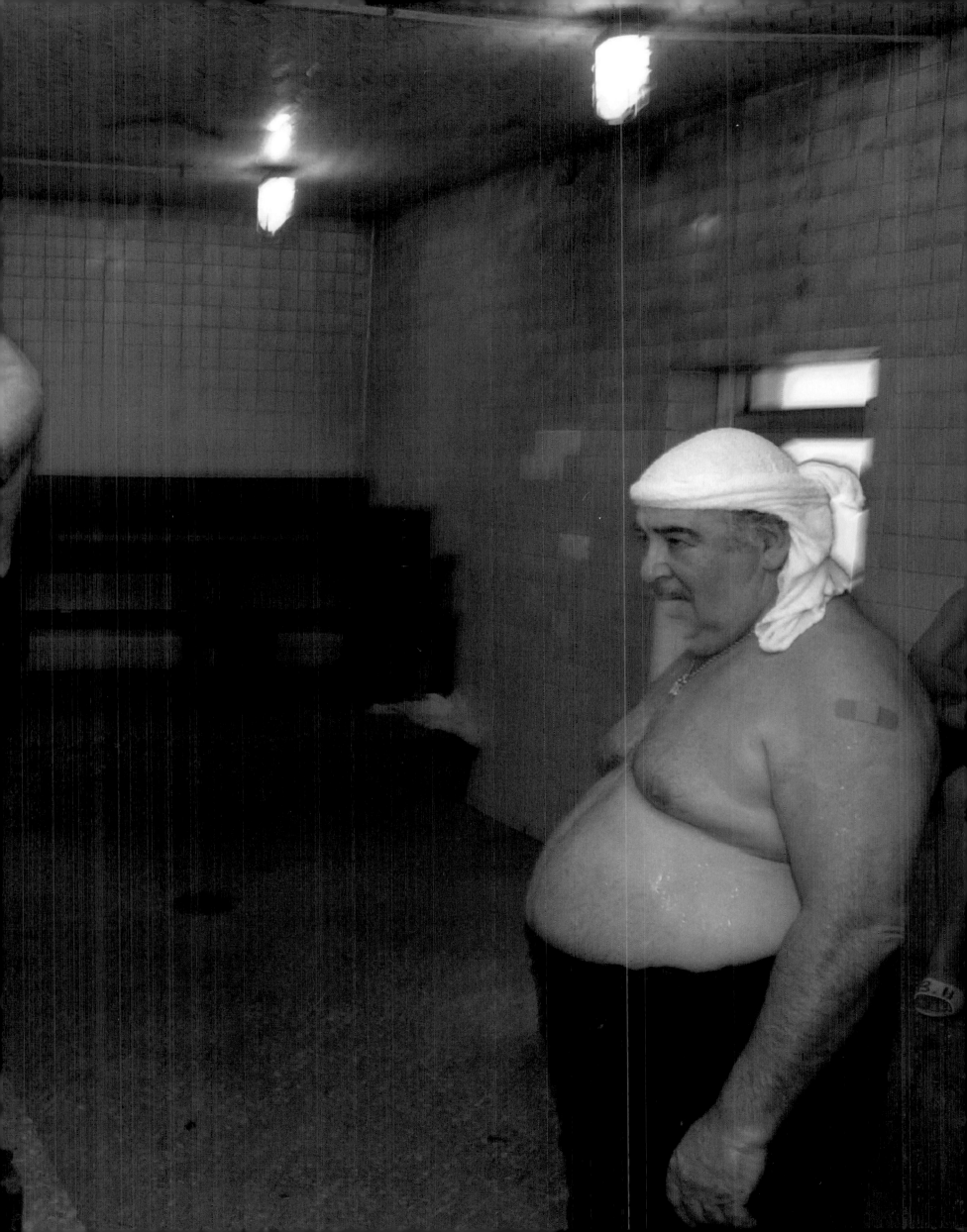

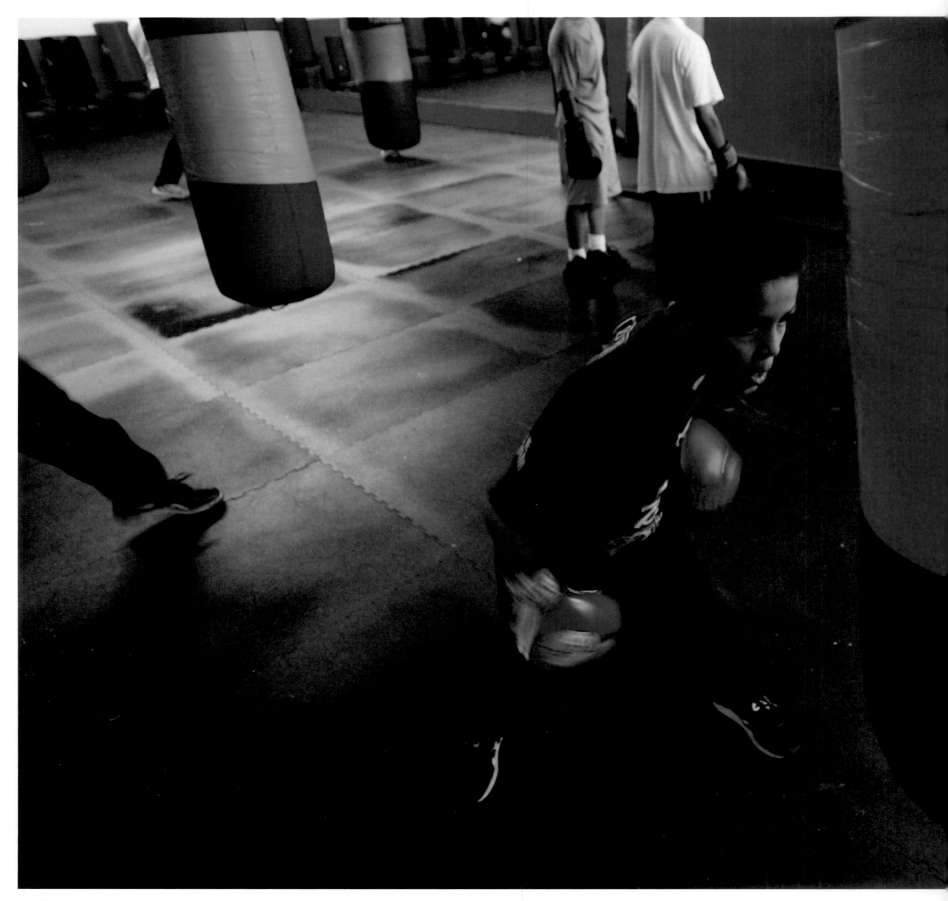

The next Oscar de la Hoya? According to Luis Baeza, 10, the answer is yes. He works the punching bag at Elgin Boxing Club during a two-hour practice. Luis says, "I do 150 percent. I want to go to the Nationals and the Olympics."
Photo by Greg Hess

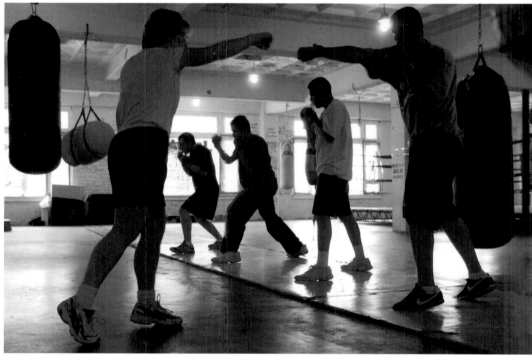

JOLIET

Carrie Marche (left) won the Chicago Golden Glove boxing championship in her division in 2000. Two years later, she had a tumor removed from her brain and quit competing. An attorney by day, Marche, 31, now volunteers at Jack's Gym in downtown Joliet. She coaches the 15 members of the Joliet Boxing Team, mostly teenaged boys, who get the training for free.
Photo by Scott Strazzante, Chicago Tribune

CHAMPAIGN
Ryan Kruidenier, 18, dressed early for the
Champaign Central High School prom.
Then he remembered the Beemer hadn't
been vacuumed, so he did it in his tux.
Photo by Scott Strazzante, Chicago Tribune

CARTERVILLE

Nick Anderson heaves himself off the felt after a night with friends at a roadhouse outside his hometown of Carterville. The occasion: a farewell bash before Anderson moves up to Chicago to find work.

Photo by Devin Miller, The Courier

CHICAGO

Radio flyer: Next stop, the park. Ben, 3, and older brother Matt, 5, make like a snake as their father, Garey Schmidt, wheels them to Beaubien Park in Lisle (a western suburb of Chicago) for their after-dinner, tire-'em-out ritual.

Photo by Tim Klein

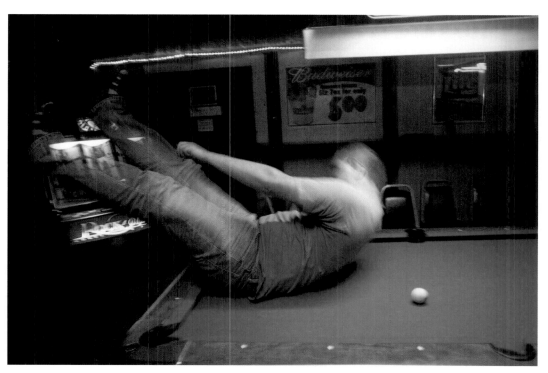

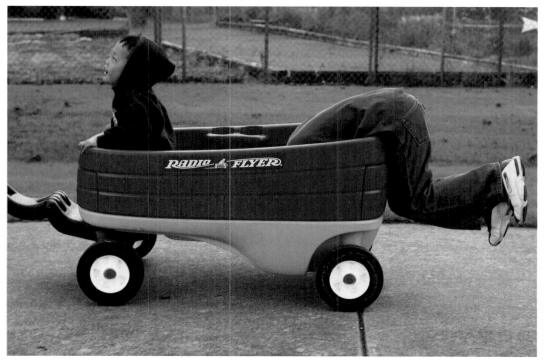

CRYSTAL LAKE
Healing hands: Carey Nolan, 10, receives Edgar Baillie's prayers. The evangelical octogenarian calls himself "a traveling salesman for Jesus," and claims the power to heal by touch. His Chicago Revival Fires meets on Saturday nights at the Christian Fellowship Church. "We jump and dance and sing. We shout glory," he says. "We're on fire for the Lord. That's revival."
Photo by Juli Leonard

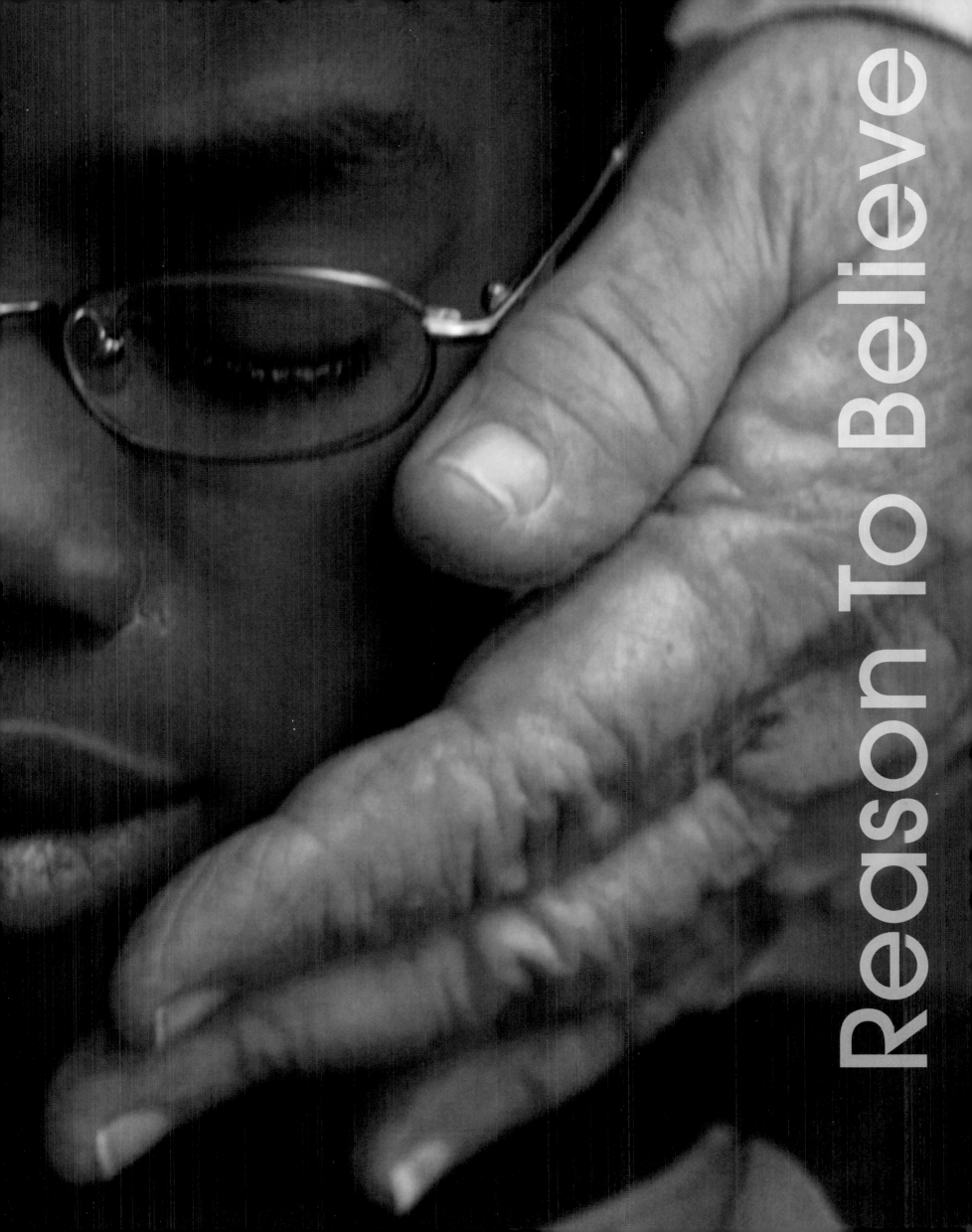

Reason To Believe

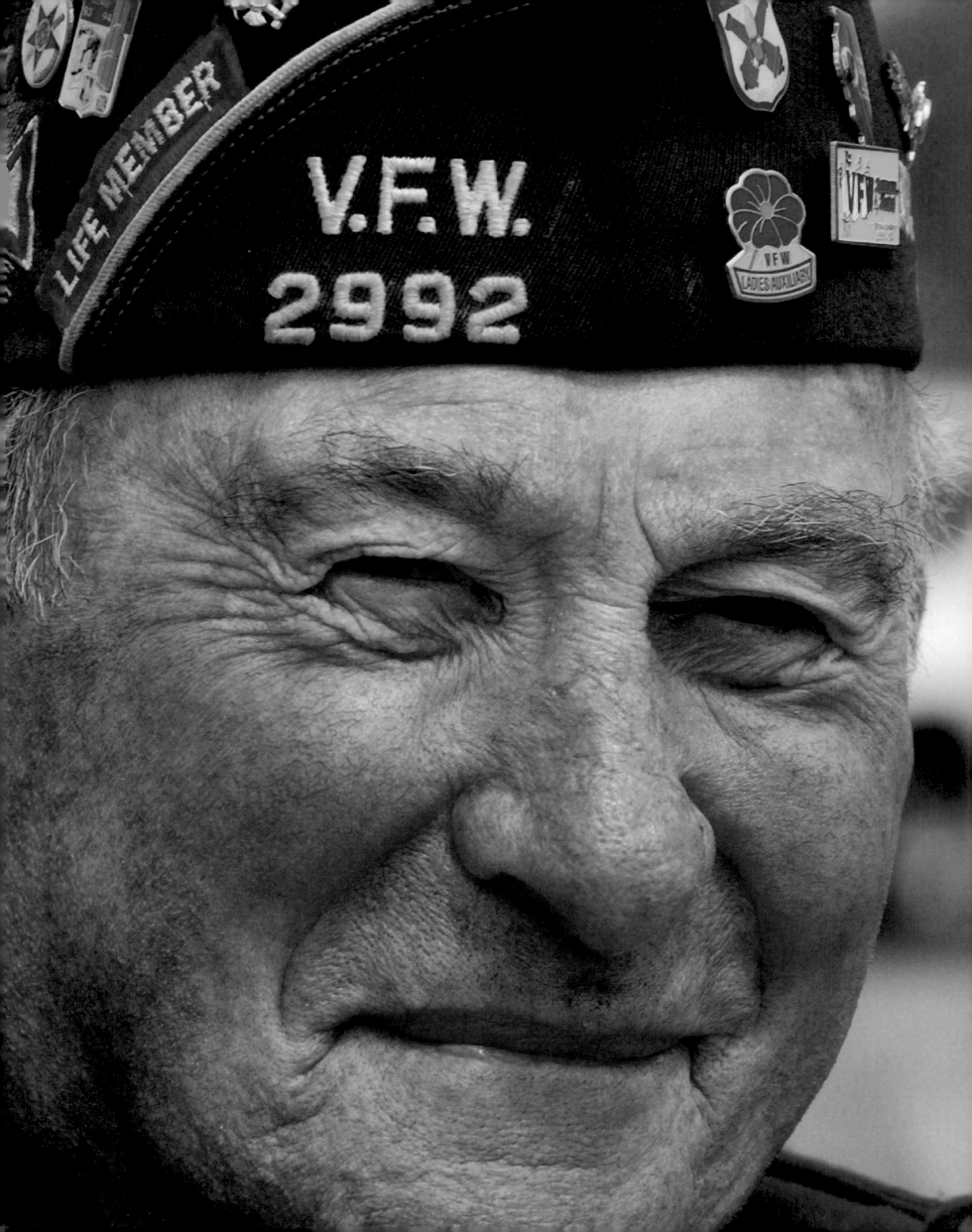

DES PLAINES

Earl Bartholomae—81-year-old father of four, grandfather of 12, and great-grandfather of one—sells poppies to raise money for disabled vets at North Chicago Hospital. After serving in England and Iceland during World War II, Earl peddled Chevrolets for 47 years.

Photo by Allen Kaleta

SPRINGFIELD

Veterans of Foreign Wars (VFW) Honor Guard members Ralph Robison, Ray Smith, and Andy Anderson swap war stories after burial detail for Army PFC Hosie Williams, who served in World War II. Fifty-eight years after VJ Day, about three WW II vets are interred at Camp Butler National Cemetery each day.

Photo by T.J. Salsman, The State Journal-Register

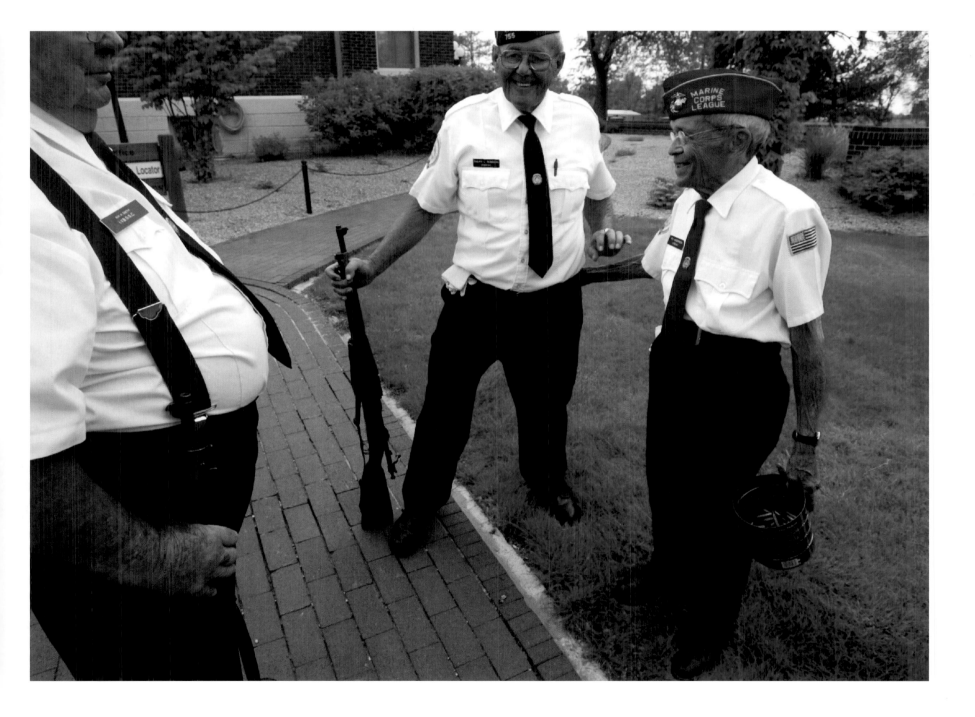

BRIDGEVIEW

While waiting for their Arabic teacher,
Muhammad Mubarik Ali helps his sons
Abdullah, 5, and Abdulrehman, 4, with their
reading homework. During the week they drive
to the Bridgeview Mosque, 10 minutes away
from their Chicago Ridge home, for prayer and
study. Originally from Pakistan, the family speaks
Arabic, English, and Urdu.
Photos by Michael Hettwer

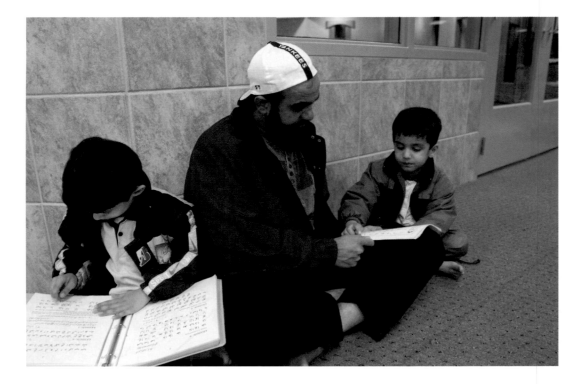

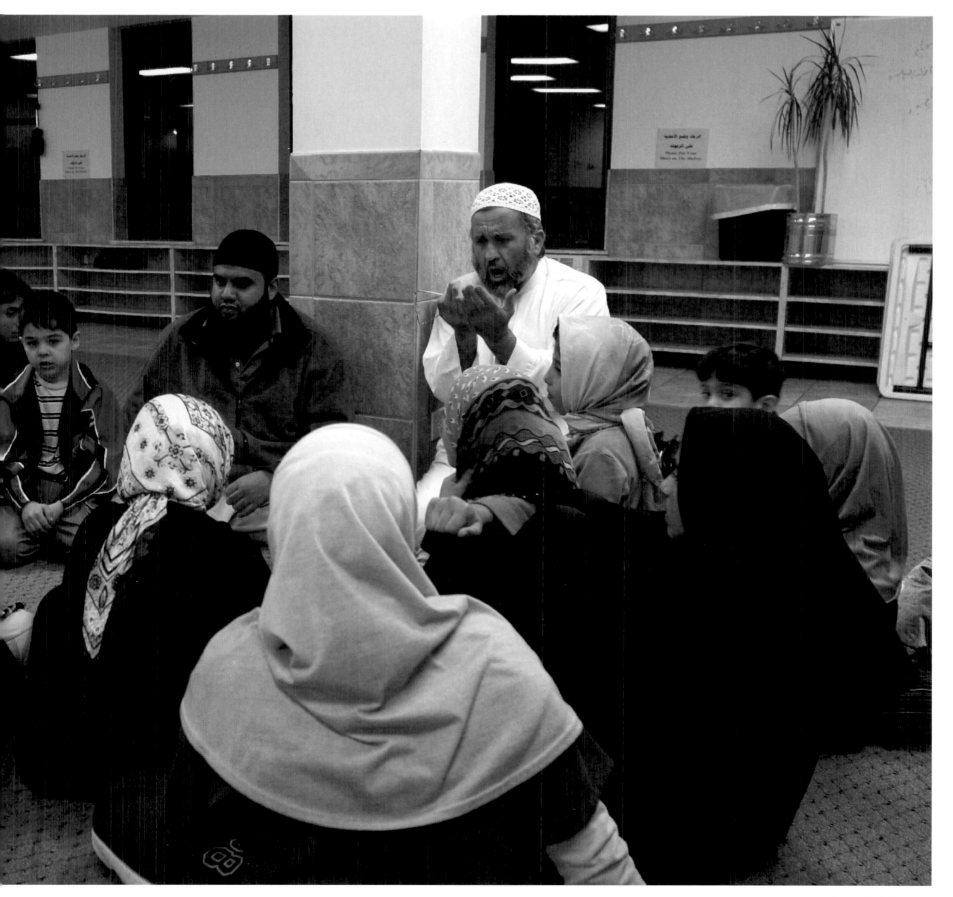

BRIDGEVIEW
Members of the Bridgeview Mosque hail from Egypt, Syria, Pakistan, Jordan, Algeria, Palestine, and elsewhere. In the evenings, Sheikh Zakaria Khudeira teaches children stories from the Koran prior to the day's last prayer.

CRYSTAL LAKE

Sunday best behavior: 6-year-old twin sisters Savannah and Sierra Leone relax in the 93-year-old Masonic Temple, where the Unity Church holds Sunday services. A healing, teaching, and prayer ministry, Unity Church does not promote a spiritual hierarchy. "Our belief is that we each have the divinity in us," says Tom Wendt, the congregation's spiritual leader.

Photos by Greg Hess

CRYSTAL LAKE
Max, a pew-trained golden retriever, waits for the pet-blessing portion of the Sunday service at Unity Church. Their owners bless the animals themselves, with homespun testaments as simple as "Thank you for being in my life" or "You bring me great joy."

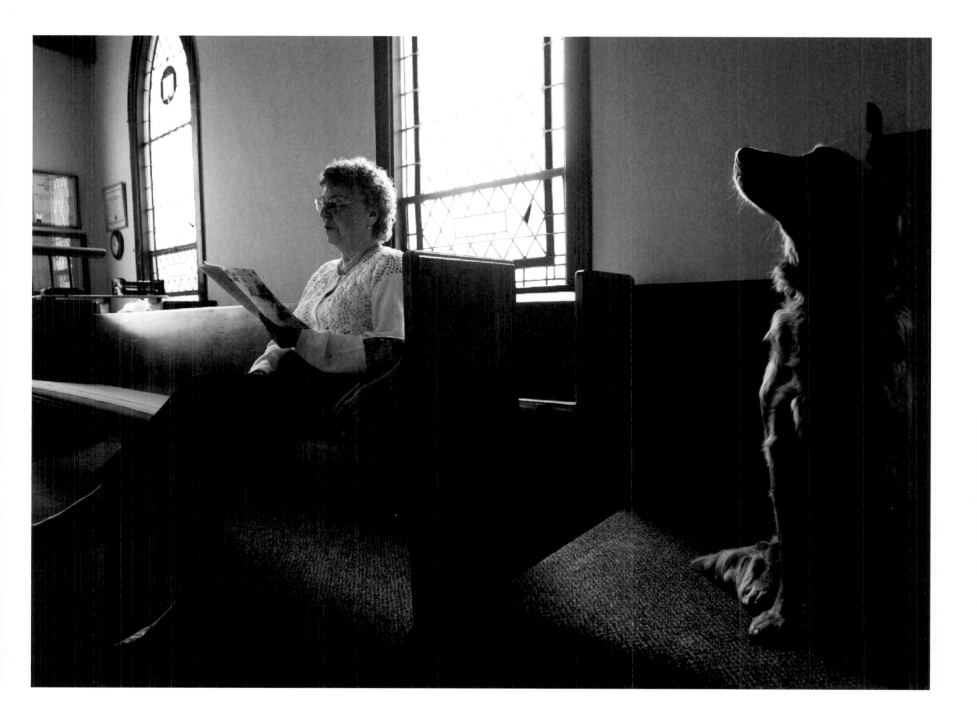

CHICAGO
Stairway to heaven: Every day after work
Gustavo Aguilar, 39, carries a cross around
the city to "help keep Christ's image alive." A
former fan of satanic rock, Aguilar now begins
his daily transformation from maintenance
man to holy man listening to the music of
Jesus Christ Superstar.
Photo by Robert A. Davis, Chicago Sun-Times

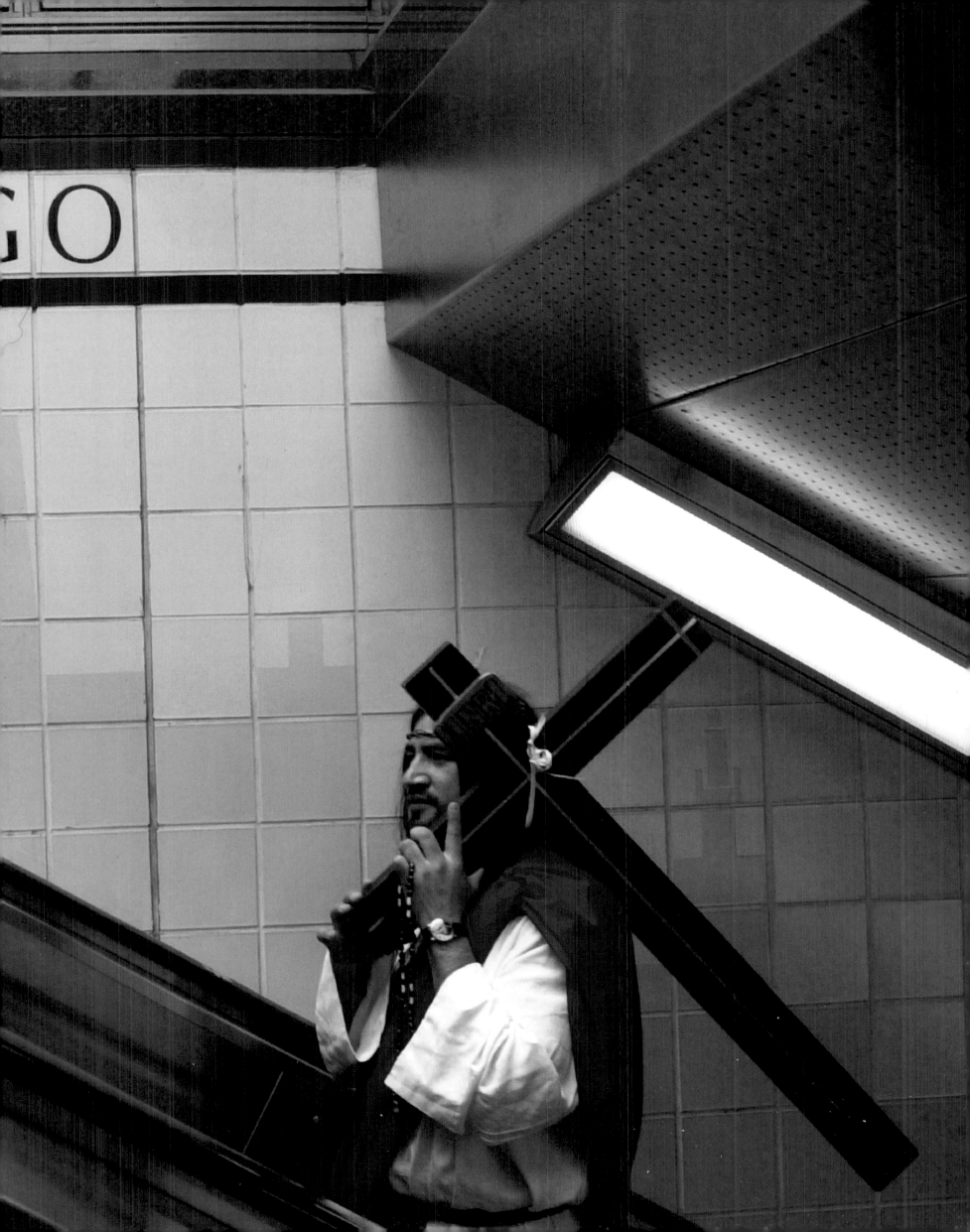

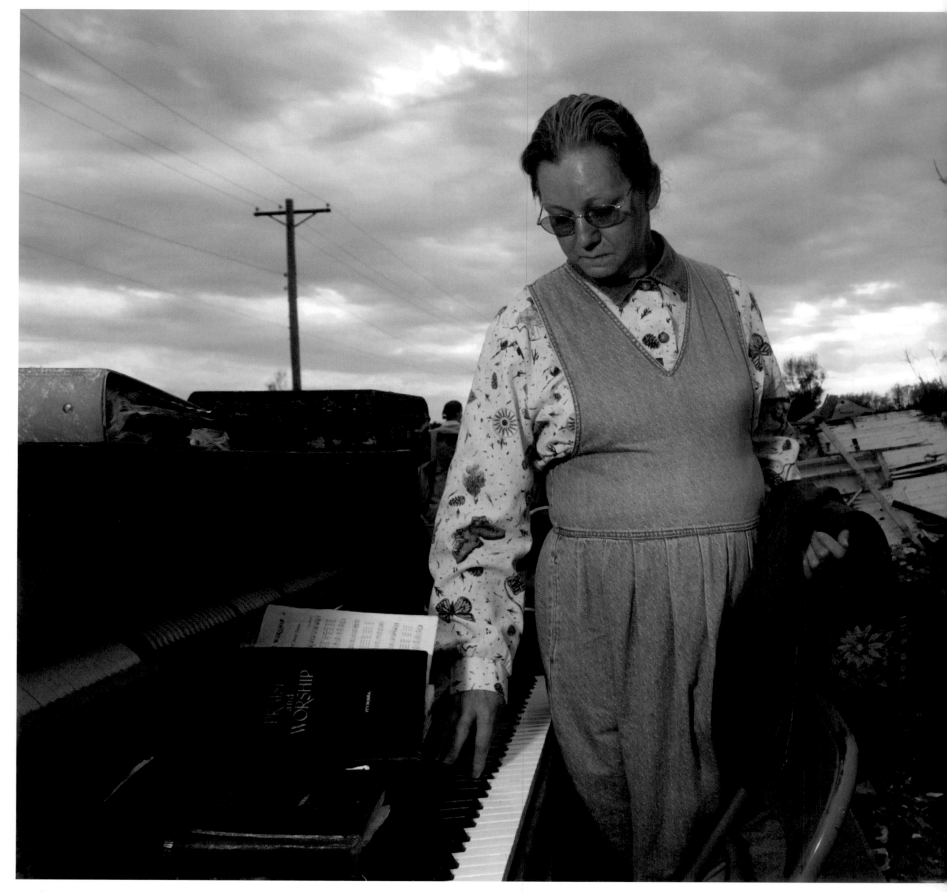

SOUTH PEKIN

Clara Jones tenderly touches the piano—all that's left of the Bible Holiness Church her parents founded 17 years ago. In four minutes, a severe funnel storm wreaked havoc in South Pekin (pop. 1,162), destroying homes and the church. The tornado cut a swath across central Illinois, damaging more than 178 homes in 20 towns before stopping 100 miles short of Chicago.
Photos by Fred Zwicky

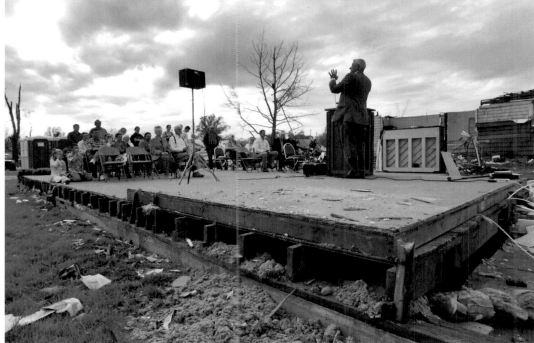

SOUTH PEKIN

Three days after a devastating F3 tornado, (winds of up to 200 mph) battered the town of South Pekin on May 10, the Reverend Wayne Knipmeyer led a final service on his church's foundations. Pledging to rebuild, the pastor noted that despite the terrifying ordeal, "God is good and we have survived."

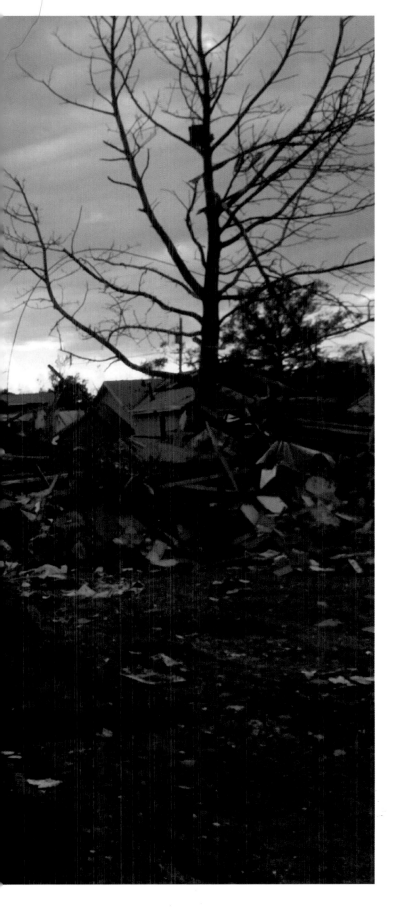

SOUTH BARRINGTON
Pastor Marie Shepherd blesses Carissa Jane
Bracken, 11 months, during a baby dedication at
Willow Creek—the nation's largest megachurch
with an average weekend attendance of 17,500.
Says Carissa's mother, Andrea Pecoraro, "I want
my daughter blessed and protected, and
brought up in a church environment."
Photos by Alex Garcia

SOUTH BARRINGTON

Worship leader Rene LeDesma brings the message of Christ to the big screen at the Willow Creek Community Church. The megachurch and its 100 subministries lead some 17,500 Christians in song and prayer every weekend, making it one of the largest in the country. Started in the 1970s by a handful of teenagers, the church now receives $20 million annually in donations.

ARTHUR

An Amish buggy rolls past Vine Street's Aschermann Motor Company, where the wares are much more self-consciously retro. Buggy sightings are not uncommon in Arthur, whose rural purlieus support the fourth largest Amish community (3,500) outside of Pennsylvania.

Photo by Chris Curry, Journal Star

A shortage of African-American men in the Catholic priesthood has led many white priests, like Father Bob Miller of Holy Angels Church on Chicago's South Side, to pastoral duties in predominantly black parishes. In Holy Angels' opulent sanctuary, choir member Deborah Powell sings "What a Wonderful World" for a baptism during the 12:15 mass.
Photo by Michael Hettwer

AURORA

Self-employed carpenter Greg Zanis carries memorial crosses to the spot on Route 25 where two people were recently killed in a car accident. Since 1996, he has made and erected 7,000 crosses at fatal accident scenes in 48 states. "I put them up for the living," he explains.
Photo by Chuck Cass

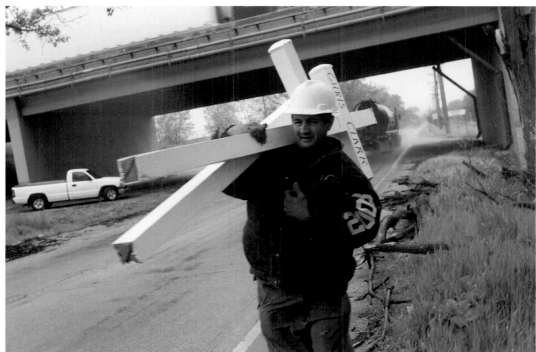

McHENRY

Neil Roberts (in plaid shorts) joined the Cub Scouts when he was 7. Now 16, he only needs to earn five more merit badges to become an Eagle Scout. Troop 149 imposes no dress code except for the uniform shirt and red neckerchief. To stiffen his radical Mohawk, which he wears once or twice a week, he uses Volumax Freezing Spray.
Photo by Juli Leonard

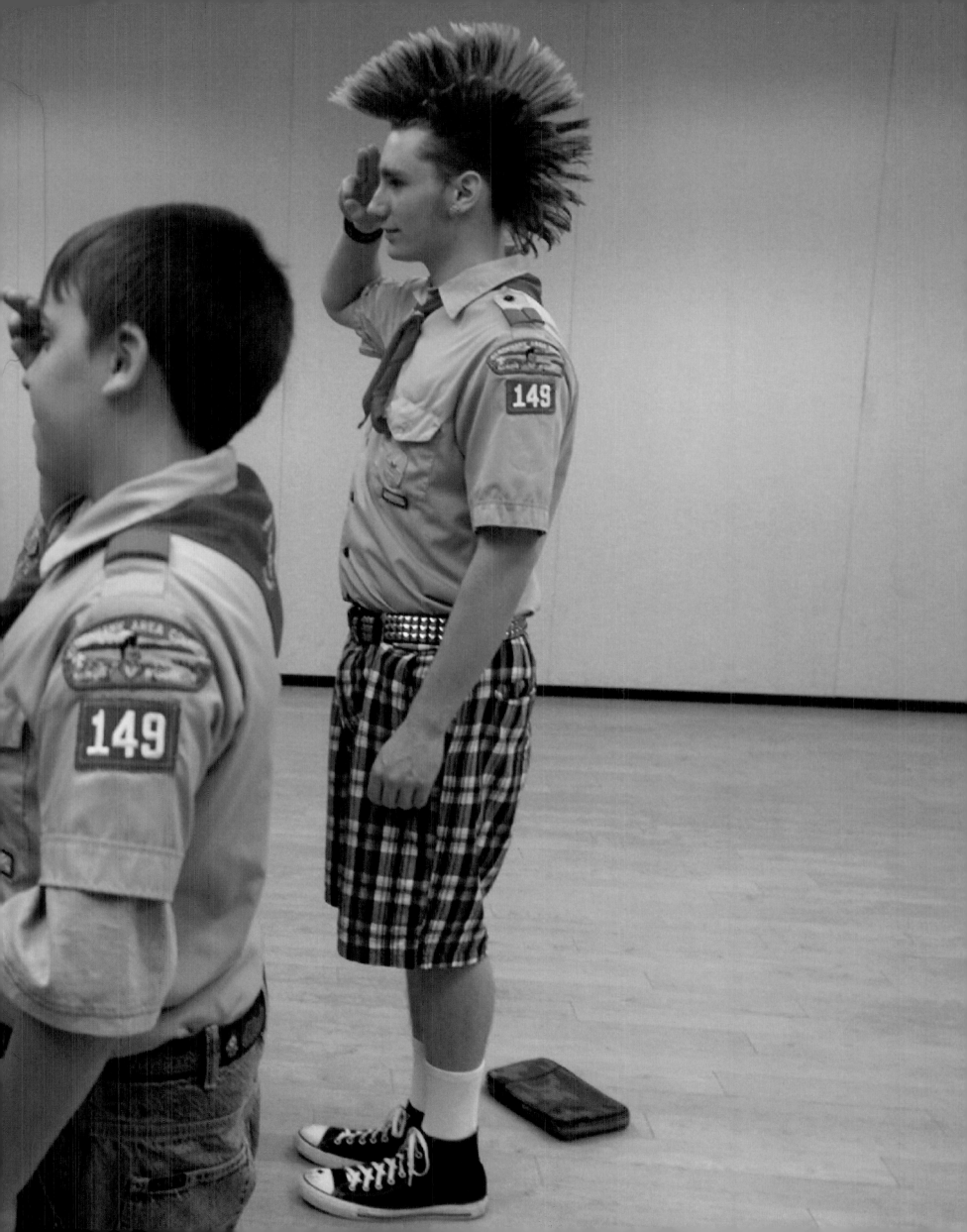

HE GAVE UP HIS LIFE
THAT A HUMAN MIGHT LIVE
EATER LOVE HATH NO MA

WILLOWBROOK
Big dog: Arap, a Newfoundland, lost his
life defending John Stankowicz's family
during the 1917 October Revolution in
Russia. Stankowicz, who had been an official
in Tsar Nicholas II's government, emigrated
to America and opened the Hinsdale Animal
Cemetery in suburban Chicago in 1926.
He erected the statue to honor his
devoted defender.
Photo by Stuart Thurlkill

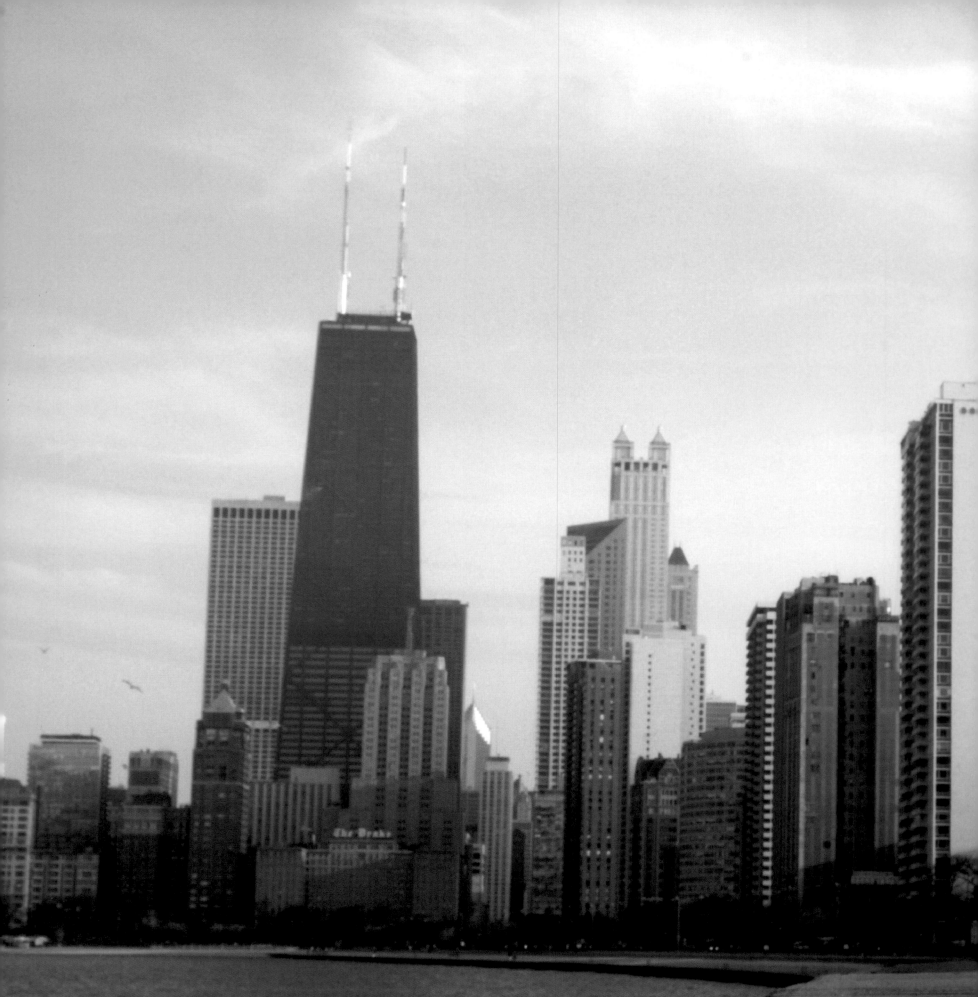

CHICAGO

The late-afternoon sun slants through Chicago and its 29 miles of waterfront, where the vertical city meets the great expanse of Lake Michigan—"Chicago's own ocean," as it's called. With warming temperatures come joggers by the thousands, who recharge their batteries on the city's promenades.
Photo by Denise Keim

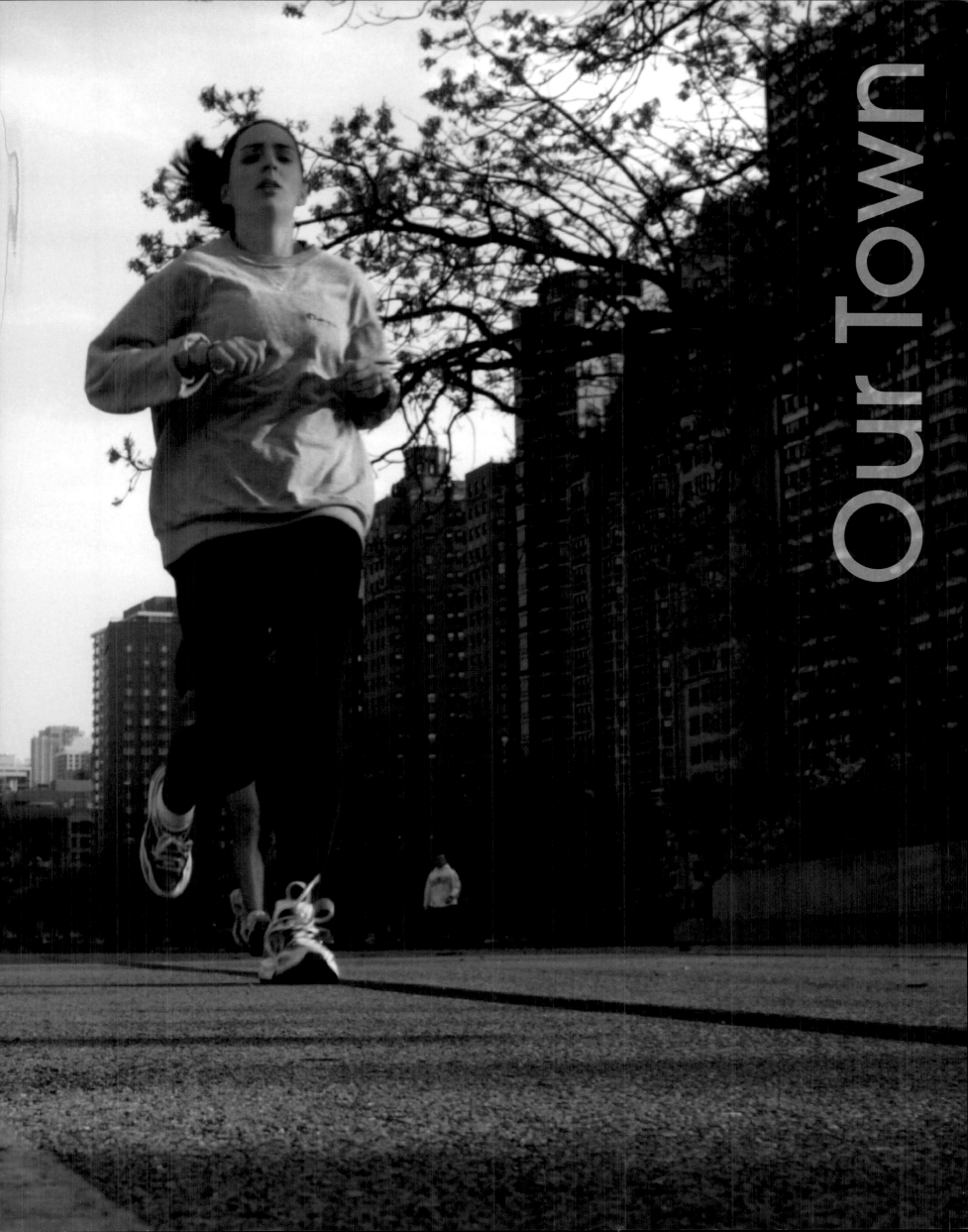

CHICAGO
Near 61st and S. Kedzie on the south side of Chicago, Julian Moreno coaches daughter Elisset, 9, on the finer points of handling the power mower. The chore was her idea — she wanted to help out her tired construction-worker dad.
Photo by Tim Klein

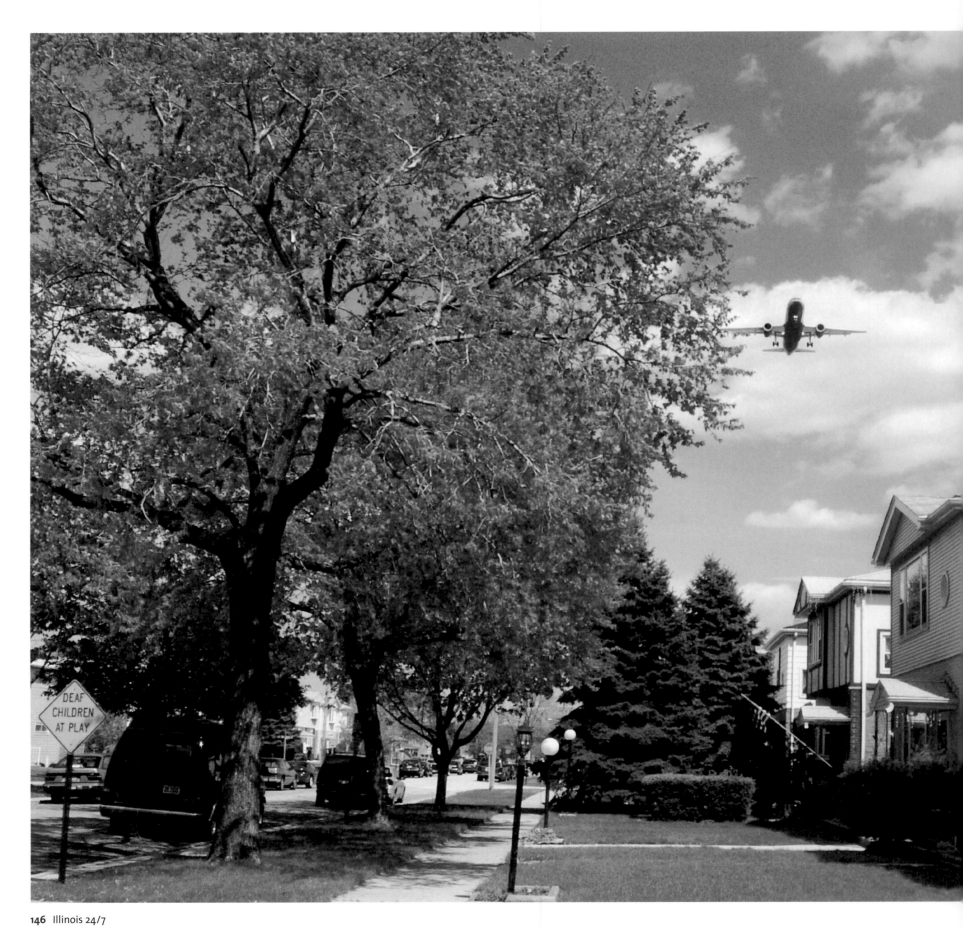

SCHILLER PARK

Small town feel, gateway to the world: This is how the Village of Schiller Park defines itself. That gateway is Chicago's O'Hare International Airport. In 2002, residents endured 922,817 takeoffs and landings—or one plane every 34 seconds.
Photo by Garrett Anglin

CHICAGO

Chicago Mayor Richard Daley walks to his car after throwing out the first ball at a Little League opening day at Livingston Field. When asked what he likes most about America, the mayor says, "The people who care and make their neighborhoods better, like those you see volunteering at events like this."
Photo by Michael Hettwer

CLIFTON

Mobile home: When Harold Peter's neighbor, Marvin Vehrends, heard that Peter's 15-room, 150-year-old farmhouse was to be demolished to make way for a new home, Vehrends offered to buy it. After a monthlong process to move it off the foundation and onto wheels, the house heads to its new home a mile down the road.
Photo by Scott Strazzante, Chicago Tribune

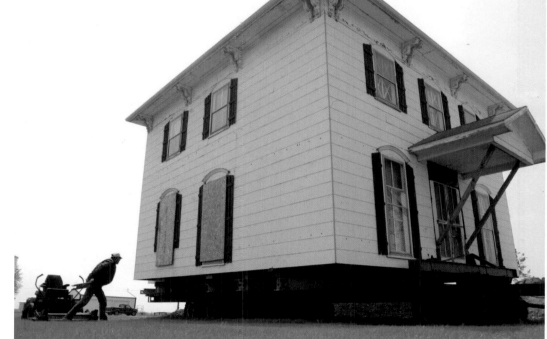

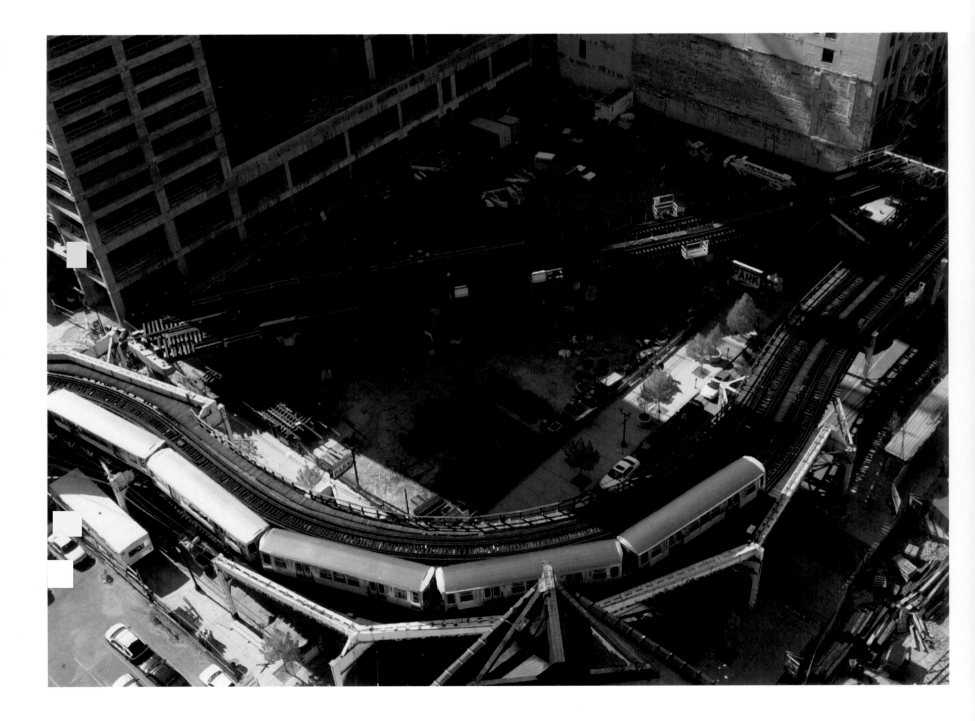

CHICAGO

The "L" rises above it all as it takes an s-curve on Wabash Street. The track extension, which is almost complete, will straighten out the curve, saving three minutes. The Chicago Transit Authority (CTA) rail system has grown from 3.9 miles in 1892 to 222 miles of track today.
Photo by Robert A. Davis, Chicago Sun-Times

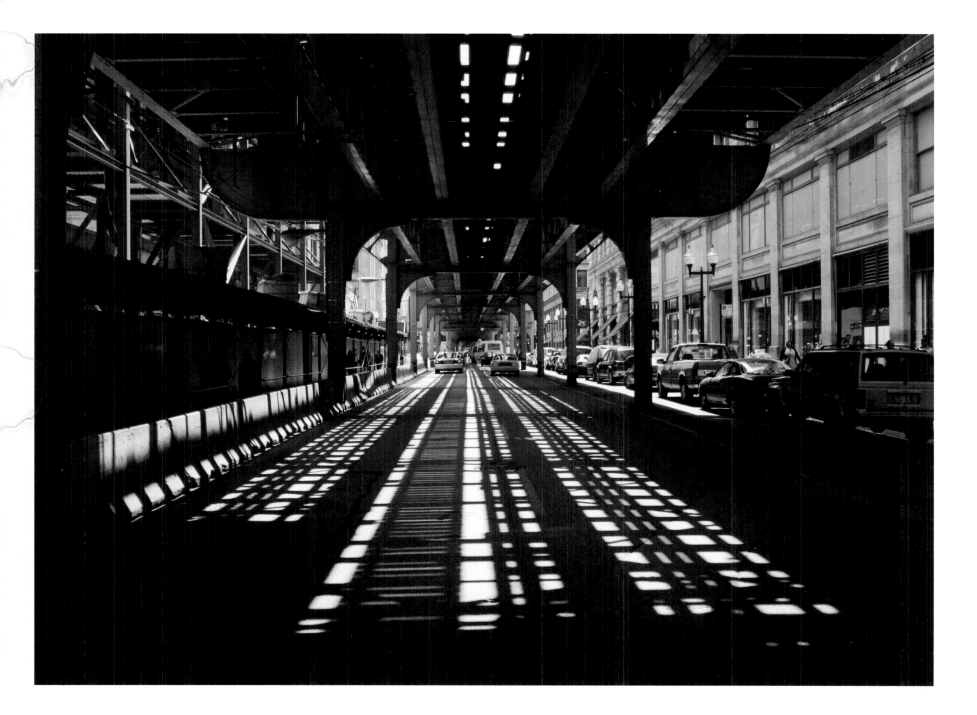

CHICAGO

The deafening noise from rumbling overhead trains makes street-level conversation and cell phone use at Wabash and Randolph almost impossible. While not the nation's first elevated railway (that distinction goes to New York City), the "L" is the most well known.

Photo by Antoine F. Terry, AFT

CHICAGO
A commuter waits for her homebound train at the Washington and Wells "L" station in downtown Chicago, or "the Loop." Originally, "the Loop" referred to the 1882 cable-car route that circled Chicago's central business district prior to its replacement by the current elevated tracks in 1897.
Photo by Garrett Anglin

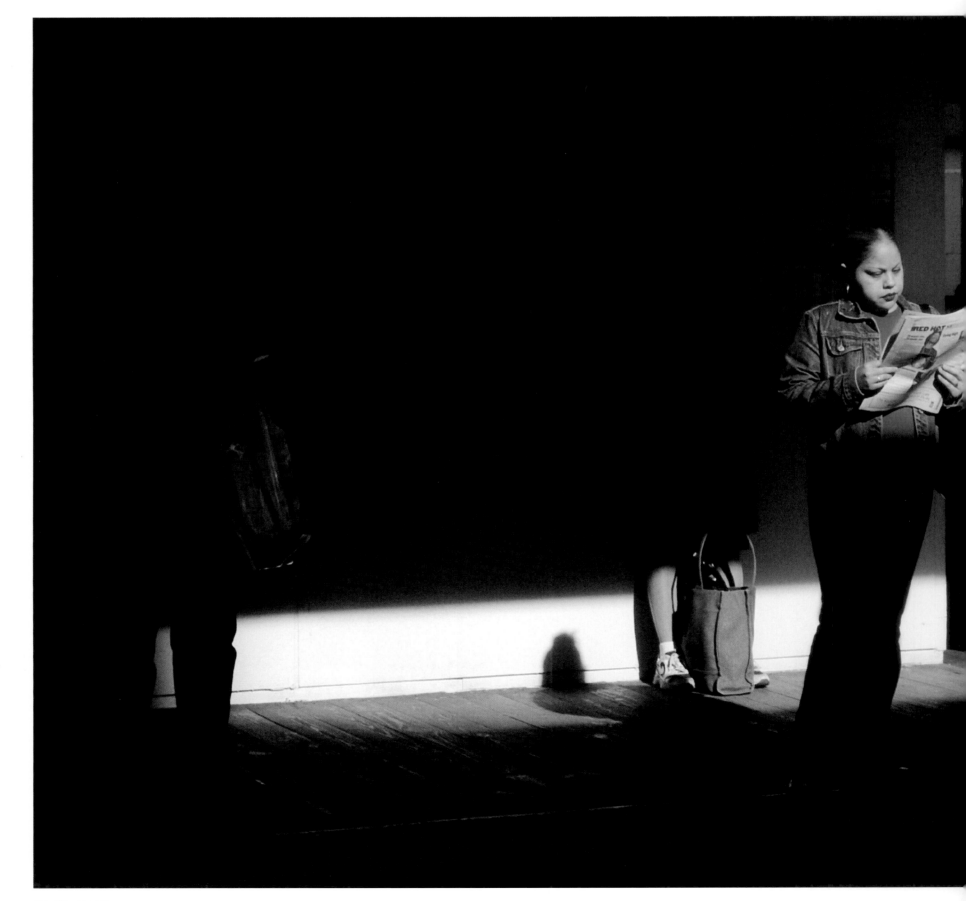

CHICAGO

During a stop at Wabash and Madison, an "L" train arrives plastered with a trademark red and white Target ad. The customized, large-format images are printed on a sheet of adhesive vinyl and applied to the train like a big sticker.
Photo by Antoine F. Terry, AFT

CHICAGO

Headed east-southeast, 3:58 p.m.: Two passengers lost in thought on the Blue Line, somewhere between O'Hare International Airport and the Loop. With 43 stops, the Chicago Transit Authority's Blue Line serves the sprawling northwest side of the city.
Photo by Garrett Anglin

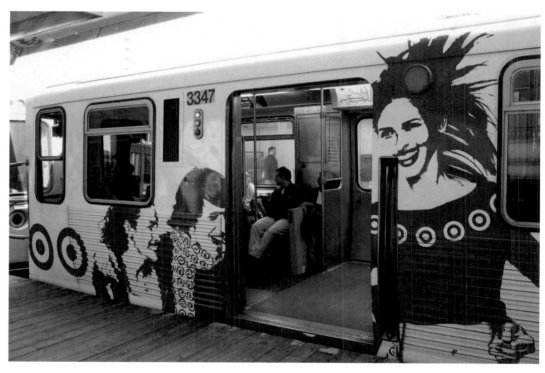

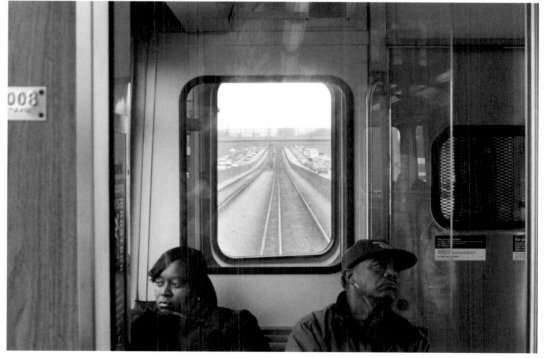

URBANA

Kallie Fairbanks, 1, congratulates her father, Sam Martland, after he received his doctorate in Latin American history from the University of Illinois at Urbana-Champaign. The newly minted Ph.D. has lined up a teaching job at the Rose-Hulman Institute of Technology in Terre Haute, Indiana.
Photos by Scott Strazzante, Chicago Tribune

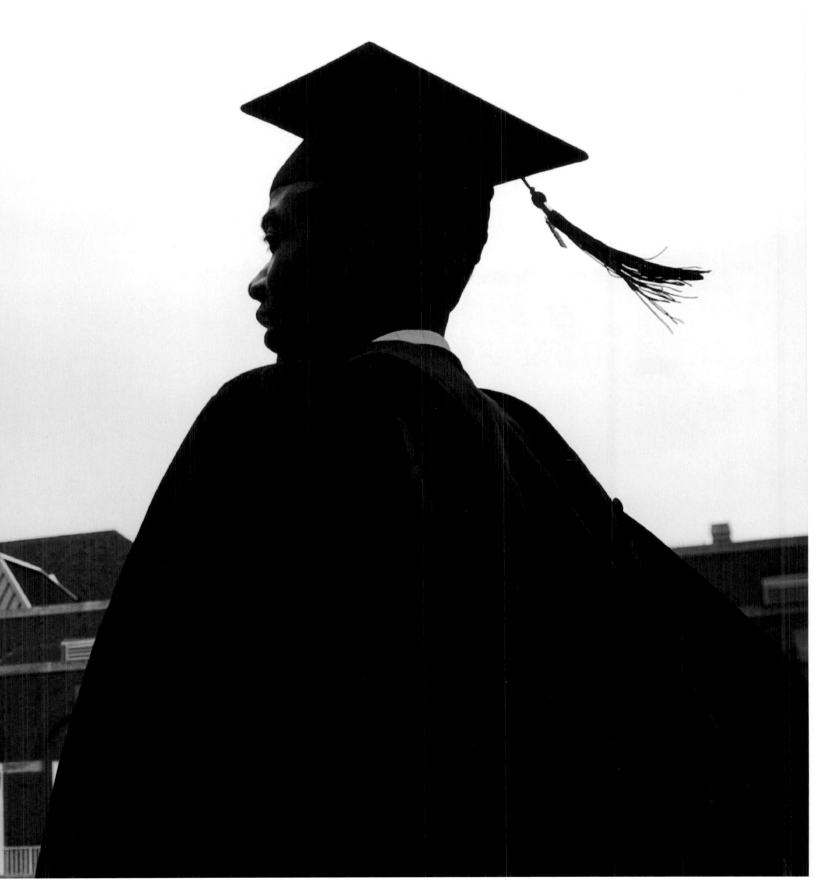

URBANA

With his law degree from the University of Illinois at Urbana-Champaign in hand, Robert Otu says he plans to return home to Lagos, Nigeria, and find employment as a corporate attorney.

CHICAGO
Stranger on a train: A lone passenger contemplates journey's end as his train pulls into Union Station.
Photo by Rowan Gillson

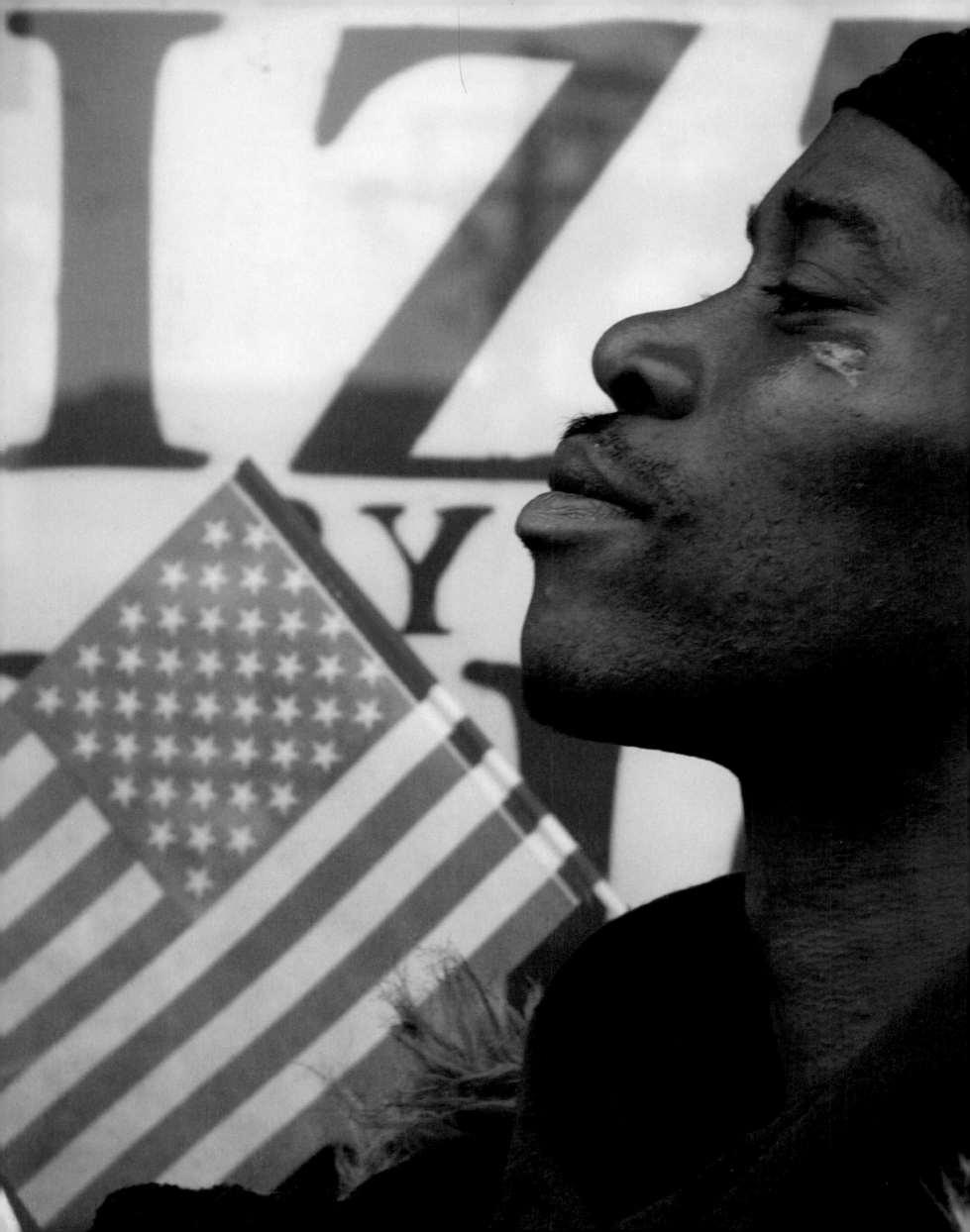

CHICAGO
Antone Dawson works most days on the street, panhandling at the corner of Western and Fullerton in front of Pepes Grocery.
Photo by Denise Keim

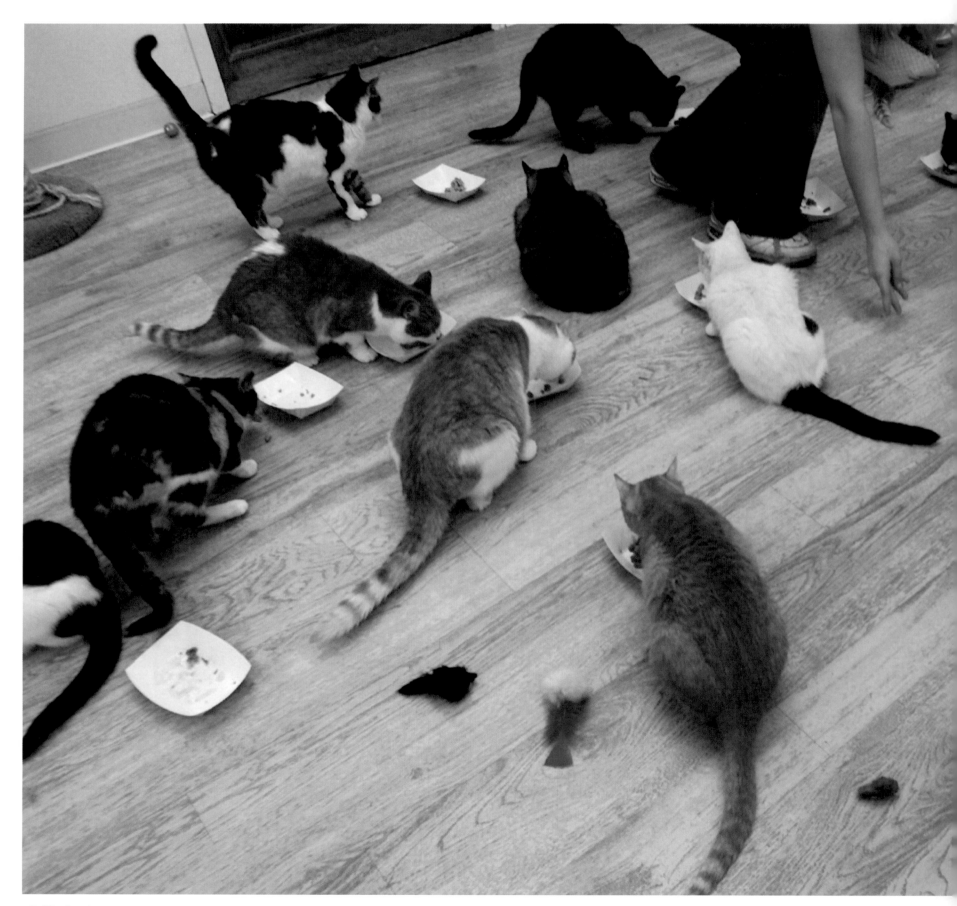

CRYSTAL LAKE
The "no-kill" Helping Paws Animal Shelter is temporary home to about 60 cats and four or five dogs at a time. Each week, around a dozen cats and kittens are adopted into carefully screened homes. In the cat room, which doubles as the shelter's reception area, waiting felines roam free. Treat time is 2 p.m.
Photo by Juli Leonard

ARLINGTON HEIGHTS
From her perch at the front door in suburban Arlington Heights, Matilda watches the world go by through a leaded glass window designed especially for her.
Photo by Mark A. Becker

CHICAGO

Trevor (drums), Mike (guitar), and Robert (everything else) of Hair Police traveled up from Lexington, Kentucky, to play their underground hit song "Blow Out Your Blood" as part of the University of Chicago's "Summer Breeze" concert series.
Photo by John Dunlevy

CHICAGO

Texas native Craig Morris, principal trumpet with the Chicago Symphony Orchestra, warms up in a rehearsal room in the basement of Symphony Center before the evening's performance of J.S. Bach's "The Four Orchestral Suites."
Photo by Robert A. Davis, Chicago Sun-Times

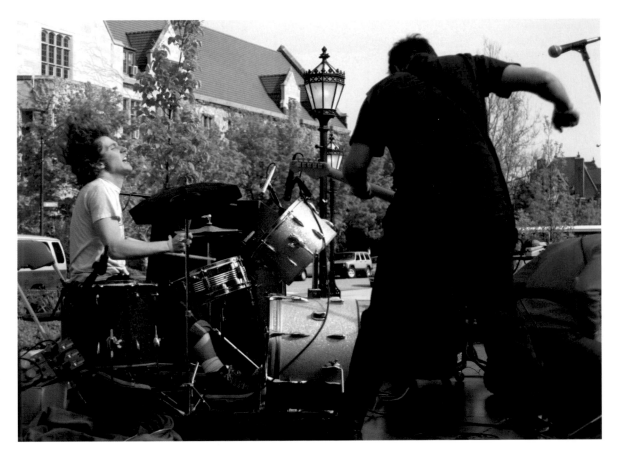

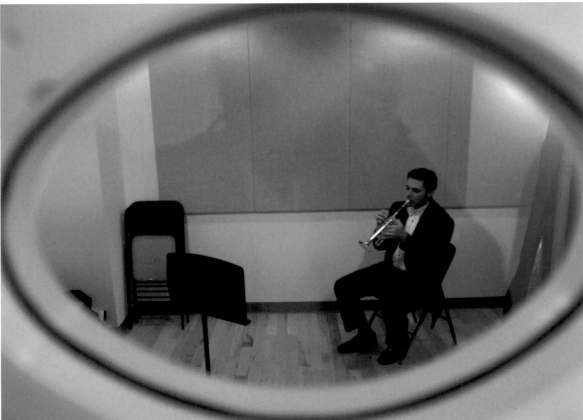

DOWNERS GROVE

A framed photo of Joliet Jake Blues reflects Jeff Rutter of the Cryan' Shames at a jam session in a friend's loft. The local pop-rock group made it big in the 60s with "Sugar and Spice," topping the Chicago charts and hitting the top 50 nationally in 1966.

Photo by Stuart Thurlkill

CHICAGO

When singin' or jammin', Jesse Cross sticks his smoke in the neck of his bass guitar. He plays at Rosa's Lounge with Sharon Lewis & The Mojo Kings, one of the Windy City's hottest blues bands.

Photo by Robert A. Davis, Chicago Sun-Times

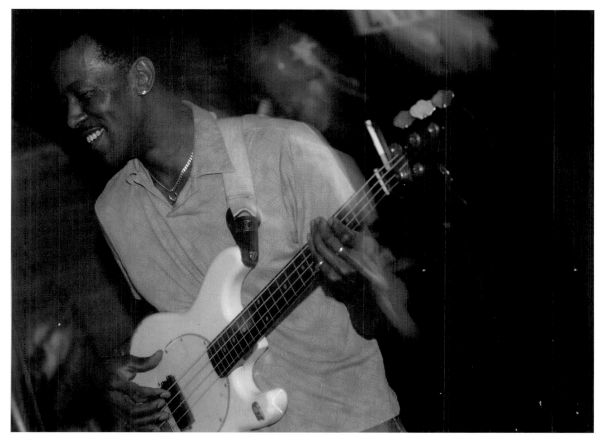

CHICAGO
SpongeBob Squarehead: Agnes Kopacz-
Oleszczuk and Marta Florczak suffer
no distraction from their evening
gelati at J Bean Coffee Shop in the
Harlem-Irving district.
Photo by John Krol

CHANA

If it's Tuesday, it must be Chana: Once a week, the Chana Sale Barn, south of Rockford, holds an auction for everything from lamps to livestock. Several hundred people come from surrounding areas to participate. "You see all kinds of folk," says Joe Salas, an art broker from Sterling. "It's one of the last great American gathering places."
Photo by Alex Garcia

MOKENA

Second thoughts: Darby Lang, 5, inspects one of the old toys he reluctantly let his mother Lynette include in the neighbor's garage sale.
Photo by Scott Strazzante, Chicago Tribune

CHANA

In addition to aluminum coffee pots and bear heads, Chana Sale Barn customers might dig up Civil War memorabilia, turn-of-the-century baby carriages, or mint-condition Pez dispensers.
Photo by Alex Garcia

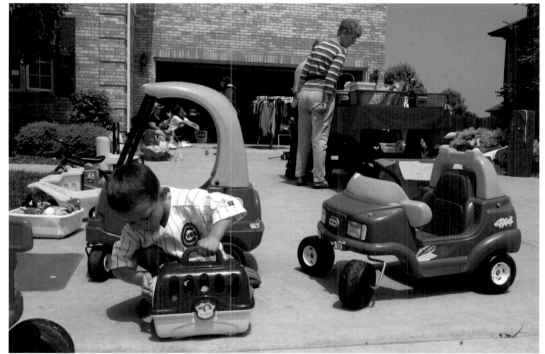

CHICAGO
Teddy Roosevelt, Marlin Perkins, and
Sir Edmund Hillary were all members of
the Adventurers Club of Chicago, founded in
1911. Current President Chuck Hannon, 68,
has traveled to 88 countries. He has climbed
Kilimanjaro, tromped through Israel, and
motored along China's Silk Road. Next, he
plans to retrace the Saharan salt and slave
routes on a three-week camel caravan.
Photo by Michael Hettwer

LOCKPORT

Tired of waiting for the developer to seed his backyard, Michael Kanosky of Willow Walk, a Lockport subdivision 35 miles southwest of Chicago, lays sod at his Cagwin Drive residence. In 2002, Illinois ranked 35th in the nation for housing growth with 43,500 new housing units.

Photo by Scott Strazzante, Chicago Tribune

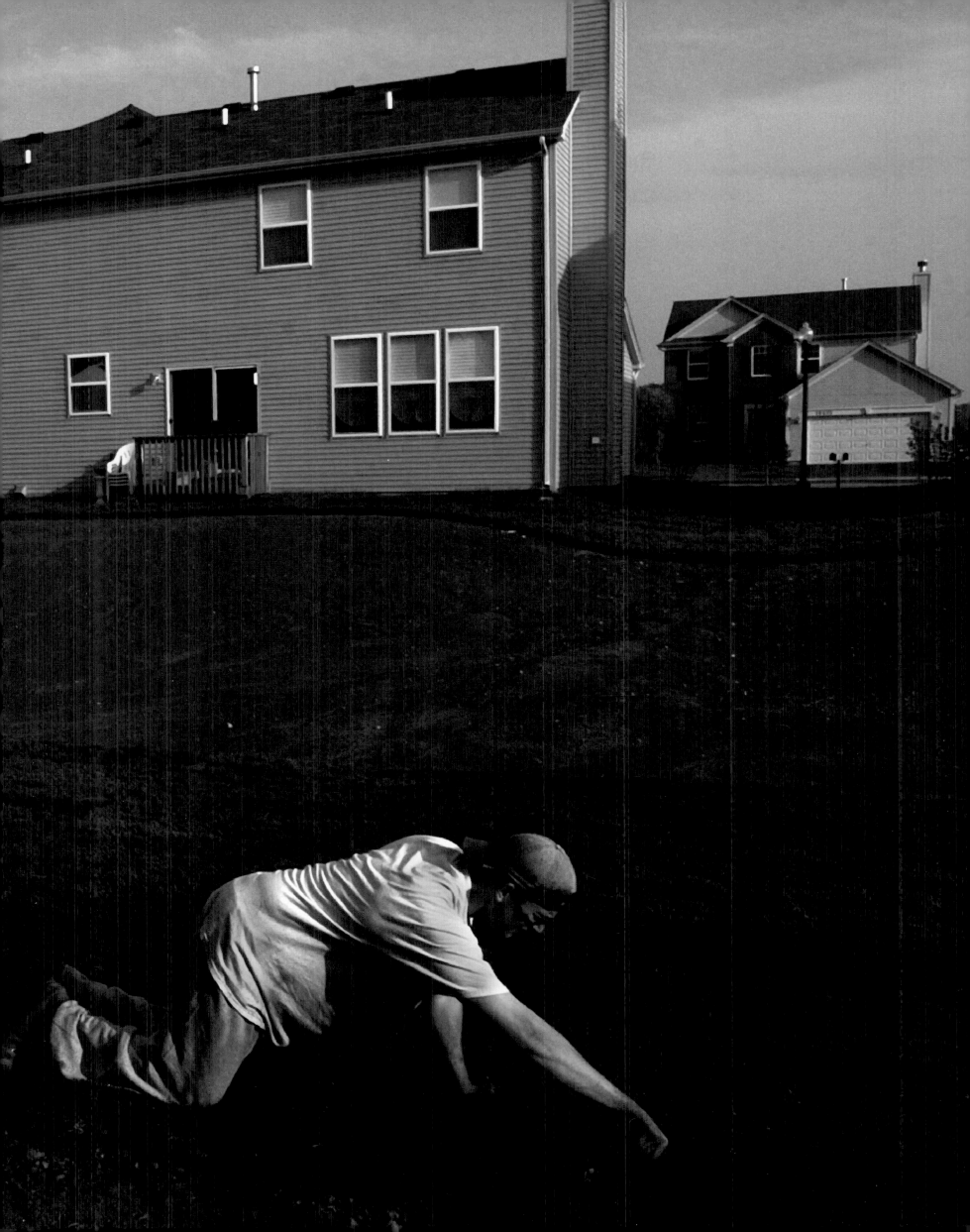

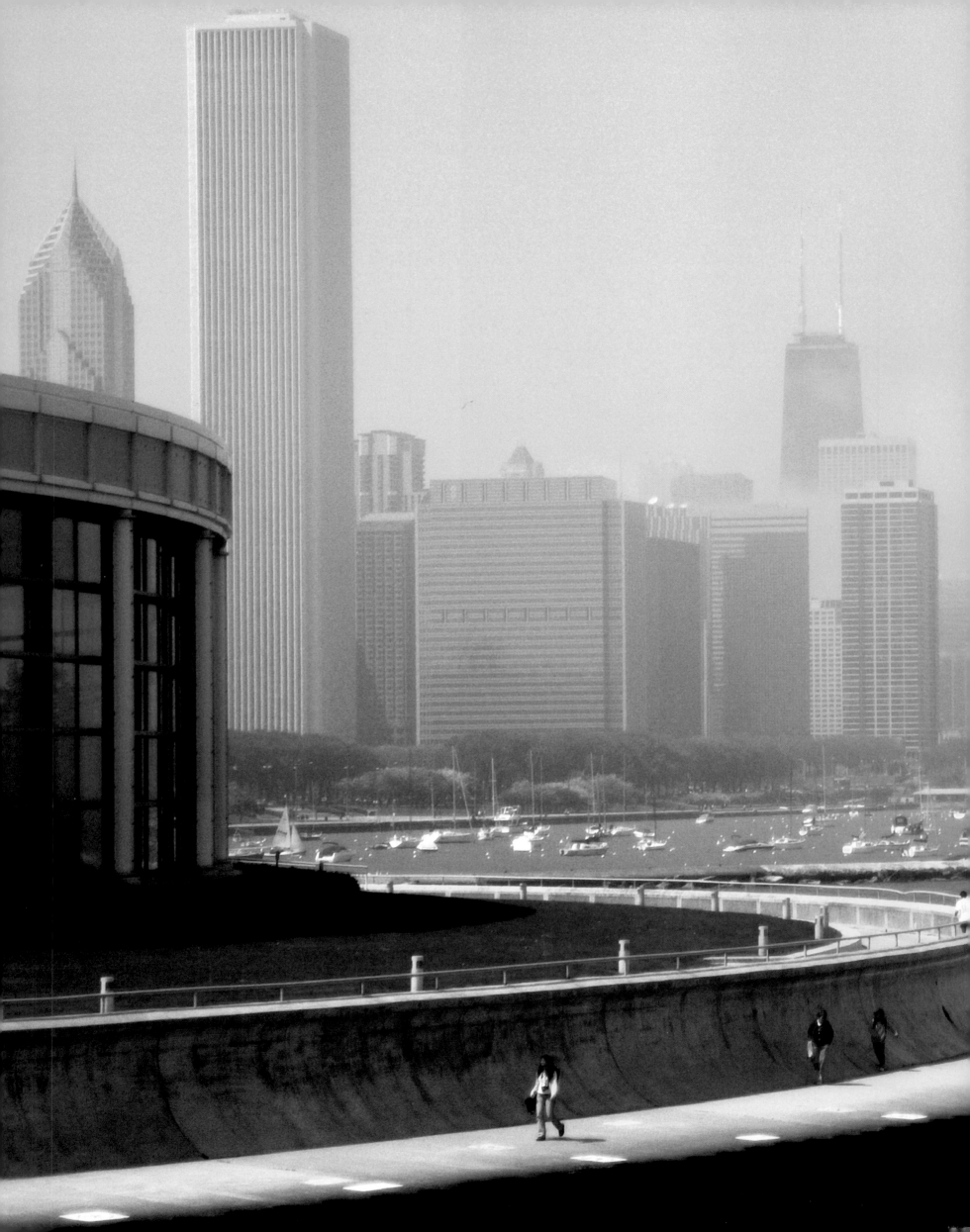

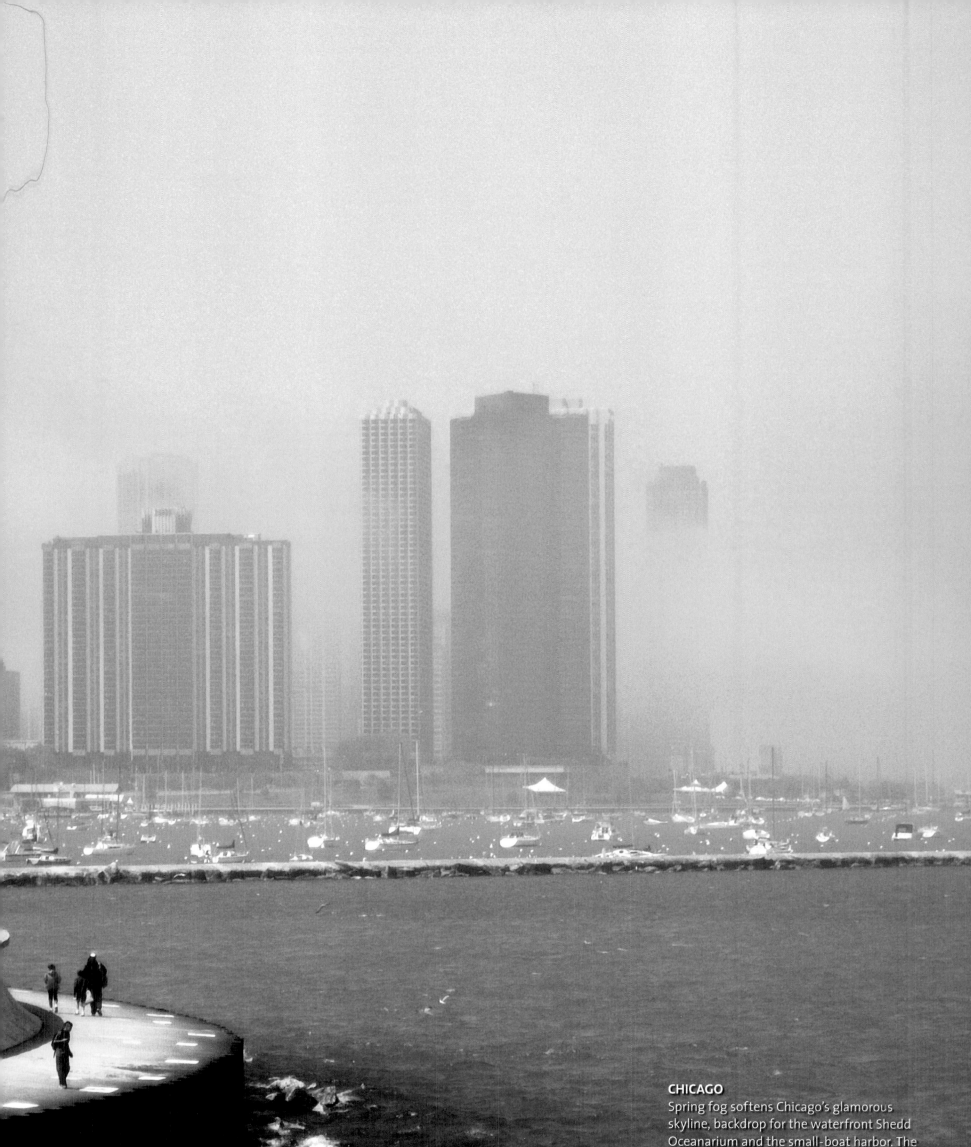

CHICAGO
Spring fog softens Chicago's glamorous skyline, backdrop for the waterfront Shedd Oceanarium and the small-boat harbor. The Oceanarium houses sea mammals inclucing dolphin, seals, sea otters, and Beluga whales.
Photo by David M. Solzman

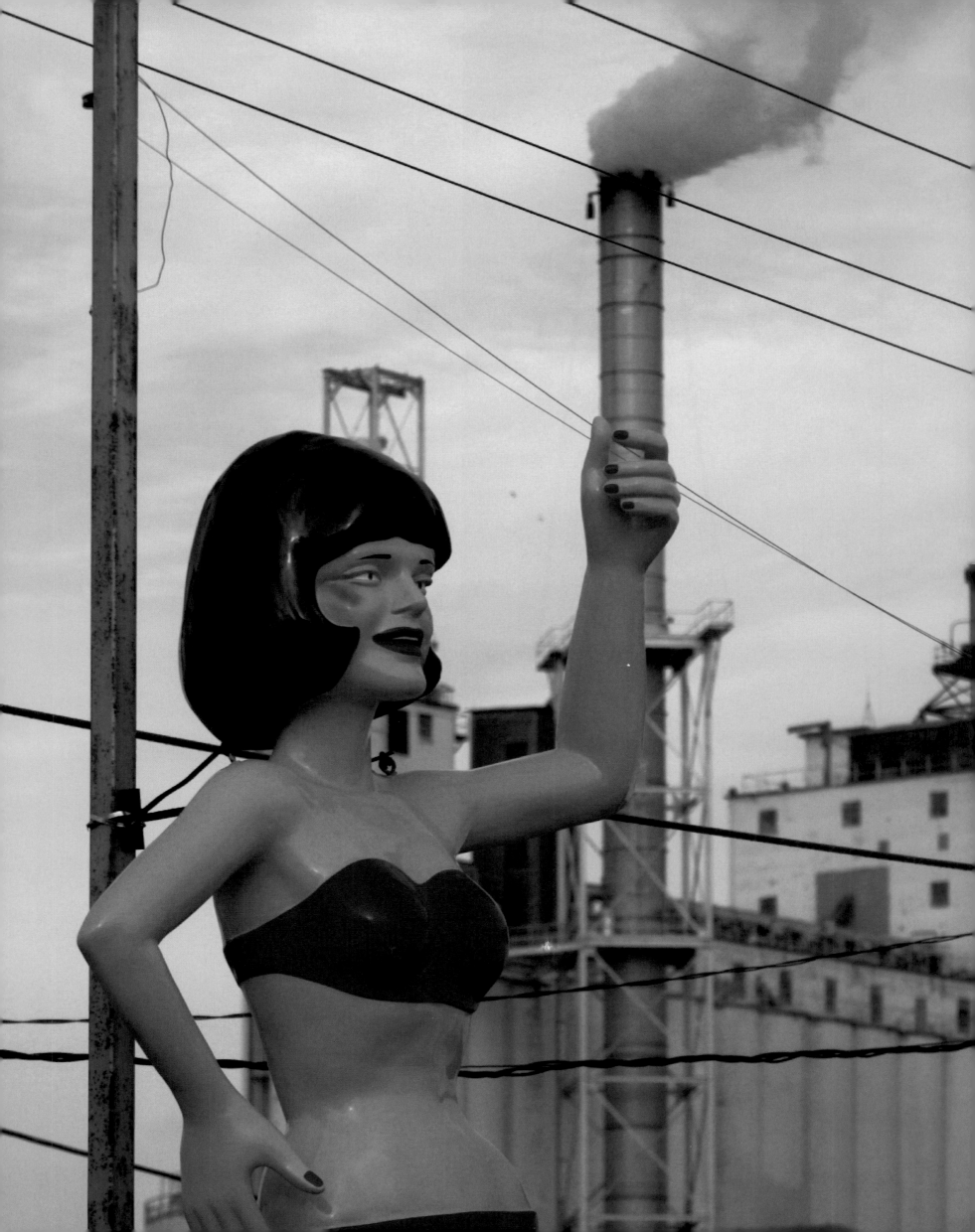

PEORIA

Lovely Vanna Whitewall, mascot of Peoria Plaza Tire since 1971, was manufactured in the 1960s in Venice, California (hence the bikini). Originally christened Miss Uniroyal, the 17' 6" tall, 450-pound fiberglass female received her current name along with a complete makeover in 1988.
Photo by Fred Zwicky

CHICAGO

Planes and trains: On its final runway approach to O'Hare International Airport, flight 336 from Kansas City floats low over the Canadian Pacific switching yard. The sprawling yard straddles Cook and DuPage counties.
Photo by Reed Hoffmann, Freelance

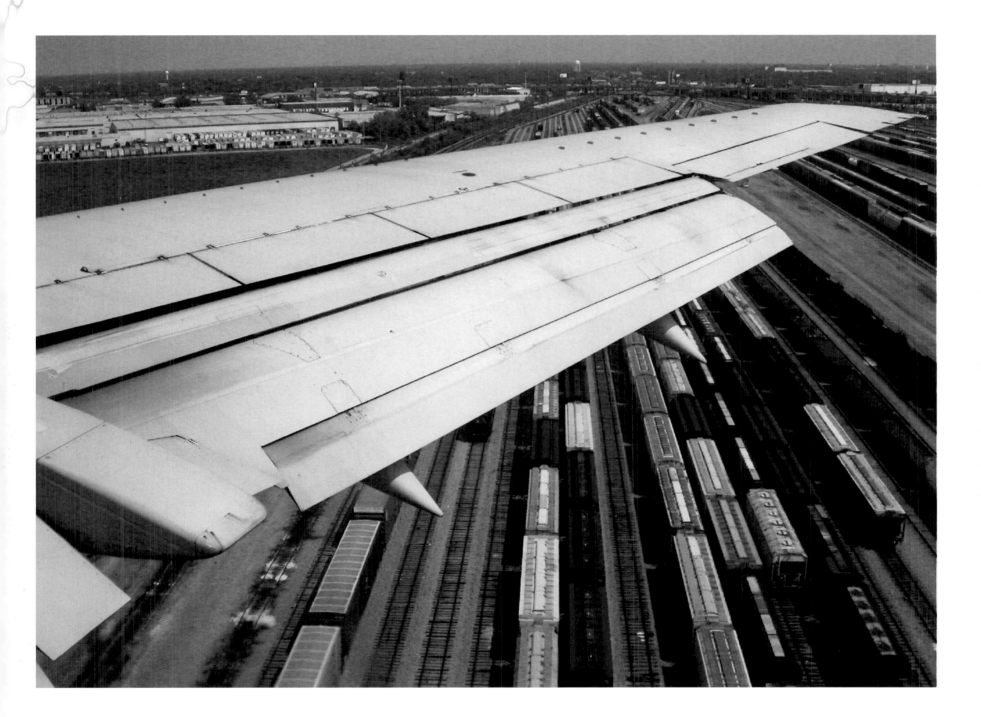

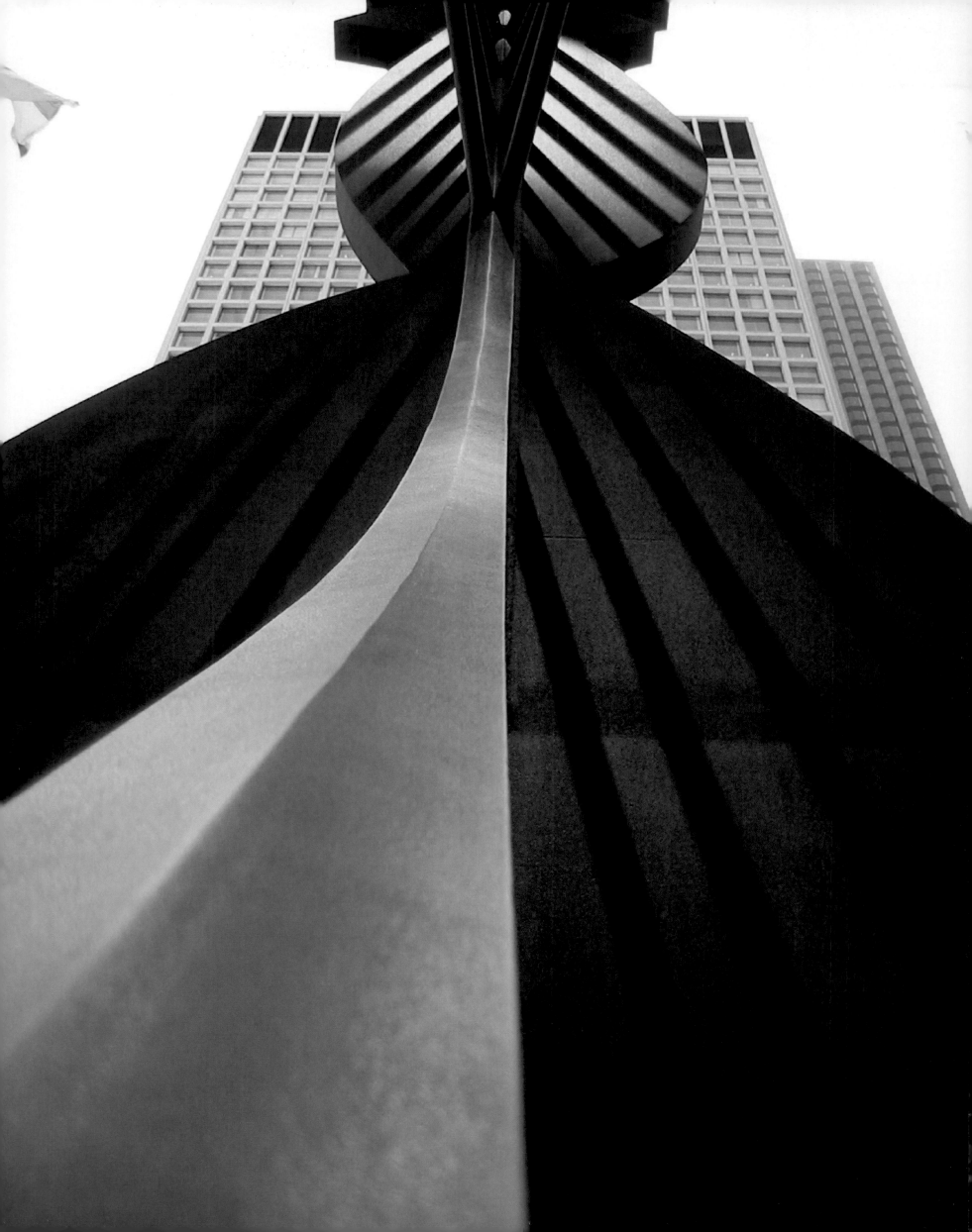

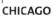

CHICAGO

When Pablo Picasso gifted Chicago with a 50-foot-tall, 162-ton sculpture for Daley Plaza in 1967, the shape-shifting yet elegant piece of steel didn't have a name, nor did the artist explain what, exactly, it was. Almost 40 years later, the "Chicago Picasso" is as beloved as the Cubs, but it remains as abstract and tough as the city itself.

Photo by Brett D. Hawthorne

CHICAGO

A spectacular feature of the Chicago Public Library when it opened in 1897, the leaded glass dome in the ceiling of Preston Bradley Hall is thought to be the largest dome ever produced by the Tiffany Glass and Decorating Company. Restored in 1991 by the people of Chicago, the library building now houses the Chicago Cultural Center.

Photo by Antoine F. Terry, AFT

CHICAGO

"I try to look at everything," says student photographer Matthew Wensing, 21. He snapped this picture looking up into the stairwell at Chicago's Museum of Contemporary Art, designed by Ber in architect Josef Paul Kleihues and opened in 1996.

Photo by Matthew Adam Wensing

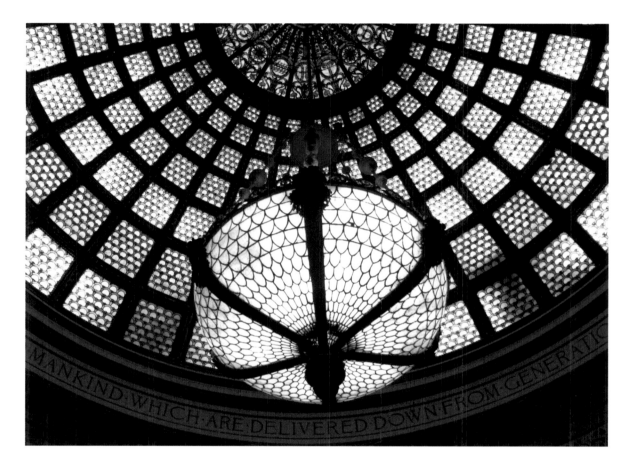

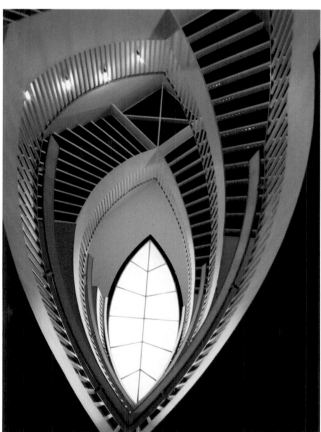

ROUTE 66

ROADSIDE ATTRACTION

1932 STANDARD OIL GAS STATION, ODELL, ILLINOIS
This restoration is a project of the Route 66 Association of
Illinois Presevation Committee. Identified November 9, 1997
on the National Register of Historic Places.
Recognized by Hampton Hotels Save-A-Landmark program as a site worth seeing

ODELL

Route 66, a storied, Depression-era
highway, stretched 2,448 miles from
Chicago to the beach in Santa Monica,
California. John Steinbeck called it "the
mother road." Motoring through Odell
(pop. 1,014), travelers filled 'er up at this
1932 Standard Oil filling station.
Renovated in 1998, it's now an official
Route 66 roadside attraction.
Photo by Michael Hettwer

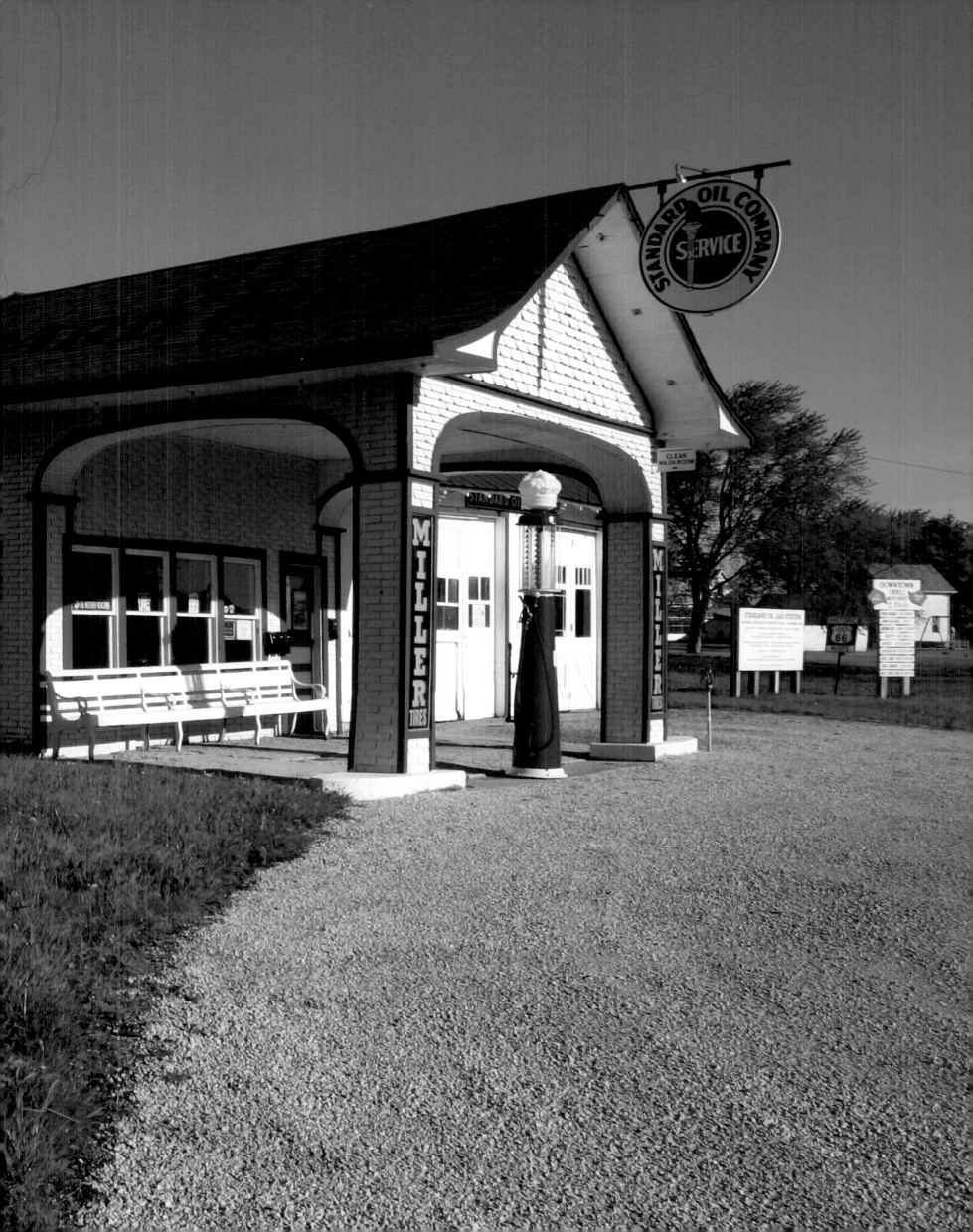

CAIRO

At one time, this southernmost Illinois city was a booming river town, host to more than 3,700 steamboats. Set behind 60-foot levies at the confluence of the Ohio and Mississippi Rivers, Cairo, or "kerro" as the locals call it, currently suffers from neglect despite efforts to save the downtown area.

Photo by Devin Miller, The Courier

HARVARD

Making hay while the sun sets: After a hard day of clearing large rocks from the family farm, Laura Dietz, 18, and boyfriend Kirk Meyer, 16, reward themselves with a slow dance on a hay wagon. Her brother David, 15, and sister Rosie, 11, seem delighted by the predinner show.
Photo by Greg Hess

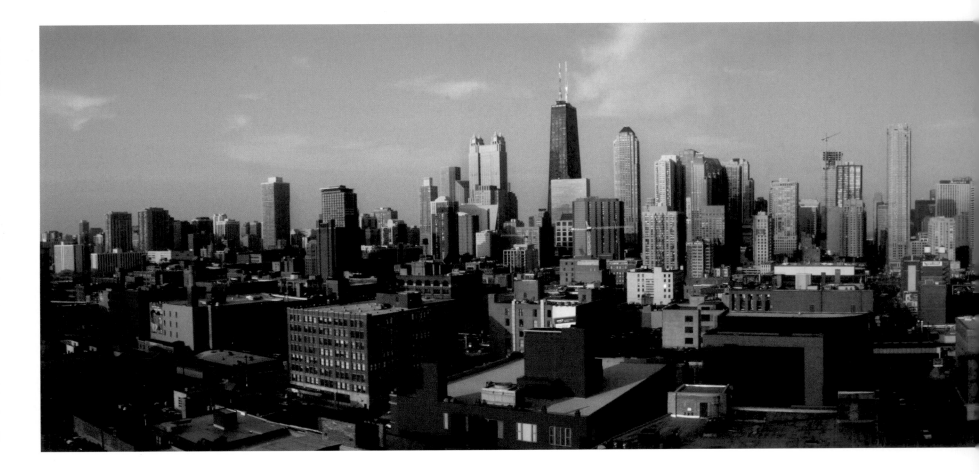

CHICAGO

Piled up at the edge of Lake Michigan, the "City of Big Shoulders" poses for afternoon and nighttime portraits, both taken from a 17th-floor apartment in the residential River North section. Punctuating the panoramas are the 1,129-foot John Hancock Center to the north and the 1,450-foot Sears Tower to the south. *Photos by Michael Hettwer*

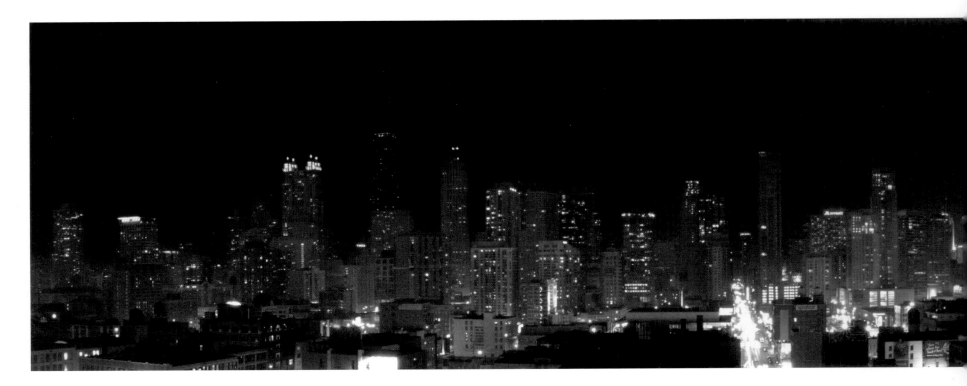

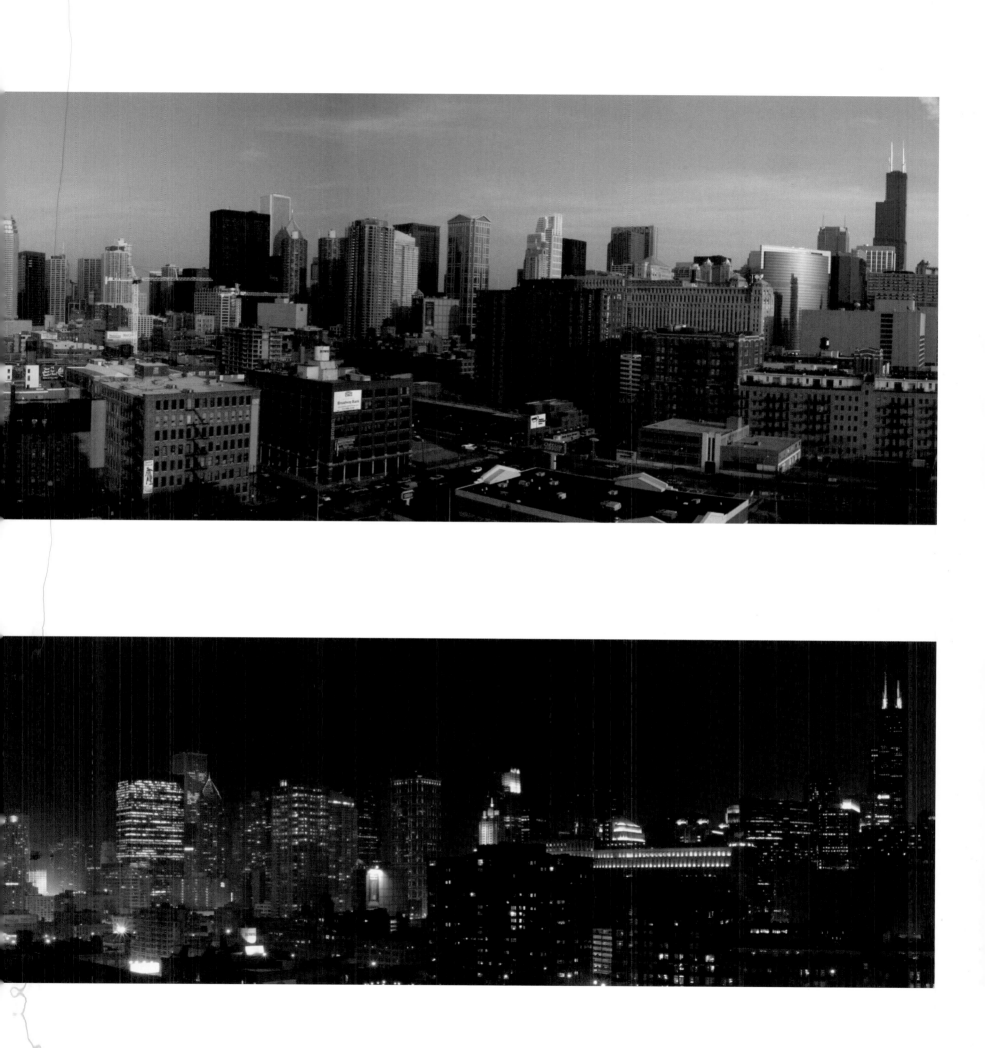

CHICAGO

The Michigan Avenue Bridge is one of 32 trunnion bascule (French for seesaw) moveable bridges spanning the Chicago River in downtown Chicago. Developed by local engineers at the turn of the century, they open up great metal jaws to allow tall boats, ships, and barges through. Trunnion bascule construction is so identified with the city that it's known internationally as "Chicago style."

Photo by Garrett Anglin

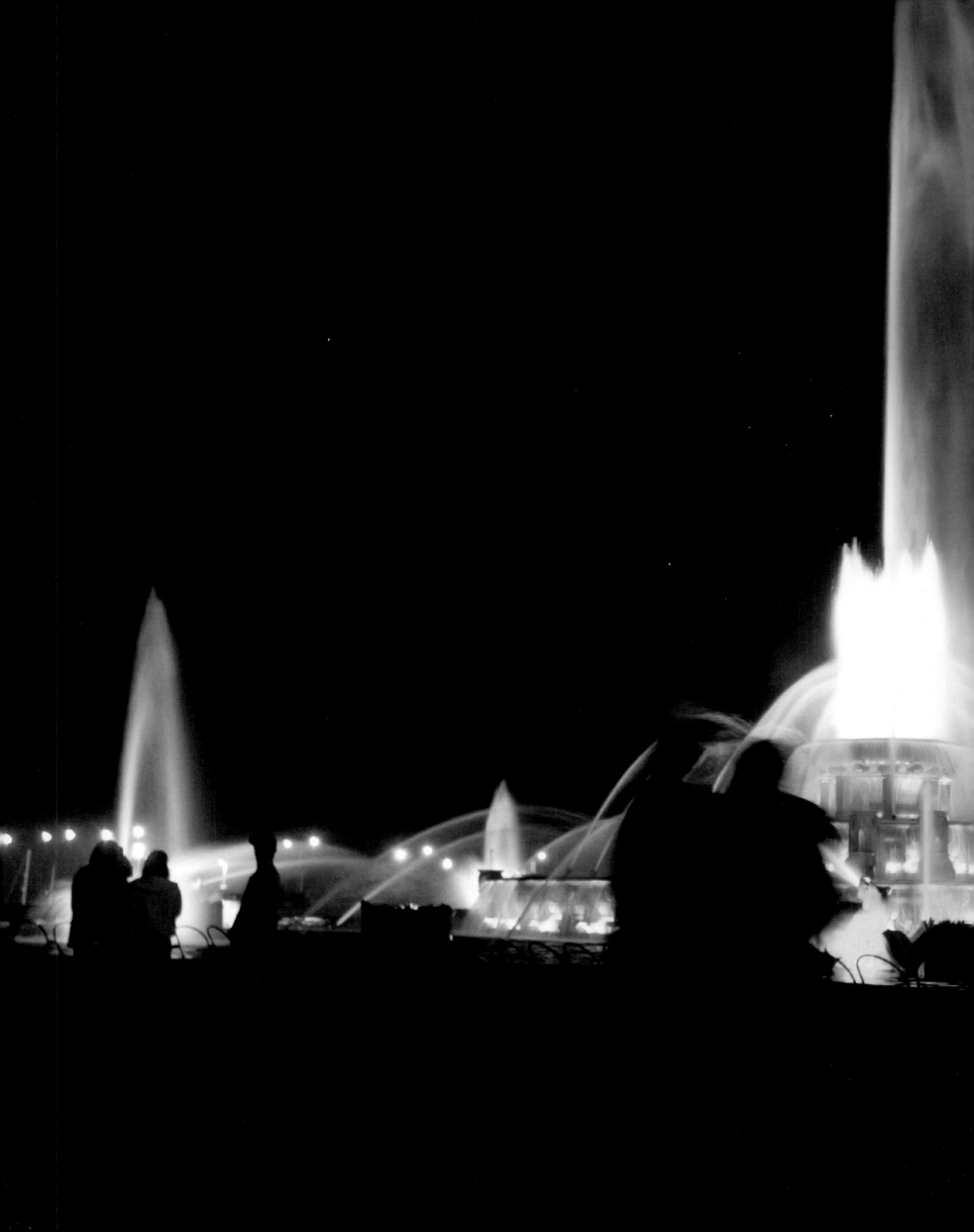

CHICAGO

A Chicago landmark, the Buckingham Fountain in Grant Park was the largest fountain in the world when it started splashing in 1927. On summer nights, it's illuminated with 820 lights. Perhaps the fountain's biggest claim to fame, however, was its starring role in the opening credits of the crude, late-'80s sitcom set in Chicago, *Married...with Children*.
Photo by Joel N. Lerner

The week of May 12-18, 2003, more than 25,000 professional and amateur photographers spread out across the nation to shoot over a million digital photographs with the goal of capturing the essence of daily life in America.

The professional photographers were equipped with Adobe Photoshop and Adobe Album software, Olympus C-5050 digital cameras, and Lexar Media's high-speed compact flash cards.

The 1,000 professional contract photographers plus another 5,000 stringers and students sent their images via FTP (file transfer protocol) directly to the *America 24/7* website. Meanwhile, thousands of amateur photographers uploaded their images to Snapfish's servers.

At *America 24/7*'s Mission Control headquarters, located at CNET in San Francisco, dozens of picture editors from the nation's most prestigious publications culled the images down to 25,000 of the very best, using Photo Mechanic by Camera Bits. These photos were transferred into Webware's ActiveMedia Digital Asset Management (DAM) system, which served as a central image library and enabled the designers to track, search, distribute, and reformat the images for the creation of the 51 books, foreign language editions, web and magazine syndication, posters, and exhibitions.

Once in the DAM, images were optimized (and in some cases resampled to increase image resolution) using Adobe Photoshop. Adobe InDesign and Adobe InCopy were used to design and produce the 51 books, which were edited and reviewed in multiple locations around the world in the form of Adobe Acrobat PDFs. Epson Stylus printers were used for photo proofing and to produce large-format images for exhibitions. The companies providing support for the *America 24/7* project offer many of the essential components for anyone building a digital darkroom. We encourage you to read more on the following pages about their respective roles in making *America 24/7* possible.

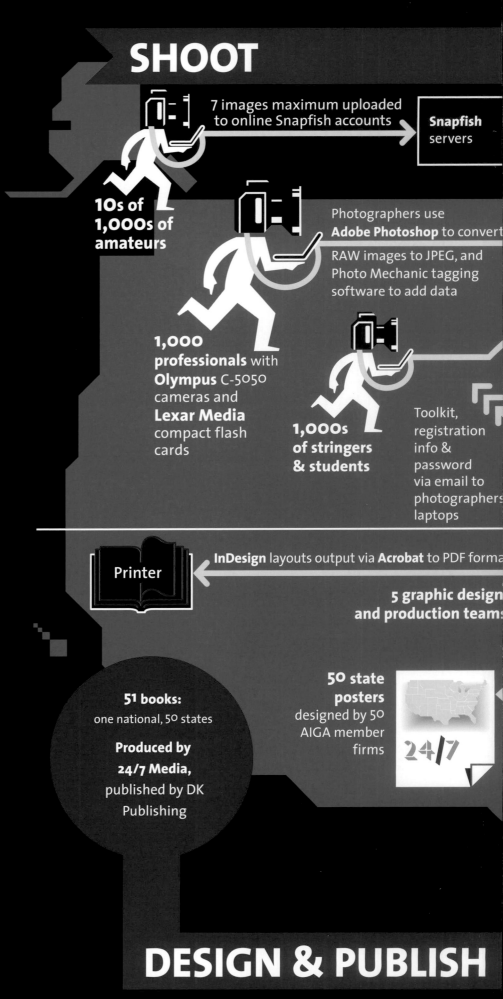

SHOOT

7 images maximum uploaded to online Snapfish accounts → **Snapfish** servers

10s of 1,000s of amateurs

Photographers use **Adobe Photoshop** to convert RAW images to JPEG, and Photo Mechanic tagging software to add data

1,000 professionals with **Olympus** C-5050 cameras and **Lexar Media** compact flash cards

1,000s of stringers & students

Toolkit, registration info & password via email to photographers laptops

Printer

InDesign layouts output via **Acrobat** to PDF format

5 graphic design and production teams

51 books: one national, 50 states

Produced by 24/7 Media, published by DK Publishing

50 state posters designed by 50 AIGA member firms

24/7

DESIGN & PUBLISH

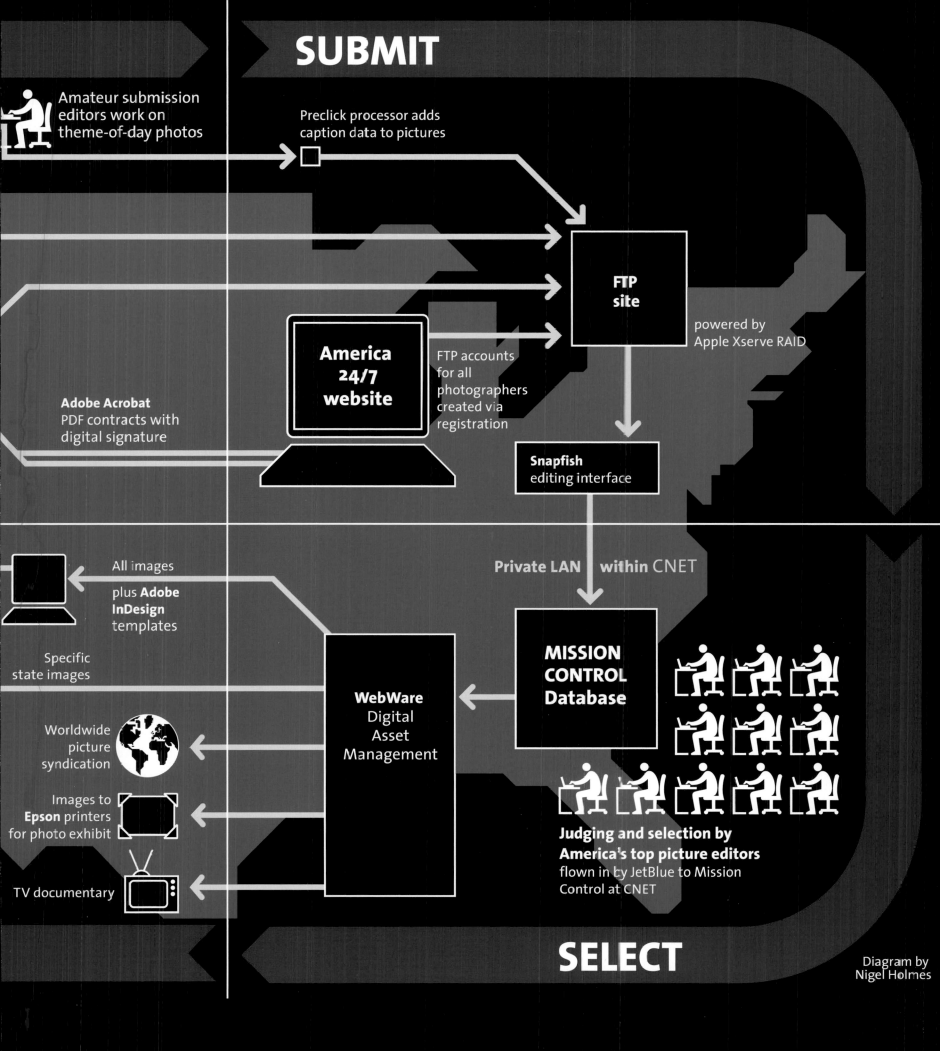

SUBMIT

Amateur submission editors work on theme-of-day photos

Preclick processor adds caption data to pictures

FTP site

powered by Apple Xserve RAID

America 24/7 website

FTP accounts for all photographers created via registration

Adobe Acrobat PDF contracts with digital signature

Snapfish editing interface

All images

plus **Adobe InDesign** templates

Specific state images

Private LAN **within** CNET

WebWare Digital Asset Management

MISSION CONTROL Database

Worldwide picture syndication

Images to **Epson** printers for photo exhibit

Judging and selection by America's top picture editors flown in by JetBlue to Mission Control at CNET

TV documentary

SELECT

Diagram by Nigel Holmes

About Our Sponsors

America 24/7 gave digital photographers of all levels the opportunity to share their visions of what it means to live in the United States. This project was made possible by a digital photography revolution that is dramatically changing and improving picture-taking for professionals and amateurs alike. And an Adobe product, Photoshop®, has been at the center of this sea change.

Adobe's products reflect our customers' passion for the creative process, be it the photographer, graphic designer, layout artist, or printer. Adobe is the Publishing and Imaging Software Partner for *America 24/7* and products such as Adobe InDesign®, Photoshop, Acrobat®, and Illustrator® were used to produce this stunning book in a matter of weeks. We hope that our software has helped do justice to the mythic images, contributed by well-known photographers and the inspired hobbyist.

Adobe is proud to be a lead sponsor of *America 24/7*, a project that celebrates the vibrancy of the American spirit: the same spirit that helped found Adobe and inspires our employees and customers to deliver the very best.

Bruce Chizen
President and CEO
Adobe Systems Incorporated

Olympus, a global technology leader in designing precision healthcare solutions and innovative consumer electronics, is proud to be the official digital camera sponsor of *America 24/7*. The opportunity to introduce Americans from coast to coast to the thrill, excitement, and possibility of digital photography makes the vision behind this book a perfect fit for Olympus, a leader in digital cameras since 1996.

For most people, the essence of digital photography is best grasped through firsthand experience with the technology, which is precisely what *America 24/7* is about. We understand that direct experience is the pathway to inspiration, and welcome opportunities like this sponsorship to bring the power of the digital experience into the lives of people everywhere. To Olympus, *America 24/7* offers a platform to help realize a core mission: to deliver and make accessible the power of the digital experience to millions of American photographers, amateurs, and professionals alike.

The 1,000 professional photographers contracted to shoot on the America 24/7 project were all equipped with Olympus C-5050 digital cameras. Like all Olympus products, the C-5050 is offered by a company well known for designing, manufacturing, and servicing products used by professionals to perform their work, every day. Olympus is a customer-centric company committed to working one-to-one with a diverse group of professionals. From biomedical researchers who use our clinical microscopes, to doctors who perform life-saving procedures with our endoscopes, to professional photographers who use cameras in their daily work, Olympus is a trusted brand.

The digital imaging technology involved with *America 24/7* has enabled the soul of America to be visually conveyed, not just by professional observers, but by the American public who participated in this project—the very people who collectively breath life into this country's existence each day.

We are proud to be enabling so many photographers to capture the pictures on these pages that tell the story of who we are as a nation. From sea to shining sea, digital imagery allows us to connect to one another in ways we never dreamed possible.

At Olympus, our ideas have proliferated as rapidly as technology has evolved. We have channeled these visions into breakthrough products and solutions to meet the demands of our changing world-products like microscopes, endoscopes, and digital voice recorders, supported by the highly regarded training, educational, and consulting services we offer our customers.

Today, 83 years after we introduced our first microscope, we remain as young, as curious, and as committed as ever.

Lexar Media has grown from the digital photography revolution, which is why we are proud to have supplied the digital memory cards used in the America 24/7 project. Lexar Media's high-performance memory cards utilize our unique and patented controller coupled with high-speed flash memory from Samsung, the world's largest flash memory supplier. This powerful combination brings out the ultimate performance of any digital camera.

Photographers who demand the most from their equipment choose our products for their advanced features like write speeds up to 40X, Write Acceleration technology for enabled cameras, and Image Rescue, which recovers previously deleted or lost images. Leading camera manufacturers bundle Lexar Media digital memory cards with their cameras because they value its performance and reliability.

Lexar Media is at the forefront of digital photography as it transforms picture-taking worldwide, and we will continue to be a leader with new and innovative solutions for professionals and amateurs alike.

Snapfish, which developed the technology behind the *America 24/7* amateur photo event, is a leading online photo service, with more than 5 million members and 100 million photos posted online. Snapfish enables both film and digital camera owners to share, print, and store their most important photo memories, at prices that cannot be equaled. Digital camera users upload photos into a password-protected online album for free. Users can also order film-quality prints on professional photographic paper for as low as 25¢. Film camera users get a full set of prints, plus online sharing and storage, for just $2.99 per roll.

Founded in 1995, eBay created a powerful platform for the sale of goods and services by a passionate community of individuals and businesses. On any given day, there are millions of items across thousands of categories for sale on eBay. eBay enables trade on a local, national and international basis with customized sites in markets around the world.

Through an array of services, such as its payment solution provider PayPal, eBay is enabling global e-commerce for an ever-growing online community.

JetBlue Airways is proud to be *America 24/7's* preferred carrier, flying photographers, photo editors, and organizers across the United States.

Winner of Condé Nast Traveler's Readers' Choice Awards for Best Domestic Airline 2002, JetBlue provides friendly service and low fares for travelers in 22 cities in nine states across America.

On behalf of JetBlue's 5,000 crew members, we're excited to be involved in this remarkable project, and for the opportunity to serve American travelers each and every day, coast to coast, 24/7.

DIGITAL POND

Digital Pond has been a leading creator of large graphic displays for museums, corporations, trade shows, retail environments and fine art since 1992.

We were proud to bring together our creative, print and display capabilities to produce signage and displays for mission control, critical retouching for numerous key images for the book, and art galleries for the New York Public Library and Bryant Park.

The Pond's team and SplashPic® Online service enabled us to nimbly design, produce and install over 200 large graphic panels in two NYC locations within the truly "24/7" production schedule of less than ten days.

WebWare Corporation is pleased to be a major sponsor of the America 24/7 project. We take pride in being part of a groundbreaking adventure that is stretching the boundaries—and the imagination—in digital photography, digital asset management, publishing, news, and global events.

Our ActiveMedia Enterprise™ digital asset management software is the "nerve center" of *America 24/7*, the central repository for managing, sharing, and collaborating on the project's photographs. From photo editors and book publishers to 24/7's media relations and marketing personnel, ActiveMedia provides the application support that links all facets of the project team to the content worldwide.

WebWare helps Global 2000 firms securely manage, reuse, and distribute media assets locally or globally. Its suite of ActiveMedia software products provide powerful media services platforms for integrating rich media into content management systems marketing and communication portals; web publishing systems; and e-commerce portals.

Google™

Google's mission is to organize the world's information and make it universally accessible and useful.

With our focus on plucking just the right answer from an ocean of data, we were naturally drawn to the America 24/7 project. The book you hold is a compendium of images of American life distilled from thousands of photographs and infinite possibilities. Are you looking for emotion? Narrative? Shadows? Light? It's all here, thanks to a multitude of photographers and writers creating links between you, the reader, and a sea of wonderful stories. We celebrate the connections that constitute the human experience and are pleased to help engender them. And we're pleased to have been a small part of this project, which captures the results of that interaction so vividly, so dynamically, and so dramatically.

Special thanks to additional contributors: FileMaker, Apple, Camera Bits, LaCie, Now Software, Preclick, Outpost Digital, Xerox, Microsoft, WoodWing Software, net-linx Publishing Solutions, and Radical Media. The Savoy Hotel, San Francisco; The Pan Pacific, San Francisco; Four Seasons Hotel, San Francisco; and The Queen Anne Hotel. Photography editing facilities were generously hosted by CNET Networks, Inc.

Participating Photographers

Coordinator: Steve Warmowski, Photo Editor, *Jacksonville Journal-Courier*

Garrett Anglin
Mark A. Becker
Chuck Cass
Chris Curry, *Journal Star*
Robert A. Davis, *Chicago Sun-Times*
Holly Digney
John Dunlevy
Adam Ford
Cesar Gabriel
Alex Garcia*
Rowan Gillson
Lynda Gleim
Brett D. Hawthorne
Troy T. Heinzeroth
Greg Hess
Michael Hettwer
Reed Hoffmann, Freelance
Bill Hough
Michael Hudson
Allen Kaleta
Denise Keim
Tim Klein
Charles Koehler
Scott Kolbe

John Krol
Jean Lachat
Juli Leonard
Joel N. Lerner
Jake JK Levandowski
Jon Lowenstein, Aurora
Devin Miller, *The Courier*
Todd Mizener
Kimber Nichols
Jon Peterson
Teak Phillips
T.J. Salsman, *The State Journal-Register*
Joel Sattler
Tom Sistak
David M. Solzman
Clayton Stalter
Scott Strazzante, *Chicago Tribune*
Antoine F. Terry, AFT
Stuart Thurlkill
Steve Warmowski, *Jacksonville Journal-Courier*
Matthew Adam Wensing
Fred Zwicky
* **Pulitzer Prize winner**

Thumbnail Picture Credits

Credits for thumbnail photographs are listed by the page number and are in order from left to right.

20 Antoine F. Terry, AFT
Juli Leonard
Chuck Cass
Chuck Cass
Alex Garcia
Chuck Cass
Erin Chan, *Northwestern University*

21 Robert A. Davis, *Chicago Sun-Times*
Elizabeth Fisco
Will Okun
Robert A. Davis, *Chicago Sun-Times*
Juli Leonard
Chuck Cass
Will Okun

26 Michael Hettwer
Bernadette Miranda
Michelle Milne
Michael Hettwer
Michael Hettwer
Kye Podshadley
Jean Lachat

27 Michael Hettwer
Kye Podshadley
Troy T. Heinzeroth
Michael Hettwer
Troy T. Heinzeroth
Michael Hettwer
Troy T. Heinzeroth

28 Alex Garcia
Clayton Stalter
Dennis Garrels
Todd Mizener
Robert A. Davis, *Chicago Sun-Times*
Robert A. Davis, *Chicago Sun-Times*
Robert A. Davis, *Chicago Sun-Times*

29 Michael Hudson
Robert A. Davis, *Chicago Sun-Times*
Tom Sistak
Stuart Thurlkill
Steve Jahnke
Scott Strazzante, *Chicago Tribune*
Todd Mizener

30 Juli Leonard
Tim Klein
Juli Leonard
Leah Missbach
Holly Digney
Robert A. Davis, *Chicago Sun-Times*
Stuart Thurlkill

32 Chuck Cass
Stuart Thurlkill
Stuart Thurlkill
Robert A. Davis, *Chicago Sun-Times*
Chuck Cass
Antoine F. Terry, AFT
Tim Klein

33 Stuart Thurlkill
Michael Hettwer
Stuart Thurlkill
Clayton Stalter
Robert A. Davis, *Chicago Sun-Times*
Stuart Thurlkill
Fred Zwicky

34 Derek Anderson
Juli Leonard
Elizabeth Fisco
Juli Leonard
Joel N. Lerner
Stuart Thurlkill
Joel N. Lerner

35 Alex Garcia
Tim Klein
Tim Klein
Tom Sistak
William A. Rice
Juli Leonard
Tim Klein

36 Denise Keim
Juli Leonard
Holly Digney
Juli Leonard
Juli Leonard
Juli Leonard
Juli Leonard

37 Juli Leonard
Juli Leonard
Juli Leonard
Juli Leonard
Juli Leonard
Juli Leonard
Robert A. Davis, *Chicago Sun-Times*

38 Denise Keim
Devin Miller, *The Courier*
Michael Hettwer
Dan Lucas, *The Daily Illini*
Jean Lachat
Gina McLaughlin
Josh Ritchie

39 Jon Lowenstein, Aurora
Jon Lowenstein, Aurora

Gina McLaughlin
Denise Keim
Victor Limjoco, *Northwestern University*
Mark A. Becker
Scott Strazzante, *Chicago Tribune*

40 Alex Garcia
Greg Hess
Chris Curry, *Journal Star*
Carol L. Jones, *The Daily Illini*
Greg Hess
Greg Hess
Greg Hess

41 Greg Hess
Greg Hess
Travis E. McKelvie
Steve Warmowski, *Jacksonville Journal-Courier*
Steve Warmowski, *Jacksonville Journal-Courier*
Greg Hess
Travis E. McKelvie

44 Denise Keim
Denise Keim
Denise Keim
Rachael L. Silvers
Denise Keim
William A. Rice
Rachael L. Silvers

46 Alex Garcia
Michael Hudson
Alex Garcia
William A. Rice
Michael Hudson
Dennis Garrels
Chuck Cass

47 Michael Hudson
David M. Solzman
Alex Garcia
Jonathan Murray, *Northwestern University*
Matthew Adam Wensing
Victor Limjoco, *Northwestern University*
Tom Sistak

48 Carol L. Jones, *The Daily Illini*
Alex Garcia
Alex Garcia
Fred Zwicky
Alex Garcia
Fred Zwicky
Carol L. Jones, *The Daily Illini*

49 Dan Lucas, *The Daily Illini*
Fred Zwicky
Carol L. Jones, *The Daily Illini*
Carol L. Jones, *The Daily Illini*
Fred Zwicky
Chuck Cass
Fred Zwicky

50 David M. Solzman
Juli Leonard
Michael Hettwer
Fred Zwicky
T.J. Salsman, *The State Journal-Register*
Michael Hettwer
Stuart Thurlkill

51 Michael Hettwer
Jean Lachat
Michael Hettwer
Michael Hudson
Tom Sistak
Michael Hudson
Troy T. Heinzeroth

52 Devin Miller, *The Courier*
Tim Klein
Juli Leonard
Rachael L. Silvers
Scott Strazzante, *Chicago Tribune*
Scott Strazzante, *Chicago Tribune*
Scott Strazzante, *Chicago Tribune*

53 Will Okun
Scott Strazzante, *Chicago Tribune*
Scott Strazzante, *Chicago Tribune*
Tim Klein
Tim Klein
Will Okun
Tim Klein

54 Alex Garcia
Reed Hoffmann, Freelance
Tim Klein
Denise Keim
Tim Klein
Jessamyn North
Denise Keim

55 Tim Klein
Stuart Thurlkill
Jon Lowenstein, Aurora
Bernadette Miranda

Tim Klein
Will Okun
Troy T. Heinzeroth

64 Juli Leonard
Devin Miller, *The Courier*
Juli Leonard
Scott Strazzante, *Chicago Tribune*
Juli Leonard
Robert A. Davis, *Chicago Sun-Times*
Robert A. Davis, *Chicago Sun-Times*
Robert A. Davis, *Chicago Sun-Times*
Robert A. Davis, *Chicago Sun-Times*
Robert A. Davis, *Chicago Sun-Times*
Denise Keim
Robert A. Davis, *Chicago Sun-Times*
Juli Leonard
Tim Klein

68 Michael Hettwer
Michael Hettwer
Robert A. Davis, *Chicago Sun-Times*
Robert A. Davis, *Chicago Sun-Times*
Michael Hettwer
Clayton Stalter
Michael Hettwer

69 Robert A. Davis, *Chicago Sun-Times*
Robert A. Davis, *Chicago Sun-Times*
Robert A. Davis, *Chicago Sun-Times*
Robert A. Davis, *Chicago Sun-Times*
Robert A. Davis, *Chicago Sun-Times*
Troy T. Heinzeroth
Troy T. Heinzeroth

70 Troy T. Heinzeroth
Troy T. Heinzeroth
Troy T. Heinzeroth
Steve Warmowski, *Jacksonville Journal-Courier*
Greg Hess
Troy T. Heinzeroth
Todd Mizener

71 Todd Mizener
Todd Mizener
Todd Mizener
Todd Mizener
Todd Mizener
Todd Mizener
Steve Warmowski, *Jacksonville Journal-Courier*

74 Robert A. Davis, *Chicago Sun-Times*
Michael Hettwer
Robert A. Davis, *Chicago Sun-Times*
Michael Hettwer
Robert A. Davis, *Chicago Sun-Times*
Michael Hettwer
Michael Hettwer

75 Robert A. Davis, *Chicago Sun-Times*
Scott Strazzante, *Chicago Tribune*
Scott Strazzante, *Chicago Tribune*
Adam Ford
Steve Warmowski, *Jacksonville Journal-Courier*
Scott Strazzante, *Chicago Tribune*
Scott Strazzante, *Chicago Tribune*

76 Tim Klein
Tim Klein
Michael Hettwer
Tim Klein
Tim Klein
Tim Klein
Tim Klein

77 T.J. Salsman, *The State Journal-Register*
Tim Klein
Tim Klein
Tim Klein
Tim Klein
Tim Klein
Juli Leonard

78 Robert A. Davis, *Chicago Sun-Times*
Robert A. Davis, *Chicago Sun-Times*
Robert A. Davis, *Chicago Sun-Times*
Robert A. Davis, *Chicago Sun-Times*
Fred Zwicky
Denise Keim
Michael Hettwer

79 Brett D. Hawthorne
Chuck Cass
Brett D. Hawthorne
Michael Hettwer
Brett D. Hawthorne
Troy T. Heinzeroth
Troy T. Heinzeroth

80 Travis E. McKelvie
Steve Warmowski, *Jacksonville Journal-Courier*
Denise Keim
Steve Warmowski, *Jacksonville Journal-Courier*

Denise Keim
Steve Warmowski, *Jacksonville Journal-Courier*
Denise Keim

81 Greg Hess
Greg Hess
Greg Hess
Greg Hess
Teak Phillips
Greg Hess
Steve Warmowski, *Jacksonville Journal-Courier*

84 Tannen H. Maury
Robert A. Davis, *Chicago Sun-Times*
Robert A. Davis, *Chicago Sun-Times*
Michael Hettwer
Robert A. Davis, *Chicago Sun-Times*
Robert A. Davis, *Chicago Sun-Times*
Robert A. Davis, *Chicago Sun-Times*

85 Travis E. McKelvie
Michael Hettwer
Steve Warmowski, *Jacksonville Journal-Courier*
Robert A. Davis, *Chicago Sun-Times*
Michael Hettwer
Travis E. McKelvie
Steve Warmowski, *Jacksonville Journal-Courier*

86 Todd Mizener
Troy T. Heinzeroth
Scott Strazzante, *Chicago Tribune*
Todd Mizener
Teak Phillips
Todd Mizener
Troy T. Heinzeroth

87 Todd Mizener
Todd Mizener
Todd Mizener
Todd Mizener
Todd Mizener
Todd Mizener
Todd Mizener

92 Fred Zwicky
Greg Hess
Greg Hess
Stuart Thurlkill
Laura Thompson, *Harrisburg High School*
Laura Thompson, *Harrisburg High School*
Greg Hess

93 Laura Thompson, *Harrisburg High School*
Jon Lowenstein, Aurora
Greg Hess
Michael Hettwer
Greg Hess
Stuart Thurlkill
Laura Thompson, *Harrisburg High School*

98 Steve Warmowski, *Jacksonville Journal-Courier*
Fred Zwicky
Devin Miller, *The Courier*
Steve Warmowski, *Jacksonville Journal-Courier*
David M. Solzman
Devin Miller, *The Courier*
Denise Keim

99 Devin Miller, *The Courier*
Denise Keim
Guido Strotheide, *Jacksonville Journal-Courier*
Steve Warmowski, *Jacksonville Journal-Courier*
Antoine F. Terry, AFT
Matt Maldre
Steve Warmowski, *Jacksonville Journal-Courier*

100 Denise Keim
Denise Keim
Denise Keim
Jeffrey Veltman, *JBInteraction.com*
Denise Keim
Jonathan Murray, *Northwestern University*
Joel N. Lerner

101 Michael Hettwer
Joel N. Lerner
Denise Keim
Steve Warmowski, *Jacksonville Journal-Courier*
Joel N. Lerner
Steve Warmowski, *Jacksonville Journal-Courier*
Robert A. Davis, *Chicago Sun-Times*

104 Antoine F. Terry, AFT
Erin Chan, *Northwestern University*
Tim Klein
Joel N. Lerner
Greg Hess
Joel N. Lerner
Mike Jarecki

105 Holly Digney
Joel N. Lerner
Joel N. Lerner
Joel N. Lerner

David M. Solzman
Joel N. Lerner
Tim Klein

106 Jennifer VanBrooker
Stuart Thurlkill
Steve Warmowski, *Jacksonville Journal-Courier*
Steve Warmowski, *Jacksonville Journal-Courier*
Steve Warmowski, *Jacksonville Journal-Courier*
Rowan Gillson
Stuart Thurlkill

107 Richard A. Chapman
Steve Warmowski, *Jacksonville Journal-Courier*
Steve Warmowski, *Jacksonville Journal-Courier*
Rowan Gillson
Jennifer VanBrooker
Steve Warmowski, *Jacksonville Journal-Courier*
Stuart Thurlkill

108 Danielle Broude
Danielle Broude
Tom Sistak
Fred Zwicky
Fred Zwicky
Todd Mizener
Esther Chou

109 Esther Chou
T.J. Salsman, *The State Journal-Register*
Scott Strazzante, *Chicago Tribune*
Scott Strazzante, *Chicago Tribune*
Todd Mizener
Mark A. Becker
Todd Mizener

112 Denise Keim
Tim Klein
Denise Keim
Robert A. Davis, *Chicago Sun-Times*
Robert A. Davis, *Chicago Sun-Times*
Jeffrey Veltman, *JBInteraction.com*
Robert A. Davis, *Chicago Sun-Times*

113 Robert A. Davis, *Chicago Sun-Times*
Robert A. Davis, *Chicago Sun-Times*
Joel N. Lerner
Steve Warmowski, *Jacksonville Journal-Courier*
Robert A. Davis, *Chicago Sun-Times*
Rachael L. Silvers
Todd Mizener

116 Greg Hess
Clayton Stalter
Greg Hess
Fred Zwicky
Greg Hess
Maira Schriber
Chris Curry, *Journal Star*

117 Greg Hess
Dennis Garrels
Scott Strazzante, *Chicago Tribune*
Victor Limjoco, *Northwestern University*
Scott Strazzante, *Chicago Tribune*
Scott Strazzante, *Chicago Tribune*
Joy L. Jensen

118 Mark A. Becker
Devin Miller, *The Courier*
Dennis Garrels
Scott Strazzante, *Chicago Tribune*
Mark A. Becker
Scott Strazzante, *Chicago Tribune*
Scott Strazzante, *Chicago Tribune*

119 Scott Strazzante, *Chicago Tribune*
Scott Strazzante, *Chicago Tribune*
Devin Miller, *The Courier*
Sarah Ehrler
Stuart Thurlkill
Tim Klein
William A. Rice

123 Bernadette Miranda
Allen Kaleta
T.J. Salsman, *The State Journal-Register*
T.J. Salsman, *The State Journal-Register*
T.J. Salsman, *The State Journal-Register*
T.J. Salsman, *The State Journal-Register*
T.J. Salsman, *The State Journal-Register*

124 Denise Keim
Michael Hettwer
Michael Hettwer
Denise Keim
Antoine F. Terry, AFT
Juli Leonard
Michael Hettwer

125 Denise Keim
Michael Hettwer
David M. Solzman
Matthew Adam Wensing
Bernadette Miranda

Michael Hettwer
Michael Hettwer

126 Robert A. Davis, *Chicago Sun-Times*
Jessamyn North
Juli Leonard
Greg Hess
Juli Leonard
Jessamyn North
Scott Strazzante, *Chicago Tribune*

127 Stuart Thurlkill
Stuart Thurlkill
Stuart Thurlkill
Greg Hess
Stuart Thurlkill
Stuart Thurlkill
Todd Mizener

130 Josh Ritchie
Fred Zwicky
Josh Ritchie
Fred Zwicky
Josh Ritchie
Josh Ritchie
Josh Ritchie

131 Josh Ritchie
Josh Ritchie
Josh Ritchie
Josh Ritchie
Fred Zwicky
Fred Zwicky
Josh Ritchie

132 Alex Garcia
Alex Garcia
Alex Garcia
Alex Garcia
Steve Warmowski, *Jacksonville Journal-Courier*
Steve Warmowski, *Jacksonville Journal-Courier*

133 Alex Garcia
Alex Garcia
Alex Garcia
Alex Garcia
Alex Garcia
Will Okun
Will Okun

136 Michael Hettwer
Chuck Cass
Chuck Cass
Michael Hettwer
Maira Schriber
Fred Zwicky
Matthew Adam Wensing

137 Robert A. Davis, *Chicago Sun-Times*
Chuck Cass
Michael Hettwer
Chuck Cass
Troy T. Heinzeroth
Robert A. Davis, *Chicago Sun-Times*
Todd Mizener

146 Alex Garcia
Garrett Anglin
Alex Garcia
Garrett Anglin
Alex Garcia
Denise Keim
Alex Garcia

147 Garrett Anglin
Michael Hettwer
Garrett Anglin
Juli Leonard
Scott Strazzante, *Chicago Tribune*
Garrett Anglin
Bernadette Miranda

148 Garrett Anglin
Alex Garcia
Matt Maldre
Robert A. Davis, *Chicago Sun-Times*
Stuart Thurlkill
Garrett Anglin
Matt Maldre

149 Matt Maldre
Garrett Anglin
Michael Hettwer
Antoine F. Terry, AFT
Rowan Gillson
Alex Garcia
Rowan Gillson

150 Joy L. Jensen
Amanda Katzenstein, *Northwestern University*
Garrett Anglin
Jessamyn North
Joy L. Jensen
Amanda Katzenstein, *Northwestern University*
Jessamyn North

151 Jessamyn North
Antoine F. Terry, AFT
Rowan Gillson
Rowan Gillson
Garrett Anglin
Rowan Gillson
Amanda Katzenstein, *Northwestern University*

152 Matt Maldre
Scott Strazzante, *Chicago Tribune*
Steve Warmowski, *Jacksonville Journal-Courier*
Will Okun
Scott Strazzante, *Chicago Tribune*
Scott Strazzante, *Chicago Tribune*
Steve Warmowski, *Jacksonville Journal-Courier*

153 Matthew Adam Wensing
Wayne C. Lee
Scott Strazzante, *Chicago Tribune*
Steve Warmowski, *Jacksonville Journal-Courier*
Wayne C. Lee
Wayne C. Lee
Will Okun

158 Alex Garcia
Juli Leonard
Alex Garcia
Bernadette Miranda
Denise Keim
Joel N. Lerner
Joel N. Lerner

159 Joel N. Lerner
Mark A. Becker
Maira Schriber
Michelle Milne
Mark A. Becker
Steve Warmowski, *Jacksonville Journal-Courier*
T.J. Salsman, *The State Journal-Register*

160 Matt Maldre
John Dunlevy
Bernadette Miranda
Pierre Burnaugh, *Culture Image*
Robert A. Davis, *Chicago Sun-Times*
Antoine F. Terry, AFT
Mark A. Becker

161 Robert A. Davis, *Chicago Sun-Times*
Stuart Thurlkill
Jessamyn North
Robert A. Davis, *Chicago Sun-Times*
Robert A. Davis, *Chicago Sun-Times*
Robert A. Davis, *Chicago Sun-Times*
Stuart Thurlkill

164 Alex Garcia
Troy T. Heinzeroth
Dennis Garrels
Alex Garcia
Antoine F. Terry, AFT
Curtis Staiger
Holly Digney

165 Denise Keim
Scott Strazzante, *Chicago Tribune*
Jon Lowenstein, Aurora
Dan Lucas, *The Daily Illini*
Alex Garcia
David M. Solzman
Troy T. Heinzeroth

173 Alex Garcia
Fred Zwicky
Robert A. Davis, *Chicago Sun-Times*
Scott Strazzante, *Chicago Tribune*
Reed Hoffmann, Freelance
Robert A. Davis, *Chicago Sun-Times*
Maira Schriber

175 Jessamyn North
Brett D. Hawthorne
Michael Hettwer
Antoine F. Terry, AFT
Michael Hettwer
Matthew Adam Wensing
Michael Hettwer

178 Brett D. Hawthorne
Duane Lofton Photography
Gina McLaughlin
Devin Miller, *The Courier*
Joel N. Lerner
Mike Jarecki
Matt Maldre

179 Matt Maldre
Joel N. Lerner
Sarah Ehrler
Greg Hess
Stuart Thurlkill
Stuart Thurlkill
T.J. Salsman, *The State Journal-Register*

Staff

The *America 24/7* series was imagined years ago by our friend Oscar Dystel, a publishing legend whose vision and enthusiasm have been a source of great inspiration.

We also wish to express our gratitude to our truly visionary publisher, DK.

Rick Smolan, Project Director
David Elliot Cohen, Project Director

Administrative
Katya Able, Operations Director
Gina Privitere, Communications Director
Chuck Gathard, Technology Director
Kim Shannon, Photographer Relations Director
Erin O'Connor, Photographer Relations Intern
Leslie Hunter, Partnership Director
Annie Polk, Publicity Manager
John McAlester, Website Manager
Alex Notides, Office Manager
C. Thomas Hardin, State Photography Coordinator

Design
Brad Zucroff, Creative Director
Karen Mullarkey, Photography Director
Judy Zimola, Production Manager
David Simoni, Production Designer
Mary Dias, Production Designer
Heidi Madison, Associate Picture Editor
Don McCartney, Production Designer
Diane Dempsey Murray, Production Designer
Jan Rogers, Associate Picture Editor
Bill Shore, Production Designer and Image Artist
Larry Nighswander, Senior Picture Editor
Bill Marr, Sarah Leen, Senior Picture Editors
Peter Truskier, Workflow Consultant
Jim Birkenseer, Workflow Consultant

Editorial
Maggie Canon, Managing Editor
Curt Sanburn, Senior Editor
Teresa L. Trego, Production Editor
Lea Aschkenas, Writer
Olivia Boler, Writer
Korey Capozza, Writer
Beverly Hanly, Writer
Bridgett Novak, Writer
Alison Owings, Writer
Fred Raker, Writer
Joe Wolff, Writer
Elise O'Keefe, Copy Chief
Daisy Hernández, Copy Editor
Jennifer Wolfe, Copy Editor

Infographic Design
Nigel Holmes

Literary Agent
Carol Mann, The Carol Mann Agency

Legal Counsel
Barry Reder, Coblentz, Patch, Duffy & Bass, LLP
Phil Feldman, Coblentz, Patch, Duffy & Bass, LLP
Gabe Perle, Ohlandt, Greeley, Ruggiero & Perle, LLP
Jon Hart, Dow, Lohnes & Albertson, PLLC
Mike Hays, Dow, Lohnes & Albertson, PLLC
Stephen Pollen, Warshaw Burstein, Cohen, Schlesinger & Kuh, LLP
Rick Pappas

Accounting and Finance
Rita Dulebohn, Accountant
Robert Powers, Calegari, Morris & Co. Accountants
Eugene Blumberg, Blumberg & Associates
Arthur Langhaus, KLS Professional Advisors Group, Inc.

Picture Editors
J. David Ake, Associated Press
Caren Alpert, formerly *Health* magazine
Simon Barnett, *Newsweek*
Caroline Couig, *San Jose Mercury News*
Mike Davis, formerly *National Geographic*
Michel duCille, *Washington Post*
Deborah Dragon, *Rolling Stone*
Victor Fisher, formerly Associated Press
Frank Folwell, *USA Today*
MaryAnne Golon, *Time*
Liz Grady, formerly *National Geographic*
Randall Greenwell, *San Francisco Chronicle*
C. Thomas Hardin, formerly *Louisville Courier-Journal*
Kathleen Hennessy, *San Francisco Chronicle*
Scot Jahn, *U.S. News & World Report*
Steve Jessmore, *Flint Journal*
John Kaplan, University of Florida
Kim Komenich, *San Francisco Chronicle*
Eliane Laffont, *Hachette Filipacchi Media*
Jean-Pierre Laffont, *Hachette Filipacchi Media*
Andrew Locke, MSNBC
Jose Lopez, *The New York Times*
Maria Mann, formerly AFP
Bill Marr, formerly *National Geographic*
Michele McNally, *Fortune*
James Merithew, *San Francisco Chronicle*
Eric Meskauskas, *New York Daily News*
Maddy Miller, *People* magazine
Michelle Molloy, *Newsweek*
Dolores Morrison, *New York Daily News*
Karen Mullarkey, formerly *Newsweek, Rolling Stone, Sports Illustrated*
Larry Nighswander, Ohio University School of Visual Communication
Jim Preston, *Baltimore Sun*
Sarah Rozen, formerly *Entertainment Weekly*
Mike Smith, *The New York Times*
Neal Ulevich, formerly Associated Press

Website and Digital Systems
Jeff Burchell, Applications Engineer

Television Documentary
Sandy Smolan, Producer/Director
Rick King, Producer/Director
Bill Medsker, Producer

Video News Release
Mike Cerre, Producer/Director

Digital Pond
Peter Hogg
Kris Knight
Roger Graham
Philip Bond
Frank De Pace
Lisa Li

Senior Advisors
Jennifer Erwitt, Strategic Advisor
Tom Walker, Creative Advisor
Megan Smith, Technology Advisor
Jon Kamen, Media and Partnership Advisor
Mark Greenberg, Partnership Advisor
Patti Richards, Publicity Advisor
Cotton Coulson, Mission Control Advisor

Executive Advisors
Sonia Land
George Craig
Carole Bidnick

Advisors
Chris Anderson
Samir Arora
Russell Brown
Craig Cline
Gayle Cline
Harlan Felt
George Fisher
Phillip Moffitt
Clement Mok
Laureen Seeger
Richard Saul Wurman

DK Publishing
Bill Barry
Joanna Bull
Therese Burke
Sarah Coltman
Christopher Davis
Todd Fries
Dick Heffernan
Jay Henry
Stuart Jackman
Stephanie Jackson
Chuck Lang
Sharon Lucas
Cathy Melnicki
Nicola Munro
Eunice Paterson
Andrew Welham

Colourscan
Jimmy Tsao
Eddie Chia
Richard Law
Josephine Yam
Paul Koh
Chee Cheng Yeong
Dan Kang

Chief Morale Officer
Goose, the dog